The German Tradition

Aspects of Art and Thought
in the German-speaking Countries

Edited by
Marion Adams

Department of Germanic Studies
University of Melbourne

John Wiley and Sons Australasia Pty. Ltd.

SYDNEY

NEW YORK　　LONDON　　TORONTO

ISBN and National Library of Australia Card
Number: Cloth 0 471 00460 X
 Paper 0 471 00461 8
Library of Congress Catalog Card Number: 70-127034

Registered at the General Post Office, Sydney, for transmission through the post as a book.

Printed by Offset Printing Coy. Pty. Limited, Chatswood.

Typeset by Dalley Typesetting Service Pty. Ltd., Sydney.

The
German
Tradition

Foreword

At present we seem to be living in an anti-historical age. The historical approach is regarded by some as a relic of the nineteenth century. For certain issues this may be appropriate, but we are in danger of losing one necessary perspective. For all of us it is the present which is most important, but this will remain obscure and even unintelligible unless we try to understand it within the co-ordinates of the past and the future.

Understanding grows out of the study of our own and of foreign traditions. This book serves such a purpose. It introduces a civilisation which, going beyond national borders, encompasses the greater part of Central Europe. Not only east and west Germany with its former and present frontiers can be assigned to the sphere of the "German tradition", but also Austria and Switzerland as well as the surrounding bilingual areas. Names emerge from the following pages which have been brought forth by this tradition and now belong to the world: Dürer and Bach, Beethoven and Goethe, Marx and Freud, Kafka and Einstein. But memories arise too of war and the extermination of human beings in this centre of Europe. Whether the course of history really leads to a final judgement about good and evil, as Schiller believed, may well be doubted in a sceptical century. But even to comprehend the dialectic of a civilisation and tradition is a step towards the humanising of the present and the future, of the kind that Schiller hoped for.

In this book, the many parts of a mosaic are presented which combine to form a picture of the German intellectual, cultural and political tradition. The reader will discover much that is new to him or enables him to see familiar things in a new context. The aim is not praise and propaganda, but recognition and understanding.

G. SCHULZ
Professor of Germanic Studies
University of Melbourne

Acknowledgements

For assistance with the illustrations thanks are due to Inter Nationes, Bad Godesberg; the Consulate of Austria (Melbourne); the Consulates-General of the Federal Republic of Germany (Melbourne and Sydney); the Consulate of Switzerland (Melbourne); the Trustees of the National Gallery of Victoria, and the Department of Germanic Studies, University of Melbourne.

Contents

List of Illustrations

Editor's Preface

The aim of this book is to increase awareness of the artistic and intellectual contribution of the German-speaking countries of central Europe. The area is not culturally homogeneous, and it has never been isolated from foreign influences. Yet the arts and intellectual life in these countries have some special premises that present unexpected features for observers outside; and the areas have been sufficiently linked through a common language and through past entities like the Holy Roman Empire to have developed a common cultural tradition. At various periods it has even been a rather self-absorbed world, intent on defining its identity as against western and eastern Europe. In fact there has long been a marked internal preoccupation in the German-speaking countries with their own tradition.

There is also what seems like an exceptional degree of inter-relatedness among the arts in these countries, and between art and theoretical fields such as philosophy, pedagogy and the sciences. A number of the greatest writers, artists, scientists and thinkers have been many-sided, and an ideal of wide-ranging comprehensive scope is a part of this tradition.

One source of this interaction of various intellectual fields and of the encyclopedic tendency has no doubt been the high level of general education, of a relatively liberal kind, from an early period. Regionalism, although divisive and for a long time a weakening factor politically, is shown here also as a source of strength in economic and cultural life, because of the local independence and competitiveness it has generated. Government has played a greater part in both artistic and economic life than in the English-speaking countries. Like Scandinavia, the German-speaking areas have long understood and fostered the economic and educational basis of the arts as part of general economic policy. It was only from a background of this kind that a locally-sponsored institution like the *Bauhaus,* embracing the arts, education and industrial design, could emerge.

We begin therefore with four chapters on the arts, as the most obvious and for many the most important contribution of these countries to western civilisation. Some of the most striking examples of a strong line or school of art within the German area are: woodcarving over a long period, both as sculpture and as architectural decoration; graphic art almost continuously from Schongauer on; the church and palace architecture of the eighteenth century; music in the eighteenth and nineteenth centuries; and a particular kind of theatre, historical, documentary and symbolic, during the last two hundred years.

Certain elements are mentioned by the writers on the arts as common or frequently met in the German areas: careful craftmanship, structural complexity, intense emotionality and an effort towards maximum scope and meaningfulness. There has very often been some tension between influences from abroad, especially from France and Italy, and the attempt to counter dependence on foreign models by reference to a native tradition.

These and other characteristics appear in various other ways in the chapters on philosophers through to political theories, which introduce the main German contributions in the sciences and learning. Some of the sources and effects of these features and attitudes are then traced in the two chapters on political and economic developments. Certain crucial social factors such as the intense preoccupation with Christianity are also best understood if one refers not only to the history of these areas, but also to their art. The final chapter then draws together a number of these general characteristics.

The separate sections should be of interest to students in particular fields, for example education, philosophy, art and economics, as a summary of German thinking and practice in their field. They may also want to see their study in the kind of context this book provides. Students and teachers of German language and literature also often express the need for this information, which is of course introductory only, and makes no claim to be exhaustive. However, the chapter topics were selected on the basis that this is what anyone who wants a fairly comprehensive view of German culture needs to know.

In conclusion, I should like to thank the authors and the very helpful publishers, and the University of Melbourne for the use of some of its resources.

MARION ADAMS

MELBOURNE
MARCH, 1971

The Artists

Margaret Plant

It is difficult to formulate views of national art: either the category is too wide, or much art is disregarded because it does not demonstrate easily classifiable tendencies. There have, in fact, been few serious studies of national characteristics in art. One of the most important scholars in the field of the visual arts, the pioneer Swiss art historian Heinrich Wölfflin, consolidated the view that north European art has opposed the classical tradition of Greece and Italy with an art of greater violence and emotional impact, and more intricate patterns of line and movement. To most observers there does seem to be a more markedly emotional drive in northern art, and a more disparate and less smoothly evolving form of art.

The Germanic tradition in the visual arts first suggests itself in the early medieval period, that fluid era in European history following the breakdown of the Roman empire. Ostrogoths such as Theodoric, a northern conqueror, took control as far south as Ravenna, in Northern Italy, in the fifth century A.D. Medieval Germanic art consisted of the artefacts of a loosely-connected and wide-spread people who produced an art which was not monumental in scale, but manifested a high degree of craftsmanship and intricacy of design in jewellery and utensils of precious metal. Animal motifs like the eagle and the lion were more important than the human figure. The northern "barbaric" art of this migratory period had much in common with Anglo-Saxon and Scandinavian art, with similar decorative intricacy and virtuoso treatment of animal and abstract motifs. Influences from the eastern empire of Byzantium are evident. The central role of the metal-worker, particularly the goldsmith, was important to the future consolidation of Germanic art: intricacy of line and fine detail are part of a tradition of German art.

The first impetus towards centralisation in northern Europe came from Charlemagne, crowned on Christmas Day in the year 800, and ambitious to recall in his Christian office the splendour of antique and pagan Rome. German scholars have sometimes lamented the southern emphasis of his culture which seemed to stifle the Germanic style of the time, and it does seem geographically fortuitous that Aachen, the capital of Charlemagne's empire, is now in Germany and not in France. *Karl der Grosse,* however, for all his Frenchness, was the founder of the Holy Roman Empire, which became the dominant political organisation through much of Germany's history. The role of religion was important in shaping Charlemagne's programmes for learning and art. In this period German art becomes a Christian art.

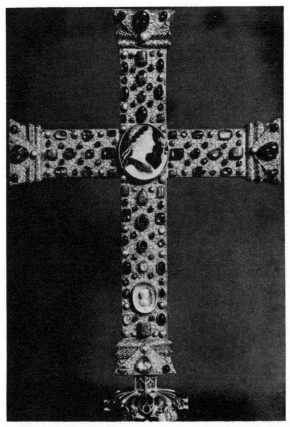

Lothar Cross, c.800.

Carolingian monuments in art are incompletely preserved, but from this time date some of the earliest extant churches outside of Rome, which was the early centre of Christianity and Christian art. Charlemagne's church at Aachen was deliberately modelled on southern prototypes: its centralised plan is not common in the north where the rectangular "hall" church is more usual. The cathedral treasury of Aachen, with its collection of carved ivories, manuscripts, chalices and monstrances, is a repository of great richness and a tribute to the importance of the so-called minor arts in providing the richest and most lavish objects for use in the sacred ritual. An ivory container for the holy water is carved with the imperial image of the enthroned King holding his orb and protected by soldiers. The famous Lothar Cross for use in processions was possibly made at Cologne. The emperor portrait at the junction of the arms of the Cross is modelled on the Roman pattern, but the cross with its gold filigree work and its studded jewels is a typical work of the northern goldsmith.

One of the most important and earliest architectural monuments in the German area is the Lorsch gateway, all that remains of the entrance to an eighth-century monastery. With its patterning of red and white brickwork and its high gable roof it is a uniquely northern adaptation of the Roman gateway.

In the eleventh century the Ottonian dynasty established the first centralised Germanic court, and church and monastery building became widespread, particularly in Saxony, as a result of Charlemagne's eastern conquests. The now isolated buildings

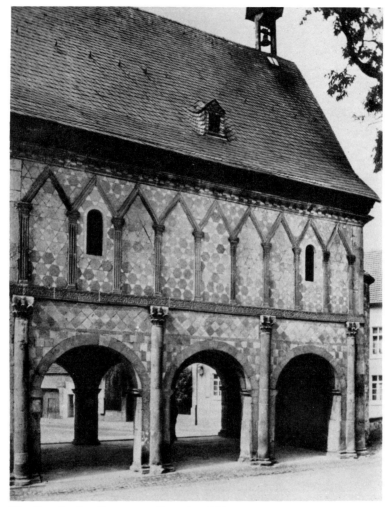

The Carolingian Gateway at Lorsch, c.800.

of the tenth and eleventh centuries that are found in present-day Germany and Switzerland are among the most important in the history of western architecture. These monasteries were famed for their manuscripts, and the art of the hand book had been given great impetus by the scholarly court artists of Charlemagne. Reichenau on Lake Constance was one of the main centres. It was noted for its manuscripts, for its frescoes in the church of St George (which are among the earliest preserved Christian frescoes) and for the ancient church of St Mary and St Mark with its high-pitched alpine roof and tenth century tower.

Germany made an important contribution to the treasured manuscripts produced throughout northern Europe at this time, like the gospels with their covers of carved ivory, gold and precious stones which confirmed the continued importance

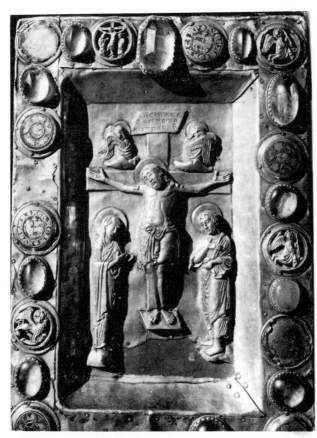

*Romanesque Silver
Book-Cover (cathedral archive,
Brandenburg a.H.)*

of the metal-working arts. These magnificent jewelled books were gifts of kings which necessarily had to enshrine the highest materials and craftsmanship to represent the highest imperial standards. The Evangeliary of Charlemagne, preserved in the treasury in Vienna, was the book on which the German kings swore their oaths. It shows the deliberate adaptation of the classical-courtly style of painting which reflected the Roman aspirations of the new empire. More characteristically northern are the Ottonian manuscripts of the eleventh century which show a restless and agitated style of painting, although the imperial portrait format persists for the representation of Christ, the evangelists and the earthly rulers. The Echternach Gospel has its cover worked in relief with the symbols of the evangelists, the saints and the images of the queen and her son Otto III. A fine collection of manuscripts is preserved in the Bavarian State Library in Munich, with particularly good examples of the distinctive style of manuscript illumination from Reichenau. No age has had such a sense of the precious, of the art of enframing jewels in gold, as the tenth and eleventh centuries in these centres of the Carolingian and Ottonian empires.

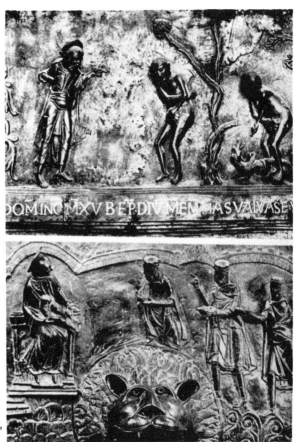

*The Bronze Door of St. Michael's,
Hildesheim, c.1030.*

The subsequent Romanesque style of the eleventh and twelfth centuries suggests in its name the continuing respect of artists and patrons for the achievements of Rome. The greatest Romanesque cathedrals are in provincial France, but Germany too has examples of major architecture from this period. One of the most important figures of the eleventh century was Bishop Bernward of Hildesheim, who commissioned some of the century's greatest works for his monastery church, St Michael's. The area of Lower Saxony with Hildesheim as its centre became one of the major centres of bronze casting and exporting of metal-work. It is often said that the real artistic activity in these centuries when the goldsmith's craft was at its peak centres on the treasuries, but the churches are also architecturally important. Hildesheim cathedral is a unique building, flat roofed and wide, with heavy simple pillars giving strength and dignity to the nave. The stonework is in bands of contrasting colour and the bold exterior has castle-like towers. The exterior is without sculpture, and here German Romanesque differs from contemporary French churches with their elaborately carved doorways. The strong towered church style spread to other German towns like Strasbourg, Speyer, Worms and Cologne. The church of St Maria in Kapitol in Cologne has a door of particular beauty, carved with the scenes of Christ's passion.

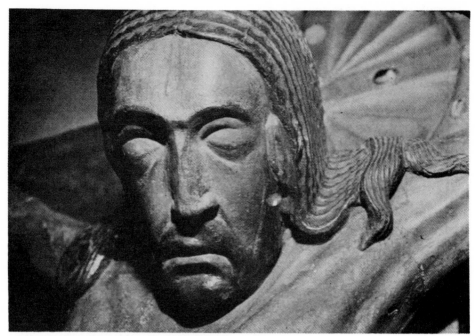

Gero Crucifix, Cologne Cathedral, c.900.

The bronze door of Hildesheim is one of the most important sculptural works of the Middle Ages. It shows an interest, unique at the time, in telling the Biblical stories rather than representing symbolic isolated figures. Scenes from the Old Testament on the left-hand side represent Adam and Eve in the Garden of Eden and Cain's murder of Abel. Adam and Eve are crouching figures, their bodies aware of their shame and bent over as they are cast out by a winged angel. In a traditional juxtaposition of the Old and New Testaments, scenes from the life of Christ are on the right side of the door. In front of the Holy Altar of his church Bishop Bernward placed a unique bronze column which was also cast with scenes of the life of Christ unwinding around the column. His bronzed candlesticks were decorated with entwined figures of Virtues and Vices and his Crozier contained scenes of the creation, the temptation and the revelation. Such representations were almost certainly based on manuscript illustrations, but their bronze form gives them a completely new bearing and significance in the history of European sculpture.

Two other important types of religious figure were widespread in the German-speaking areas in this period: the crucified Christ and three-dimensional figure of the Madonna, often with the body of Christ. Both were important for many centuries of later Christian art. One of the most famous and ancient crucified Christ figures is the monumentally scaled Gero Crucifix in Cologne Cathedral, a giant expressive wooden image of Christ with sunken head, closed eyes and a face of intense grief. Other images of this expressiveness are found in the Minden and Werden Christs, which are powerful examples of the intensity of the Christian

sculpture of Lower Saxony. The Essen Madonna, worked in gold, is somewhat stiff and ungainly but undeniably haunting in her straight-backed pride and her strange eyes set into the gold. This new Eve Madonna holds the apple of her predecessor in her hand and offers it to the infant Christ. Works like this are also found in the treasuries of the French cathedrals, and the most famous medieval goldsmith, Nicholas of Verdun, came from Lorraine to work in Cologne and to produce one of the greatest of all Gothic treasures for Cologne Cathedral. This is a shrine for the relics of the Three Magi, in which gold is bent and hammered to tell the Biblical story with wonderful grace and fluidity.

Gothic art in Germany continued the tradition of metal-working and manuscript illumination, and initiated full-scale church building projects, as in the increasingly important city of Cologne, with its cathedral built to rival the Gothic architecture of the Ile-de-France with heaven-climbing verticality. In sculpture Germany did not attempt to vie with the exterior elaboration of the French cathedrals, but there are many masterpieces: the gracious angel blowing a trumpet from a pillar carved with pictures of the Last Judgement in Strasbourg; the famous donor portraits of Uta and Ekkehard in Naumburg with their quiet dignity; and the equally famed Bamberg rider, the Hohenstaufen knight, who may remind us of the courtly art reflected in the songs of Walther von de Vogelweide and the Minnesingers, represented in illustrated manuscripts now collected in Heidelberg.

Röttgen Pieta, Bonn, c.1320.

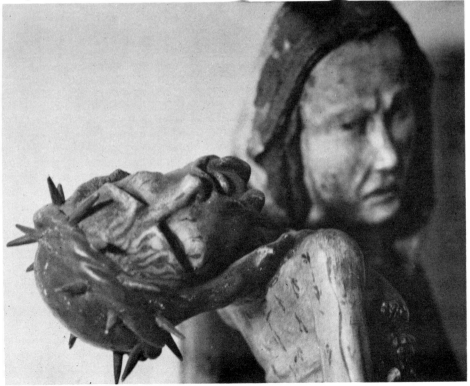

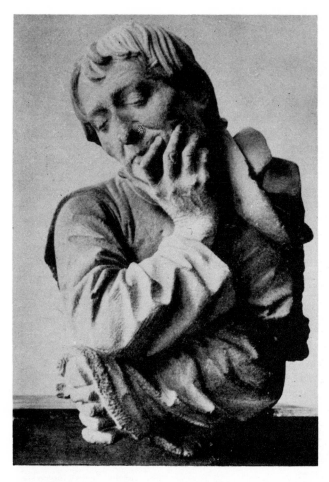

*Nicolaus Gerhaerts:
Self-portrait, c.1467.*

The late fourteenth-century development in wood-carvings was very important. The Swabian school produced many polychromed religious figures of great distinction, and even today wood-carving is a widespread folk art particularly in Austria, South Germany and Switzerland. A particular "Germanic" style seems evident in this sculpture. It is represented in a work like the Bonn *Pietà* (also called the Röttgen *Pietà*), a work of awkward passion showing the Madonna with her face turned ugly by suffering, holding an angular Christ with spiked head tipped backwards. Elegance and polish is barred from the portrayal of death. The expression of pain is often said to represent a Germanic preoccupation in art. This is a simplification, but certainly the Expressionist artists of the twentieth century regarded the work of the Gothic carvers with their powerful distortions as an important source of inspiration for their own strident art, and the Röttgen *Pietà* is echoed in Max Beckmann's paintings of suffering after the First World War.

The fifteenth century saw the acceleration of the arts of wood-carving and stone-carving in Germany, and in particular the climax of the art of the carved and painted altarpiece. In Italy the work of Donatello and Ghiberti was part of a Renaissance in the south, whereas the medieval format of German sculpture has

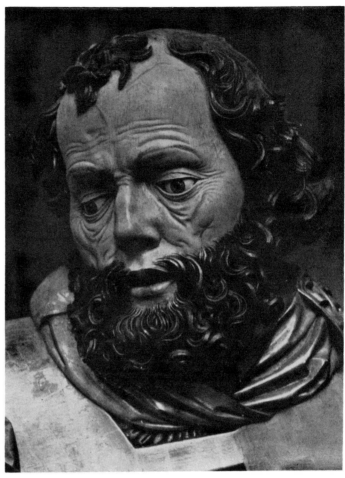

Veit Stoss:
Head of St. Peter
from his high altar
in St. Mary's, Cracow,
c.1480.

been regarded as unprogressive. Nevertheless, the numerous and brilliant examples of German carving show a great vitality in sculpture. The altarpieces of great intricacy contain many figures in swirling and elaborate costumes enacting the Biblical stories under intricate Gothic canopies. This is an adaptation of the "house" given to the figure on the exterior of the French Gothic cathedral. One of the masters is Michael Pacher, painter and sculptor. His Coronation of the Virgin altarpiece for St Wolfgang's church in Stuttgart is elaborately architectural and full of angels singing and trumpeting with open wings, while the Virgin with ringlets and crown kneels against a splendid drapery for her coronation. One of the greatest sculptors of the fifteenth century, Nicolaus Gerhaerts, was from the Netherlands. Called "the greatest of magicians", his work in Germany brought him great fame and influence. His supposed self-portrait of *c.* 1467 is unique in its warmth and naturalness of pose, a stone portrait of the artist with his eyes closed in gentle meditation, chin in hand.

There was great regional variety in this sculpture, and Strasbourg, Ulm, Lübeck and Nürnberg were important centres. An internationalism which resulted from the

journeyman system of apprenticeship established a vital relationship in particular between sculpture and painting in the Netherlands and Germany. As well as the altar form there are many smaller figures such as those known as "the fair Virgins" and the donor portraits and tomb sculptures. The carved figures in the choir stalls of Ulm with their intense personality are very beautiful. One of the last of the large carved altars is Veit Stoss's forty foot high altarpiece in Cracow, a life of the Virgin and scenes from the passion. Nürnberg, soon to become a Protestant city, was a great centre in the time of the young Albrecht Dürer, producing the sculpture of Veit Stoss and Adam Kraft.

In the fifteenth century Germany's development of the art of printing made one of the greatest contributions to European culture. During this period the development of the woodcut as a means of illustration produced not only the first illustrative artists using the woodcut technique (as in the famous printed Bibles of Cologne and Nürnberg), but also the great masters of the independent art print, such as Schongauer, Holbein, and above all Albrecht Dürer, perhaps the greatest German artist. The particular feeling of the goldsmith, his training in the handling of intricate engraved line, is basic to the high art of the German print-maker.

Schongauer, who was trained as a goldsmith, announces in his work the new sophistication of both engraving and woodcut techniques. He was a master of close parallel lines and intense and closely worked cross-hatching effects, and in his Biblical renderings the detailed line gives a new reality to the story and a whole new sense of illustrative complexity to narrative art. The curls of leaves, heavy folds of drapery, grasses growing in cracks in bricks—all this sense of the minute in nature was developed by Schongauer's admirer Dürer into prints of larger and more authoritative size. The effect of Dürer's two journeys to Italy, where he studied contemporary Renaissance art, is well known. Dürer added his essentially Germanic sense of detail and his especial commitment to the visual density and picturesqueness of the world around him to the Italian pictorial disciplines of perspective renderings of space and the classical anatomy of the figure (best reflected in his engraving of Adam and Eve of 1504). Among his most powerful woodcuts are the works of the Apocalypse of 1498, which are visions of death and revelations of the Christian end of the world. Dürer made fifteen woodcuts to form a book in which one of the most well-known pages shows the Horsemen of the Apocalypse galloping beside Death, brandishing swords, felling king and peasant girl alike, accompanied by rushing clouds and a witnessing angel. Here again is the urgency we have observed in the Expulsion on the doors of Hildesheim, in the Gero Crucifix, and in many works of Gothic German sculpture. These themes of death and judgement are particularly frequent in Germany—Holbein's woodcuts of the dance of death are further reflections on the temporality of life. Dürer's great prints of the trial and crucifixion of Christ known as The Great Passion clearly reflect the "Germanic tradition" of the representation of religious suffering. These graphic works are to the visual arts what the passions of Johann Sebastion Bach would later be to music.

The great patron of the time was the Emperor Maximilian. Dürer worked for him on important projects: a famous prayer book for which he did margin illustrations, a triumphal arch and geographical illustrations including a sky map of 1515, which was the first of such maps to be published. A man of wide-ranging interests, Dürer also produced important theoretical studies on the art of measurement and principles of proportion, and illustrated the German text. As a painter he worked

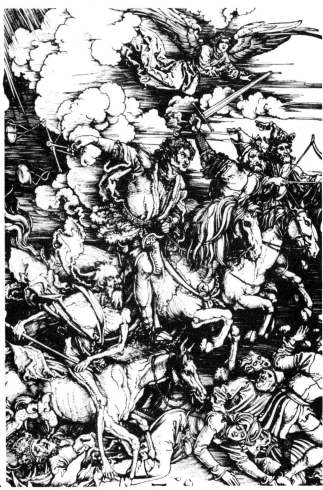

*Albrecht Dürer:
Horsemen of the
Apocalypse, 1498.*

on major altarpieces, with the subjects of the Nativity, the Adoration and the famous Feast of the Rose Garlands, as well as the humbler well-loved watercolours, such as views of Innsbruck, or the minutely described tuft of grass.

Dürer's emphasis in his graphic art on mystical revelation and on the anguish of suffering is combined with a vast power of untroubled observation. This union of the mystical and heavenly with the daily and earthly is found in the work of other artists of the fifteenth and sixteenth centuries. The Swiss artist Conrad Witz paints the Lake of Geneva as a setting for his Christ walking on the water, and the detail of nature appears in the work of the distinctively northern artists Altdorfer and Grünewald, who painted strange and haunted visions.

The forests of the Rhine and the Danube become settings for painters of nature, and the mood is ominous rather than picturesque. The intricacy of nature's buds and grasses as described by Schongauer and Dürer becomes threatening in the work of Grünewald and Altdorfer. Grünewald's important Isenheim altarpiece of 1513 is one of the most fiendish religious paintings. St Anthony has been tempted

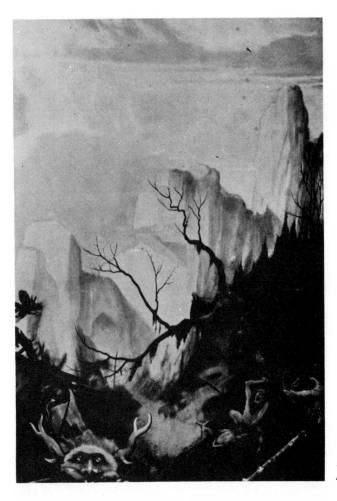

*Detail from
Matthias Grünewald's
Isenheim altar-piece, 1515.*

by a great variety of devils in many portrayals (as in a print of Schongauer's) but the most serious attack is staged by Grünewald, who makes even the winter branches behind the saint hooked and menacing. The Crucifixion painted on the closed doors of the altar offers one of the most lacerated of all bodies of Christ, and recalls the harsh physical anguish of the Gothic Crucifixes. How far removed is this collapse and pain from the nobility of Michelangelo's Crucifixes and *Pietà* which are contemporary with the Isenheim altarpiece.

Grünewald's contemporary, Altdorfer, specialised in panoramas of the forest country which are among the first purely landscape paintings and are also among the first to suggest the winter remoteness of the northern forest and its strange light. His St George encounters the dragon in a remote alpine setting. The sense of urgent nature begins to form a wilful personality which excludes man in some German painting of the sixteenth century.

This distinctive style of landscape painting did not, however, eclipse the importance of religious art. The main followers and contemporaries of Dürer, above all Lucas Cranach, can be understood only in relation to the Reformation and the

whole background of Christianity in Germany. As late as Schongauer, Dürer and Cranach, artists were didactic especially in their widely-diffused graphic art. The particular sense of apocalyptic hell fire which one finds in these woodcuts is not a mere hangover from medievalism in an area geographically separated from the more mature artistic tradition of Italy, but the very centre of speculation in northern religion. The nature of death and human life, the visionary centre of religion, is the emotional impetus for Luther with his visions and teaching that opposed the complacency of the Italian papacy. The art of the time helps to explain the prophetic role that Luther assumed.

Lucas Cranach was the close friend of Luther, godfather to his son, and painter of many distinctive portraits of the reformer. Cranach is interesting in that his religious paintings, portraits, and support of Luther are in strange contrast to much of his art, which was more truly a courtly art as was much of the so-called Mannerist art in the sixteenth century. Cranach painted many courtly portraits for his patrons, and female nudes which challenged the well-known Italian prototypes. They are northern Venuses with high round breasts, distinctly protuding stomachs and very long curved legs. It is as if the artist, forsaking the revered ideal, has looked at real girls, given them a gossamer drape that heightens their erotic nudity, and has stood them against dark backgrounds so that their curves stand out sharp and clear. Dürer could not have produced female figures of such grace and fluidity. It is a strange testimony of the age that the painter of Luther could produce such women, posing with their long legs like the fashion models of today.

This Mannerist court age is best reflected in the Prague court of Rudolf II which brought together scientists, mathematicians and artists. But artistic production was disrupted by the wars fought for the new religion. Art in Germany declined and did not achieve the abundant productivity of Italian art, which by now was confidently secular, or courtly and religious. The Protestant Church avoided the sensuality of art. One year after Nürnberg became a Protestant city, Veit Stoss was forbidden to sell the products of his workshop in front of Nürnberg's *Frauenkirche*.

The Lutheran chorale was to contain the art of the new religion. There is little in the architecture of this period that can lay claim to originality and strength, and German architecture is provincially pale beside the achievement of Italy from the fourteenth to seventeenth centuries, the great age of Renaissance and Baroque building. But in the late seventeenth century, a period of relative consolidation after the Thirty Years' War, the elaborate Baroque style was adopted by German and Austrian architects and a new style of great splendour began. The secular Baroque style of Versailles—Louis XIV's domestic monument—inspired secular edifices like the Belvedere Palace in Vienna, the Palace of Würzburg, Sanssouci near Potsdam and the Zwinger in Dresden, all splendid examples of eighteenth century aristocratic architecture.

German ecclesiastical architecture is distinguished by its radiant scale and lightness, abundant swirling sculptural decoration which is a real renaissance of the sculptor's art, frescoed ceilings with cloud effects and floating angels, altarpieces of breathtaking confusion and light gold and white stucco palaces and chapels. In these churches Germany achieves its great architectural total art or *Gesamtkunstwerk*. Monasteries in particular were given a new importance in the delayed German Counter-Reformation. One of the most famous is the monastery at Melk, built by Jakob Prandtauer and fantastically sited like a Gothic castle above the Danube. Despite Italian sources, German towers and turrets and the siting suggest

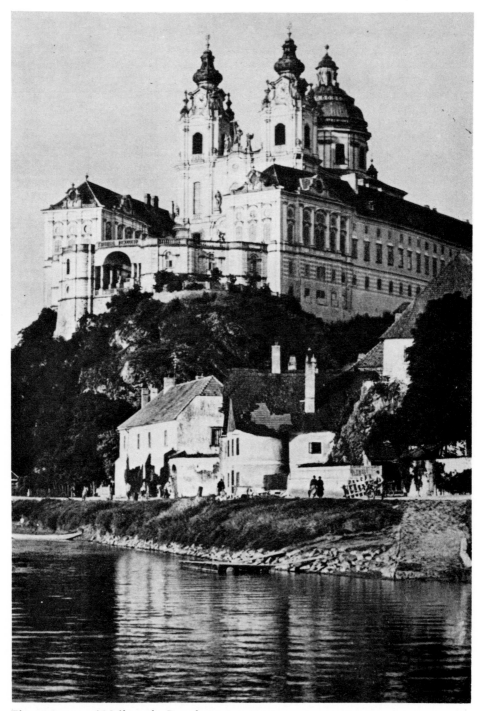

The monastery of Melk on the Danube in Austria.

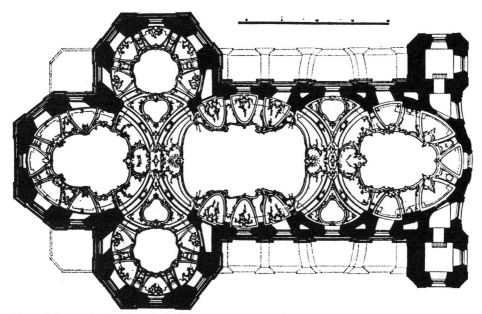

Plan of the vaults in Vierzehnheiligen.

a continuity with early Gothic, just as the sculptural decoration by Baroque masters like Schlüter and Ignaz Günter have Baroque grace and fluidity as well as the heightened and often tragic emotional expression of early Gothic art. The virtuoso drapery folds which feature so strongly in early sculpture and in the graphic art of Schongauer and Dürer again dominate, and one is reminded of the sunburst effect of Grünewald's angel concert in the Isenheim altar.

The gilded and painted ceiling on which the heavens seem to open is seen at its best in the famous church of Vierzehnheiligen, rectangular in plan but rippling inside from one oval dome to another. The stucco columns have gilt capitals, and high windows between elaborate decorative scrolls give great brilliance to the whiteness and the gold and illuminate the fantastic carriage-like altarpiece in the centre of the church. In the famous pilgrimage church of Wies the architecture seems to strive to dissolve itself in clouds, to let the angels that fly round frescoed frames and capitals turn the solid structure into cloud. In sculpture the greatest exponent of grace and fluidity is Feuchtmayer. His *putto* angel steals honey in one of the well-known decorations for a church in Birnau on Lake Constance; his Virgin of the Annunciation in Berlin with her high-standing scalloped collar, swan neck and waved chignon hair incorporates in full-scale sculpture the poise and sheen of contemporary porcelain which had developed to a new degree of fineness and grace in workshops like Nymphenburg in Munich.

The splendour of Baroque (or Rococo) art in Germany is a splendour of architecture served by the other arts. The highest positions in German eighteenth-century art were held by architects such as Balthasar Neumann. Italy still held the lead in painting, and the greatest eighteenth-century paintings in Germany were

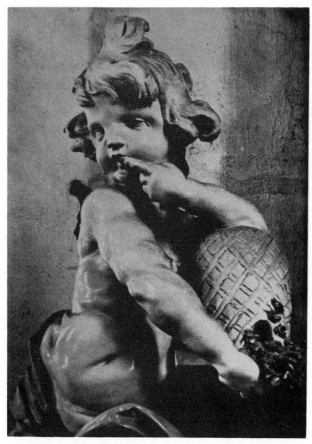

*J. A. Feuchtmayer's
Honey-Eating Angel at Birnau.*

done by the Italian artist G. B. Tiepolo, who worked for Neumann in the Episcopal Palace in Würzburg.

Romanticism, developing in the late eighteenth century, was an art of painting rather than of sculpture or architecture. In Germany it was perhaps a poor reflection of the surge of activity in literature and in music, but one or two painters developed intense personal styles. Men of literature took an interest in art: Goethe organised art competitions in Weimar on mythological themes, his theory of colour had important implications for later artists, and his essay on the Gothic "forest" of Strasbourg Cathedral is an important interpretation of Gothic art. Herder's essay on sculpture was influential with its emphasis on organic growth and its appreciation of the Middle Ages. Friedrich Schlegel extolled the creativity and ardour of the Middle Ages and published a periodical in which he wrote specifically of the German contribution to art, especially in the medieval period.

The literary circle around Tieck in Dresden included the painter Caspar David Friedrich, the master Romantic painter whose work was formed in response to the landscape of his childhood in Greifshafen on the Baltic Sea. Loneliness, the small scale of man amid nature and the bleak solitariness of religion are the themes of Friedrich's paintings. He painted a ruined Cisterician abbey near his

home, a Gothic wall with haunted trees, tombstones and the shapes of diminutive monks in the snow. The crucified Christ is painted in shafts of light, inaccessible on a mountain top. The wrecked ship, the *Hoffnung*, is shown buried under huge slabs of ice. If one is reminded of Schubert's *Winterreise* one soon realises that, unlike Schubert, Friedrich did not alleviate the chill with any transcending human warmth. His contribution to feeling in landscape painting is a unique one. Contemporary romantic landscape artists like Constable and Turner in England saw either the rustic intimacy of the English countryside, or the radiance and colour of sun, rain and sea. Friedrich's landscapes are unique in their winter cold.

Sharing Friedrich's reputation as a significant German Romantic painter is Runge, who painted the human figure contemplating infinity and pondered on the importance of light and the spiritual power of colour, a subject on which he wrote an important treatise and corresponded with Goethe. His paintings and designs of the time of day—like "Morning" with its angels dancing on a lily, or the new-born child lying naked amid nature—are perhaps sentimental to twentieth-century taste, but they represent the mystical yearnings of the romantic painter. A band of artists known as the Nazarenes were romantic in spirit, though somewhat academic in style; they became hostile to the training of the Vienna Academy and went to Rome to found a medieval-like brotherhood of Christian artists. They reflected the deepening medievalism of the period, like Wagner's operas and Ludwig II's nouveau-Gothic castles. Goethe himself sketched on his journeys through Switzerland and Italy and produced some bold scribbles for his *Faust* which are vignettes of the romantic style in the visual arts.

Caspar David Friedrich: The Wreck of the "Hoffnung", 1822.

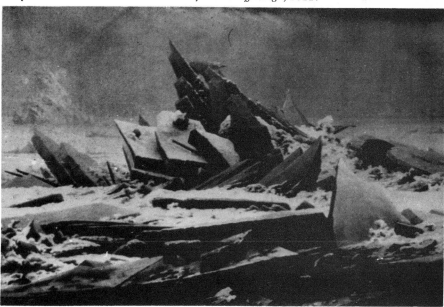

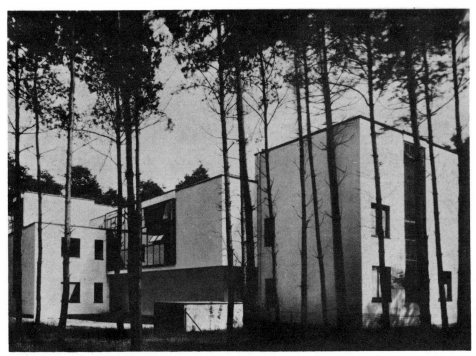

Walter Gropius: Staff Houses at the Bauhaus, 1925.

In the nineteenth century a special strain of homely illustrative and narrative art known as the Biedermeier style flourished in Germany. It drew largely from legends like the Nibelungen tales, fairy tales, folk tales and the medieval dance of death. The older Germanic graphic artists like Dürer were reassessed. Schwind, a friend of Schubert's in Vienna, provided illustrations for Mozart which are romantically musical in theme. The most popular and imaginative of the illustrators was Wilhelm Busch, who created comic-book characters like Max and Moritz, again drawing on the contemporary fairy-tale medievalism. Adolf Menzel made illustrations for works of Goethe and did wood engravings of the life of Frederick the Great. Menzel's painting "Room with a Balcony" of 1845—the open window with a fluttering curtain and delicate interior light—suggests an affinity with the later French Impressionists. Other artists like Leibl (the minutely described "Three Women in Church" is one of the most popular nineteenth-century paintings) and Feuerbach reveal the influence of the art of Paris, the most progressive and vital centre of European art.

There was a group of minor painters working in Germany: the Swiss painter Böcklin, who painted islands of the dead and grandiose allegorical paintings, and Hans von Marées, who did his most eminent work as murals in the Zoo at Naples. The later Impressionist painters in Germany, Liebermann, Slevogt and Corinth, contributed a particular vitality to German art at the turn of the century. Journals like the *Jugendstil* spread the popularity of the decorative style of the late nineteenth century, and in small centres like Dachau and Worpsede artists dedicated themselves to a style of landscape painting of particular intensity known as *Naturlyrismus*.

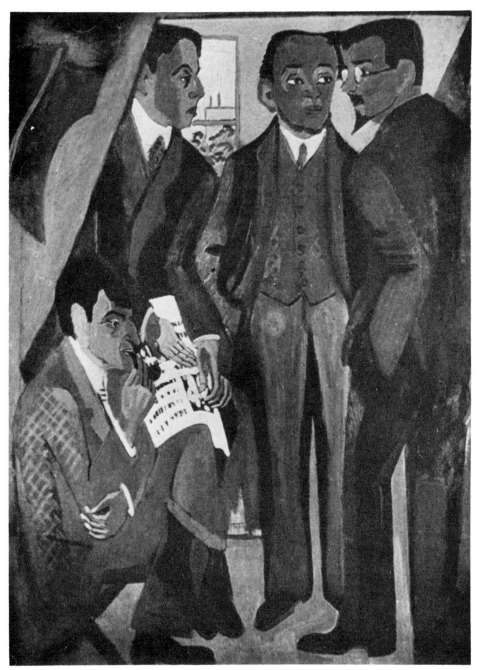

E. L. Kirchner: Painters of the "Brücke" Group.

In the first part of the twentieth century, before the artistic dictatorship of Hitler, German art was full of vitality and experiment, and artists both German and living in Germany have produced some of the greatest masterpieces in twentieth century art. German architecture and industrial design was important. As early as 1899 the *Deutsche Werkstätten* (Craft Association) concerned itself with the design of cheap furniture, and the electricity company, the A.E.G., employed the architect Peter Behrens as a designer. In 1919 the *Bauhaus* was established by Walter Gropius as a school for training in architecture and design, and it has influenced art education and industrial design throughout the world.

German Expressionism was creative in all the arts, including the new art of cinema. In painting, it was the expression of a preoccupation with the urgency and honesty of the artist's personal emotion, particularly in the face of city life, and a corresponding pantheistic mystically-felt concern with nature. Its inspiration was in part the art of primitive peoples, and folk art and the western Renaissance traditions were bypassed in favour of a more distorted form of art. A young scholar, Wilhelm Worringer, wrote topically of "the will to abstraction", which he saw in the new art as a deep-rooted part of a Germanic tradition.

Various artists of the period working in different centres are now usually called Expressionists. Around 1905 a group of artist-architects in Dresden called themselves the *Brücke* group and aimed to exhibit together to produce a popular art that would influence the people. They used the woodcut as a medium because it was direct and strong in contrasts, and also because it was cheap and easily reproducible.

Emil Nolde, an artist from the north of Germany, produced canvases thick in paint and vibrant in colour—roughly rendered landscapes, sea paintings, flowers, and painting of the life of Christ which were very different from the neat religious paintings of the nineteenth-century Nazarenes. Nolde was vitally interested in primitive art (as were the *Brücke* group who were familiar with the ethnological museum in Dresden) and in 1913 he travelled to German New Guinea. He often painted the mask as a still-life object, and his religious figures assume masks which overstate and intensify their emotion. Kirchner, a member of the founding *Die Brücke* group, painted city pictures and women on the street or in their boudoirs, combing their hair on the one hand; on the other, the idyllic nude in landscape paintings. In Vienna Kokoschka wrote plays which are among the first Expressionist writings and painted portraits and landscapes in a romantic chaotic manner, projecting his "sea ringed with visions". The waning of hectic Expressionism was evident as he grew older and became a travelling landscapist working in a panoramic Impressionist manner.

Expressionist sculpture is best represented by the work of Ernst Barlach, whose figures are of simple peasant-like people shown in extreme gestures prompted either by poverty or the depth of their emotion. Anger and the clash between people are the prophetic subjects of Barlach's sculpture of the thirties. One of his most powerful pieces is "The Avenger", a vehement rushing figure with raised sword. His simplification of the human form and overstatement of gesture and emotion seem possible only in the climate of the twentieth century, but Barlach's wood sculpture was deeply affected by the masters of German Gothic sculpture, and his work suggests the spirit of piety often associated with early Christian art. He also contributed to the great German tradition of graphic art in woodcuts, using fierce

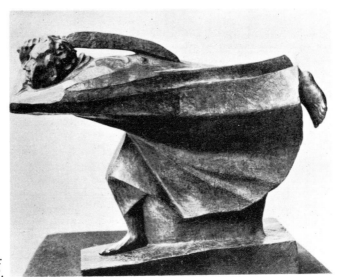

Ernst Barlach:
The Avenger, 1922.

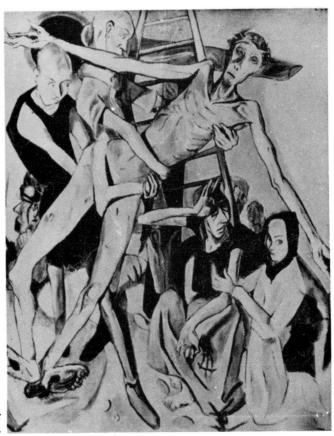

Max Beckmann:
Descent from the Cross.

contrasts of black and white. During the thirties there were pressures on Barlach to emigrate, but he resisted and answered attacks on his work, which was said to fail to embody the spirit of resurgent Germany, by insisting on the nordic roots of his art. Biographers think that the pressure of this pre-war life hastened Barlach's death in 1938. His monument to the fallen of the First World War, the Hovering Angel known as the *Totenmal*—a trunk-like angel hanging free over a commemorative tablet—had to be hidden, like almost all Barlach's work, during the Nazi ascendency. One of the most noble works in twentieth century art, it now commemorates two World Wars.

The most socially conscious painter of the Expressionist period is Max Beckmann, who changed his late Impressionist style of painting after the First World War to paint modern crucifixions enacted by laymen wielding instruments of torture. His anguished style is again clearly related to works like the Bonn *Pietà* and the Isenheim altar in early German painting and sculpture. In a series of self-portraits throughout his life Beckmann gave one of the most relentless visual portrayals of modern man, tense, but heavy-featured and peasant-like, although he wears a lounge suit and may smoke a cigarette. In large paintings using the three divisions of the old religious triptych Beckmann painted allegories, difficult to explain but clearly relevant to the happenings in Germany—to grief and fear, to departure and journeying as a consequence of war. Beckmann was one of the "degenerate" artists, as Hitler termed them. Dismissed from his teaching position in Frankfurt he went to Berlin, but soon left Germany altogether.

In this period of the twentieth century, a Germanic tradition can be distinctly felt through the works of art that draw inspiration from the distortions and piety of early styles. The Expressionist artists above all were aware of and indebted to earlier German art. The power of medieval woodcarving is reflected in Barlach's work, the abstract intricacy of medieval ornament contributes to modern abstraction, the emotional content of a Grünewald serves the portrayal of tension in the twentieth century, and the graphic tradition was deliberately revived. These northern qualities were too subtle to be understood by Hitler, who saw art as a vehicle for a particular subject matter. Aggrandisement rather than criticism was to be the role of his art, but artists like Beckmann, Barlach, and the powerful graphic artists Käthe Kollwitz and George Grosz testify in their work to a free German spirit not easily subdued.

Among the most significant contributions of German painting is the work of Paul Klee and Wassily Kandinsky, Klee Swiss born, and Kandinsky from Russia. Both artists lived in Munich in the early part of the century, and in the twenties they were teachers and important theoreticians at the *Bauhaus*. They expanded the range and meaning of painting. Around 1910 Kandinsky gathered a group of artists around him to form the *Blaue Reiter* group, which included August Macke and Franz Marc (both killed in the First World War) and Arnold Schoenberg, who was active as a painter as well as a musician at that time. The *Blaue Reiter* group shared an interest in the power of colour in painting, and saw colour as a musical function, setting the important emotional keynote. A strong strain of mysticism contributed to their ideas. Kandinsky published an essay called "Concerning the Spiritual in Art" which recommended painting without subject matter. He argued that through the power of colour and shape, painting could mirror the spiritual life of the artist and correct the materialism and decadence which Kandinsky saw destroying the arts. He drafted a colour play of music and dance, called *Der Gelbe Klang*, interestingly close to Schoenberg's expressionistic musical dramas.

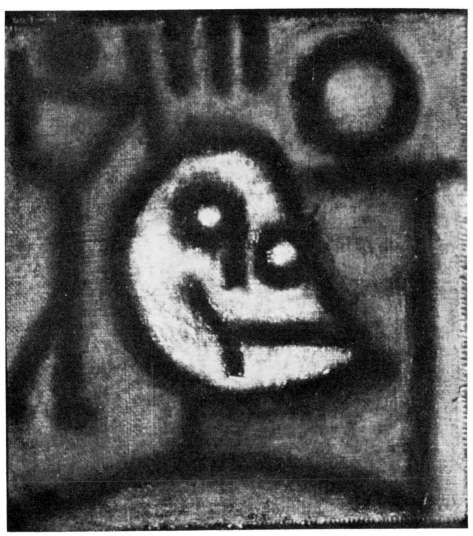

Paul Klee: Death and Fire, 1940.

The *Blaue Reiter* almanac, a collection of drawings, illustrations of primitive and folk art, music by Schoenberg, and essays by artists, is one of the most important documents of early modern art. Kandinsky's abstract paintings, beginning around 1911, were the first concentrated *oeuvre* of non-representational painting. From the *Bauhaus* Kandinsky went in 1933 to Paris, where he died in 1944.

Paul Klee, one of the greatest artists of the twentieth century, developed a style generated by his consciousness of the organic unfolding of the line in a drawing and the final power of colour. He is an heir to the tradition of German romantic thought. A powerful satirist, Klee displayed the foibles of mankind with deceptive comedy. His abstract colour blocks are some of the most lyrical paintings of the

century, and his pedagogical theory has had far-reaching effects on art. At the closing of the *Bauhaus* in 1933 Klee returned to his native Switzerland, and his art more and more revealed the burden of the Nazi threat to artistic freedom. Klee's last paintings before he died in 1940 in Switzerland were heavy, predominantly red and black, and have themes of death. They are a unique group of paintings by an artist deeply aware of the termination of life, both for himself and for Europe.

All these artists were affected in some way by the Nazi art purge and were included in the 1937 exhibition of "Degenerate Art" in Munich which was to end "artistic lunacy and . . . the artistic pollution of the people." Ironically enough, this must have been one of the greatest exhibitions ever held of modern art.

German art has not recovered from the war. The great artists and architects of the first generation have died, or else they have become permanent exiles. Other countries absorbed their gifts: expatriates like Max Ernst, Germany's great surrealist painter, and Josef Albers, one of the masters of abstract painting from the *Bauhaus*, went to the United States and were to a great extent responsible for the post-war dominance of American art. Albers' publication of *The Interaction of Colour* is in the *Bauhaus* tradition of investigation of the language of painting. Walter Gropius and Mies van der Rohe, undoubtedly two of the major architects of the century and foremost contributors to an "international style" of architecture, have made an important post-war contribution in the United States as architects and educators. German scholars in the late nineteenth century were among the first to initiate art history as a full-scale university study and two of the greatest contemporary art scholars, Erwin Panofsky and Ernst Gombrich, were self-exiles from Germany.

Some signs of a greater variety and originality in post-war German art are once again becoming evident, and most commentators agree that the rebuilding that followed the war has been "phoenix-like". Germany is now the host country of one of the most important and carefully staged international art exhibitions, the Documenta Kassel, held every two years. Yet Germany seems far from attaining the richness and originality of her pre-war excellence in the visual arts. The slow recovery indicates the depth of the break of the tradition; Germany's philistine dictatorship reveals what care must be taken with official intervention in the arts.

The Composers

Felix Werder

In the visual arts the German contribution is sometimes described as the "alternate tradition" to classical and other Mediterranean art. But for several centuries the main body of great European music has been provided by composers from the German-speaking countries. In general their achievement has been to give meaning and purpose to sound-textures, sometimes derived at least partly from the south. It is characteristic of German music to be intensely charged with personal emotion and a spiritual impulse, and this music has long been closely related to religious, mythical and political themes and ideas. At the same time it is a tradition of immensely thorough craftsmanship in composition.

European music began with the choral chant of the church, a pure, expressive linear style. This is still the style of the formalised single-voice songs of the troubadours, with themes of love and war, which were often ironic or didactic comments on their time. Walther von der Vogelweide (*c*. 1170-*c*. 1230) gave political expression to his age, much as Richard Wagner was to do later. In his "Palestine Song", written about 1200, the bellicose line is continued within a rigid form of balanced phrases which flowers unexpectedly into a sensuous melodic strain.

Polyphony, which combines monodic lines into a moving entity, came to Germany from the Netherlands and by the fifteenth century Flemish composers were beginning to control the German courts as choir-masters and performers. In the *Lochheimer Liederbuch* (1452), one of the earliest examples of German polyphonic music, a steady inner voice goes its own way, surrounded by embroidery in the outer parts, without any apparent imitative relation to the voice line. This style continued to develop in Germany for the next hundred years, until the arrival of Orlando di Lasso in Munich in 1560 supplanted it for some time in the official music of the church.

Meanwhile the pamphleteering tradition of German troubadors, or *Minnesinger*, was being carried over into the artisan class to create the *Meistersinger*, associations of guild members who prided themselves on their avocation for poetry and music. Their tonality and simple rhythms aim at popular communication and anticipate the Lutheran chorale by nearly a century. They also took over the peasant religious plays with music, which were both devout and satirically anti-clerical and anti-feudal. Protestant music is a natural development from the expression of these popular sentiments. The Council of Trent of 1545 was concerned with

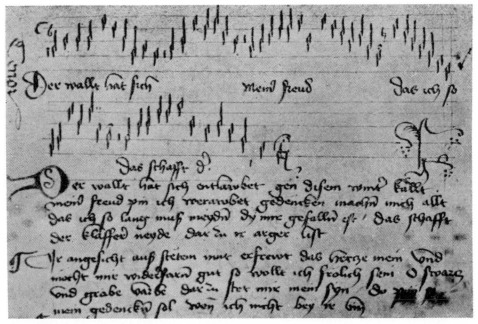

Lochheimer Song Book, c.1460.

church music and tried to impose a return to the older, purer style.

The music of Martin Luther and his contemporaries reflects the revolutionary sentiments of the times. Luther's hymns and chorales became the national music of the German middle class, and during the coming centuries of war and struggle chorales like "Ein' feste Burg" remained the popular music of the day. The music of Luther's work *Das deutsche Sanctus* of 1526 is German in feeling, with its rise to the dominant and its anticipation of the symphonic span. This style mingles easily with the broad melodic line of the mastersingers. The *Silverweise*, a work of the early sixteenth century by the Nürnberg mastersinger Hans Sachs, fuses the courtly grace of the earlier scholar poets with a homely and popular style of new strength.

In the early seventeenth century an important characteristic of German music became established. This is its symbolist tendency, the transference of symbolism into sound imagery. In Leonhard Lechner's *Deutsche Sprüche von Leben und Tod* (1606), images of peril, fall and instability are expressed in corresponding musical figures. This was to be developed in the oratorio, the song and opera. Even details of musical notation are invested with meaning: Johann Sebastian Bach, for example, considered the sharp (in German *Kreuz*, which also means "cross") to be of the utmost significance.

Modern German music is usually said to begin with Heinrich Schütz (1585-1672), who was born in Saxony exactly a hundred years before Bach. Schütz trained in Venice with the Italian composer G. Gabrieli, and he brought an Italian elegance and softness to the older and barer German polyphonic mode. His music became increasingly introspective, but his oratorios and passions have considerable dramatic tension as well as seraphic visions of line. While retaining the spirituality of the older

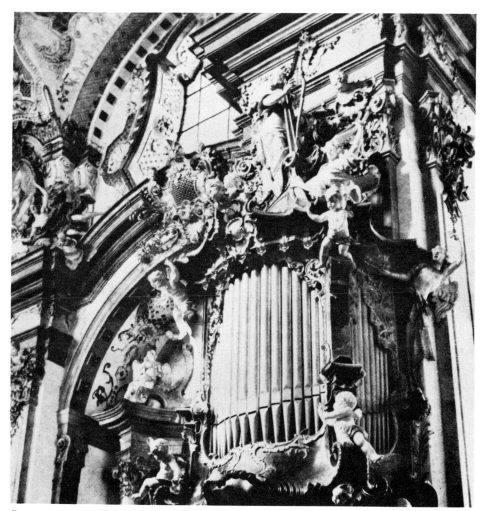

Baroque organ (Wilhering, Austria, c.1730).

music, Schütz learned something of instrumental colour from the Venetians; in fact his subject often seems lost in a forest of sound.

The music of the seventeenth century reflected the ardour and energy of the European Counter-Reformation, and provided an eloquent musical language for religious subjects by sacrificing the harmonious symmetry of repose for the welling of the spirit. There was a danger at this time that the native musical tradition in Germany would succumb to the influence of Italy, which had developed a new vitality in music with the sound-massing of the homophonic style. This struggle against southern influence, together with assimilation of the Italian melodiousness, continued at least until the time of Gluck in the mid-eighteenth century.

Schütz's great successor, J. S. Bach (1685-1750), is in some ways the most German of all composers, and his melodies gathered up the seventeenth-century heritage and fulfilled older north European trends.

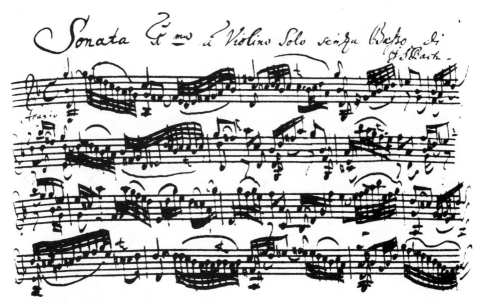

Manuscript of a Solo Violin Sonata by J. S. Bach.

The approach to Bach's music has never been easy. His extra-musical thought content requires complete audience participation, and his music also makes a tremendous interpretative demand on the performer. Bach used music as a language to convey both meaning and an imaginative experience. The accusation of difficulty was levelled at his music in his own time, as it was also at Mozart's and Wagner's and is now again levelled at modern German music. The reason is partly the dense and meticulous structure. Bach was dismissed by one contemporary critic as an "artisan of music", and it was said that his works were too complicated and difficult to perform; the fellow even wrote down all the notes to be played, leaving no room for the performer to improvise! But the difficulty is not really technical or formal. Formal problems as such do not seem to have concerned Bach; in this he is like Mozart, who would have considered a formal aberration as bad taste. The demand made by the German composers is rather for both performer and listener to be prepared to participate in a profound experience.

Two main streams of musical thought are fused in Bach. They are the polyphonic style out of which he grew, and the harmonic style which he fulfilled, so that to Beethoven he seemed the "primaeval father of harmony". The essence of Bach's polyphony is stress, the building of tensions and their release. This holds true not only for the melodic line, but for all elements of the composition. The special genius of Bach is that these tensions are suggested in the single thematic strand. A Bach theme moves and grows like a living organism. Melodic fragments are spun into streaming melodies, latent with explosive emotion.

Bach's musical gestures are declamatory, a manner based on the speech-rhythm type developed by Schütz and abstracted by Bach into the instrumental arioso. This *parlando* style has a deceptive appearance of shapelessness and was disliked by mid-eighteenth century composers for its relentless continuity and apparent

lack of grace. Bach's more popular contemporary Georg Philipp Telemann (1681-1767) anticipated the *avant-garde* movement of his day by writing finely-articulated smaller fragments of tune-shapes interspersed with rests and syncopation. But Bach as well as Telemann responded to the Italian influence and both accepted the singing *bel canto* vocal ideal of the Italians, translating it into instrumental terms.

However, like most earlier and contemporary German composers, Bach took over very little of the Italian interest in orchestral texture and colouration. His lines live independently of orchestration, and it is a truism that even the worst arranger cannot completely ruin his scores. Bach himself cared little which instrument played the written line. The vocal line of a cantata can turn up as a flute solo or in a piano concerto without any loss of beauty or meaning. Apart from this colouristic indifference, Bach also seems to have had no rigid view on the distinction between secular and sacred music and the same piece of his music can make its entry to a different text.

Bach is a much more personal and subjective composer than his great contemporary Georg Friedrich Händel (1685-1759), who spent most of his adult life in England writing operas in the Italian manner and in his later years oratorios, of which the most famous is the *Messiah*. Both Bach and Händel, however, were practical composers who wrote for immediate performance. When Bach became choirmaster at St Thomas' in Leipzig in 1723, he had to write a new choral work for each Sunday service, and he taught harpsichord and violin as well as sitting at the organ as the unsurpassed master of this instrument. Through his industry as well as his genius Bach combined the ethos of the master craftsman with the new ideals of humanism, and strained the archaic shell of the older forms to the breaking point.

In the baroque style of the seventeenth century, and in Bach's music, the elaborate musical ornamentation is tightly composed. But in lesser hands it became empty and affected. Imitation of natural sounds was all the rage, sometimes as scene-painting, sometimes for caricature; this was to revive in nineteenth-century programme music. The sons of J. S. Bach, Wilhelm Friedemann and Karl Philipp Emmanuel, looked for simpler and more direct communication in music. They replaced outmoded musical rhetoric and formulas with more personal expression of emotions. They were composers of human sensibility, and with them classicism was born.

K. P. E. Bach (1714-88) was an important contributor to musical aesthetics, and his monumental work on keyboard technique is still of interest. His was the age of investigation of the nature and purpose of the arts, and he worked and exchanged ideas with authors and thinkers like Lessing and Moses Mendelssohn.

His particular contribution to the development of German music was thematic dramatisation. Both Schütz and J. S. Bach had shown how music can express the inner life. But K. P. E. Bach was able to create half-tone effects of new subtlety and refinement by demonstrating how a note changes its emotional significance according to the weight of harmony with which it is surrounded. Moreover, the baroque composers had worked with one subject which they spun out. K. P. E. Bach brought together two conflicting types of theme—the idealised march, with all its German overtones, and the Italian serenade; his thematic material unfolds and resolves this conflict, often ending with a restatement of the original theme. Thus was born the sonata form. The younger Bach in Berlin, J. W. A. Stamitz in Mannheim and C. W. Gluck in Vienna consolidated the German style which in its developed state was to emerge in the symphonies of Haydn and Mozart.

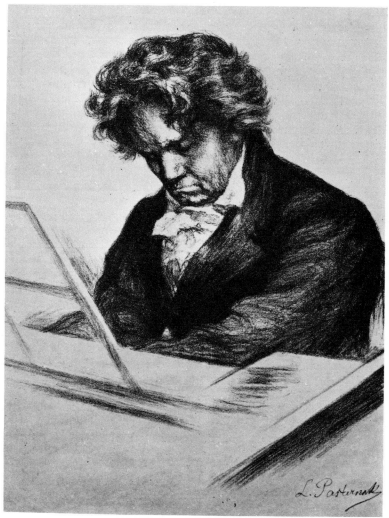

Ludwig van Beethoven.

The sonata principle of K. P. E. Bach, when orchestrated, becomes the symphony. However, symphonic construction requires in a composer the ability to control the musical perspective known as tonality or key, and to span time and subordinate diverse musical elements in time. With Joseph Haydn (1732-1809), Wolfgang Amadeus Mozart (1756-91) and the earlier music of Ludwig van Beethoven (1770-1827), the symphony began to dominate European musical culture. From about 1770 to 1830 their achievement made Vienna the most important musical centre in Europe.

This was the so-called "classical" age of music, a term that should apply only to the form, never to the content of this music. The classical composer pours his musical ideas into an existing mould. He uses an existing form to contain new ideas. For example, Mozart took a dance movement like the minuet and gave it unheard-of tragic overtones, as in the D minor quartet or the Jupiter Symphony. Mozart was not an innovator in form. He reflected the rationalism of his time, the belief in order and hope for social equality, and the disillusionment of the later eighteenth century, which he expressed in irony. Music as art existed at this time only by the grace of wealthy noblemen for whom the composer was just another servant. Haydn was to spend forty years as a liveried court musician, dependent, as were Mozart and K. P. E. Bach, on the generosity of aristocratic tyrants whose taste at best was for clear, symmetrical and elegant music. It says much for the genius of Haydn and Mozart that they managed to build so solidly behind this facade. This was due in part to the unbending adherence of the German composers to their traditional seriousness, even at rococo courts, and also to the lasting influence of the older popular German music with its vigour, directness and spiritual references.

Beethoven is the cornerstone of German achievement in the symphony. He built massive concentrated sound blocks, and carried the earlier development of anticipation of stress, delayed resolution of dissonances and composed silences to a high degree of tension and meaning. Beethoven's letters bear witness to his response to the literature and the revolutionary political events of the day. He had a tremendous admiration for Klopstock, Schiller and Goethe and a passionate belief in equality and freedom. His independence of attitude had an effect on the status of composers. His opera *Fidelio* is about freedom, and his Ninth Symphony, the crown of his orchestral creation, is a stirring call to oppressed humanity. Writers like the Austrian dramatist Franz Grillparzer recognised that Beethoven was expressing attitudes and feelings which censorship made it much more difficult to express in literature.

After Beethoven the symphony declined in Germany. In the symphonies of Franz Schubert (1797-1828) and even more so in those of Robert Schumann (1810-56), the thematic song-melody, however beautiful, is unable to sustain itself. K. P. E. Bach and later Haydn had worked with themes or fragments to gain unity of floration. The disadvantage of the song as a theme is that the more perfect it is in itself, the more unyielding it becomes to development and growth—one can write variations on a song, but not a symphonic development.

The difficulty was recognised by Johannes Brahms (1838-97), who tried desperately to remain a classicist at a time when romantic music was reaching its peak of achievement. Brahms had no time for the "new music" of Liszt and Wagner and denounced their psychological and literary approach to composition. His own symphonic concept was classical in that it operated within the bounds of the sonata form. He had a fine sense of harmony and grasp of rhythmic interplay as well as the classical ability to build through contrapuntal development. He also drew on the folk song, and his symphonies further develop the emotional language of German music.

The last significant symphonic composer in the German line was Gustav Mahler (1860-1911). Mahler is an outstanding composer of orchestral mass, and his orchestration is often of overwhelming impact. His musical symbolism can turn a trivial tune into a profound experience, he has a fine sense of the pertinent, and in spite of contrasting elements the various movements of his symphonies retain their

unity. His weakness is his concern with literary and metaphysical concepts which he was not fully able to translate into musical terms. But his daring chromaticisms, supported by changing notes and appoggiaturas, anticipated modernism in music.

Parallel with the rise of the symphony runs the development of the German music drama. The German courts of the seventeenth century had been fascinated by Italian opera, but did not have the resources to produce it and had to content themselves with chamber music. One can in fact sum up the difference between Italian and German music by saying that the Italian line is vocal and the German line instrumental. This is true even of the developed forms of the nineteenth century. In practice the Italian composers thought in terms of a singing line with the orchestra in the pit as an enlarged guitar. German operas are rather orchestral symphonies with the voice line counterpointed through them.

In its infancy in Florence opera had been a dry affair, with an unimaginative recitative plodding along. But the genius of Claudio Monteverdi transformed this amorphous form into a vibrant work of art, and his lead influenced Schütz to introduce opera into Germany. But baroque opera remained a sort of declamation from a platform, and Schütz's transcription of J. Peri's *Dafne* in 1627 was little more than that. The Thirty Years' War (1618-48) prevented any further development, although there were spasmodic attempts in Nürnberg, Leipzig and Hamburg to get opera started using sacred texts. In 1678 the first secular opera was established in Hamburg.

A great advance was made by Christoph Willibald Gluck (1714-87), with whom German music drama proper began. Gluck's early attempts at opera had been completely Italian in style, with the awkward relation of the form between literature and music. Later Gluck was able to merge these elements and create something new. He responded to the humanist theatre of his contemporary Lessing, the simplified stage bringing in popular elements, and he instigated the revolt against artificiality in opera and against the dominance of ornamentation and the virtuoso singer. His melodic line is German in its simplicity and heart-rending speech rhythms. Gluck's famous and moving opera *Orfeo* (1762) is the high point of German achievement in the opera before Mozart.

Mozart's dramatic genius translated eternal problems and eternal types into a rich musical imagery. As compared with the conventional neo-classical subjects of Gluck's operas, Mozart's themes are a social mirror of his times, sharpened by satire. *Il Seraglio* (1782) is a manifesto of the emancipation of women, *The Marriage of Figaro* (1786) proclaims the rights of servants and *The Magic Flute* (1791) the rights of all men. Mozart lifted the stylish Italian comic opera to new heights of grace and significance, and showed as well how German might become a language for opera. Goethe, who had been interested in the development of German opera and had himself written *libretti,* described how all these efforts were in part justified but also seemed irrelevant "when Mozart appeared".

Around 1800, stimulated by authors like Tieck and Novalis, music began to discover the magic of deep forests, lonely wanderings and alpine storms, and to reflect nature in a more direct and extensive way than before. German opera at this time became more closely linked with northern landscape and myth, most obviously in Carl Maria von Weber's *Der Freischütz* (1821) and in the fairy-tale opera *Undine* (1816) by the author-musician E. T. A. Hoffmann.

In his one opera, *Fidelio* (1806), Beethoven had not quite managed to relate

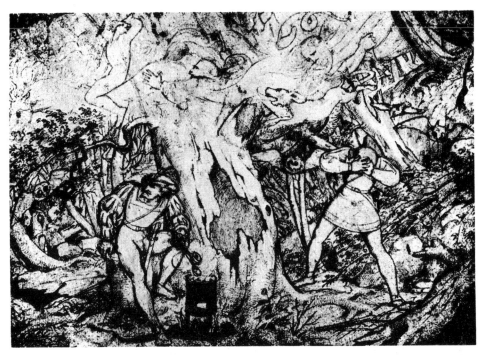

Illustration for Weber's Der Freischütz *by Moritz v. Schwind.*

his tremendous symphonic genius to the new directions suggested by Mozart and by the romantic authors and composers. From the 1840's this fusion was achieved with ever-increasing complexity and monumentality by the greatest of all nineteenth-century composers after Beethoven, Richard Wagner (1813-83).

Wagner's outstanding qualities as a composer are the powerful unity and development of his symphonic thematic material, and his extension of the harmonic palate. He had the same capacity as J. S. Bach and all the major German composers after Bach to create a meaningful theme which could grow and change, and the same constructive logic, maintained over a great span in the dramatic, psychological and musical structure of his operas. He is also characteristically German, and the true successor to Bach, in that he put all the elements of his music to the service of an idea. Even more than Mozart and Beethoven, Wagner was steeped in the political and philosophical thought of his time, which he projected into interpretations of old north European epics and sagas. Wagner was politically active in his early years, and his operas (especially his great four-part work *The Ring of the Nibelungen*) lend themselves to political interpretation. He also had the typical German preoccupation in the arts with art itself, and artistic problems are part of his operas, usually represented through the role of the singer, as in *Tannhäuser* (1845) and *The Mastersingers* (1868). Wagner's music, with its chromaticism and dissonance, is also the basis of modern music, which one can derive from the opening chord of what is possibly his finest opera, *Tristan and Isolde* (1865).

Scene from Wagner's Tannhäuser.

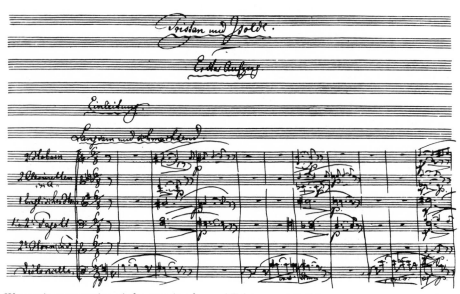

Wagner's manuscript of the opening bars of Tristan and Isolde.

Richard Strauss (1864-1949) was the most distinguished of Wagner's followers in Germany. His operas are constructed like Wagner's in that the voice lines are projected through the orchestration rather than moving above or apart from the orchestra; they are in fact tone-poems with voices. His early work *Elektra* (1909) carries Wagner's rhetoric to an extreme of violence, and is still a work of great impact. Strauss is best known for his very different, Mozartian opera *Der Rosenkavalier* (1911). His collaboration with the Austrian author Hugo von Hofmannsthal is suggestive of the long-standing relation between music and literature in the German-speaking countries.

Opera has continued as a popular and living form in central Europe in the twentieth century. Arnold Schoenberg's works for voice and orchestra were based on older types: his monodrama *Erwartung* is thought of in terms of the Bach solo cantata, and his *Moses in Aaron* recalls Händel's oratorios. His pupil Alban Berg shows typical careful craftsmanship at the service of a highly expressive idea in *Wozzeck* (1920) based on Büchner's drama. Paul Hindemith, Werner Egk and Gottfried von Einem have made important contributions. Hans Werner Henze, (b. 1926), the most imaginative of present-day German composers, and Carl Orff must be mentioned. Orff is an original figure, a composer of successful operas often based on medieval subjects, with a simplicity and immediacy that recall the *Minnesinger*.

Apart from the symphony and the music drama, the *Lied* or song has undergone special development in the German-speaking countries. Often the composers have set important contemporary poetry to music, as Gluck set Klopstock's *Odes* and Mozart Goethe's poem "The Violet". Haydn and Beethoven wrote songs, but it was Schubert who in his six hundred songs (some arranged in cycles) brought the form to perfection. Schubert was a master of mood and changing emotion, and he provided poetry and folk-songs with a complex and dramatic piano accompaniment. None of his successors achieved his freshness and melodic purity. With Felix Mendelssohn (1809-47) the new art-form became all charm; with Schumann, Brahms and Hugo Wolf it was mainly solemn; and Richard Strauss' songs leaned heavily on the earlier masters. Mahler, with his fine feeling for texture and interest in popular music, might be considered the true heir of Schubert. In the twentieth century German composers have not been much interested in the solo song, and have concentrated rather on the larger canvases of opera and cantata.

The modernist revolution that occurred in music around 1900 was due above all to the music and theoretical writings of the Austrian composer Arnold Schoenberg (1874-1951) and his pupils Anton von Webern and Alban Berg. In many ways their attitude was a rejection of both classical and romantic music and an attempt to take a new direction from the older forms. Schoenberg's school systematically set out to destroy the illusion of keys and tonality, and Schoenberg regarded his effort as parallel to that of his friends Kandinsky and Klee in their break with pictorial perspective in painting. Schoenberg himself retained the broad sweep of the classical composers, but Berg and Webern were basically miniaturists who meticulously set off each phrase and sometimes each note with a vigour that recalls medieval scholasticism. There is a real unity of form in these works, although of a different kind from the previous harmonic coherence.

The next step was to work with pure sound patterns, written for instruments or put together with the aid of electronic machines. In his music Karlheinz Stock-

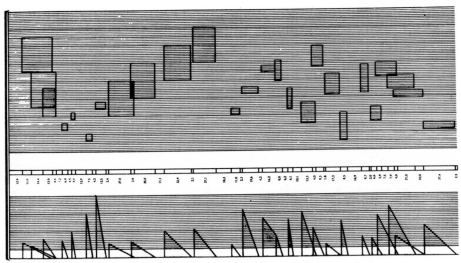

From the score of Stockhausen's Electronic Studies.

hausen (b.1928) emerged after the Second World War as an internationally known leader. His works are a lexicon of novel ideas, and generally electronic music has forced composers writing for the traditional instruments to take account of the new formal possibilities and thematic material that it offers.

The strong emphasis of the past in German music on the expression of emotion and the human situation has reasserted itself against the rather arid trend of recent modernist music. One of Stockhausen's own best works is his "Youth's Song", which is a work constructed from tapes using a snatch of a psalm sung by a boy—a humanist basis, therefore, for a hauntingly beautiful work.

This continuity and frequent reference to its own older music is perhaps the most striking aspect of the German musical tradition. At least between J. S. Bach and Wagner composers constantly built on the involved contrapuntal complexity of their predecessors, in a constant thorough absorption of previous music as the basis for something new. The sheer industry of the German composers has also been remarkable; if certain special forms or developments have been discussed here, the German composers have contributed to the enrichment of almost all musical forms.

Today Darmstadt has become the focus of the world's *avant-garde* in music. On the practical side, this cultural chain has been strengthened by the very generous government support for composers and for the performance of music in the German-speaking countries. Good work is done by the broadcasting stations, and the studios for broadcasting electronic music in Cologne and Munich are internationally admired. Concert promoters and the public demand and get a fair proportion of contemporary music, and the heavily state-subsidised opera houses provide and even commission a certain number of new works every season. This state aid cannot of course produce talent, but it allows the abundant natural musical talent in these countries to develop.

Medieval Literature

C. Kooznetzoff

The Middle Ages is a comprehensive term covering everything from the reign of the last Roman emperor to the capture of Constantinople by the Turks in 1453. This span of nearly a thousand years had earlier been looked upon as a dark hollow between ancient and modern civilisation. Now, however, this time is usually divided by literary historians into two distinct periods, with a date about 1100 marking the division. The darkness has been pushed back to the centuries prior to 1100, while the succeeding age, though still medieval in name, is seen as a first awakening compared to which, as one literary historian says, "the Renaissance is a mere ripple on the surface of literature." Exaggeration or not, the half century between 1180 and 1230 is certainly one of the great creative periods in the history of German literature.

The advent of this new era was heralded by the sudden appearance of new languages and their literature, particularly those of the Romance countries. With scarcely a warning came the love-songs of William IX (1071-1127), Count of Poitou and Duke of Aquitaine, who was the first of a long line of Provencal troubadours. The rise of the Angevin empire, intimately connected with the fortunes of William's grand-daughter Eleanor (c. 1122-1204), saw the new sentiment of courtly love radiating in all directions. Courtly poets appeared in quick succession in France, Spain, Portugal, Italy and England. Clerics and scholars, like Abelard before them, abandoned the mysteries of the Trinity to sing of love's secrets in Latin. By the end of the twelfth century the movement had also swept through Germany, superseding native tastes and fashions. German *Minnesinger* had begun to contribute to this new tradition, among them Heinrich von Veldeke, Friedrich von Hausen, Albrecht von Johansdorf, Heinrich von Morungen, Reinmar von Hagenau and, above all, Walther von der Vogelweide. Courtly poetry was not of their making, but enriched by them it later merged into the *dolce stil nuovo* of Petrarch and Dante to become a continuing inspiration down to the nineteenth century.

No satisfactory explanation for the origin of courtly love has yet been found. Ovid, Mariolatry, Arabic and Goliardic influences, the feudalisation of indigenous poetry, or a synthesis of some or all of these have been suggested. But if the origins of this poetry are obscure, its characteristics are not, and have repeatedly been described. Perhaps the most representative description is that of C. S. Lewis, who postulates four main components: humility, courtesy, thwarted adultery and the religion of love.

The Minnesinger *as bond-servant of his lady-love, Manesse manuscript, Heidelberg, early 14th century.*

Hartmann von Aue, Manesse manuscript, Heidelberg, early 14th century.

Wolfram von Eschenbach, Manesse manuscript, Heidelberg, early 14th century.

Ulrich von Lichtenstein, Manesse manuscript, Heidelberg, early 14th century.

The relation of the knightly lover to his lady is seen in terms of feudal service *(frouwendienst),* but with no prospects of requital. The usually abject lover can only hope and despair, although his outpourings are more conventional than confessional (courtly love is poetry about love and not the poetry of a lover). Only the courteous (that is, those at court) can love and only love as a noble and ennobling passion can make them courteous. The situation also had its hazards:

> . . . this love, though neither playful nor licentious in its expression, is always what the nineteenth century called 'dishonourable' love. The poet normally addresses another man's wife, and the situation is so carelessly accepted that he seldom concerns himself with her husband: his real enemy is the rival (C. S. Lewis, *The Allegory of Love,* pp. 2-3).

By parodying the Christian religion, this amatory ritual soon developed into a rival religion, achieving a well-argued body of theory in Andreas Capellanus' *De amore libri tres* (*c.* 1185). This new cult, C. S. Lewis claims, "erected impassable barriers between us and the classical past or the Oriental present", and its legacy is present even in "our code of etiquette, with its rule that women always have precedence" (pp. 3-4).

C. S. Lewis' description of courtly love no doubt deserves the currency it enjoys in literary histories. It nevertheless has two serious shortcomings. First, courtly love is treated as a static phenomenon, with no regard paid to its historical development. Secondly, Lewis takes no account of the regional differences in its manifestation.

The earliest extant *Minnelieder* are the one-stanza *Frauenmonologe* (monologues spoken by women) dating from around 1160. They are an important distinguishing feature of *Minnesang,* for in no other contemporary European literature is there a

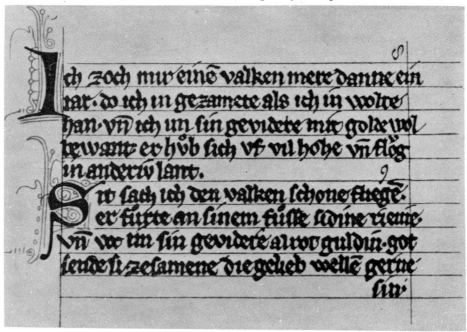

Two stanzas of a Frauenmonolog *by Der von Kürenberc, Manesse manuscript, Heidelberg, early 14th century.*

counterpart to the German one-stanza *Frauenmonologe*. There are about twenty-five of them, some anonymous, but mostly written by a poet known as Der von Kürenberc. All have subject matter that would hardly comply with C. S. Lewis' description: sorrow of separation, passionate yearning for reunion with the lover, doubt about the lover's faithfulness, confirmation of one's own loyalty in the face of tribulation, jealousy, triumph over the rival, renunciation, and tender remembrances. The ingredients are invariably the same: a simple, unsophisticated lyric form; a symbolic nature setting; a girl, unmarried and of the peasantry rather than the court, as the wooer; and a suggestion of physical intimacy. The following is an illustrative example, the spirit of which has admirably been recaptured by a modern German composer, Carl Orff, in his scenic cantata *Carmina Burana* (1936):

Gruonet der walt allenthalben.	The forest is green all around.
wa is min geselle also lange?	Why does my friend tarry so?
der ist geriten hinnen.	He has ridden away.
owi, wer sol mich minnen?	Oh who will love me now?

As J. G. Herder in his *Stimmen der Völker in Liedern* (1778-9) first showed, these monologues are indigenous to every country and race. They have their origin not in literary tradition but in folk customs, in the primitive rites and ceremonies of the old Nature festivals and in May dances and songs where the female partner is invariably the wooer and aggressor. It is German *Minnesang* of the twelfth century which has preserved, perhaps more than any other world literature, this folk-song tradition in a relatively uncontaminated form.

The original one-stanza *Frauenmonolog* readily lent itself to stylisation and narrative expansion and is present in infinite modifications in world literature. In medieval German literature it acquired a second stanza quite early which was spoken by a man to produce a dialogue *(Gespräch)* or an exchange *(Wechsel)*. Later it became embedded in a dance song, or a *Kreuzlied* where the woman is left lamenting the departure of her crusading lover; or it was set into a *pastourelle,* with the central theme of the often facile adventure of a knight with a country girl. More often its traces are found in dawn-songs *(Tagelieder),* which tell of the parting of lovers after a night spent together, perhaps best known to English readers from later literature like the "Wilt thou be gone" dialogue of Shakespeare's *Romeo and Juliet* or John Donne's "Busie old foole, unruly Sunne".

The most radical transformation, which for a time threatened to eradicate all traces of the original *Frauenmonolog* setting, occurred in the second half of the twelfth century, when the chivalric-courtly culture of the Provence had swept over Europe. With the feudalisation of love, the scene changed from nature to court, the roles of the participants were transposed and socially upgraded, and the style and treatment assumed a refinement verging on casuistry. It was now the knight who sang in anguish of his undying love for an unattainable object—the married lady at court. This is the poetry and sentiment that C. S. Lewis has described.

At the height of this vogue in Germany, the original *Frauenmonolog* eked out a meagre existence in dawn-songs. But for the most part it went underground into the Latin poetry of the Goliards *(Carmina Burana, The Cambridge Songs),* to be rediscovered and reinstated in vernacular literature by Walther von der Vogelweide, foremost of the German *Minnesinger.*

There is very little external information available about any of the *Minnesinger,* Walther included. The two famous anthologies of the fourteenth century, the so-called *Manessische* codex in Heidelberg and the *Weingartner* manuscript in Stuttgart,

Walther von der Volgelweide (c.1170-c.1230).

show stylised portraits of the poets along with their respective coats of arms, which often give a clue to a possible place of birth. But in a majority of cases the evidence in inconclusive. As far as Walther is concerned, biographers are fortunate in having in him a particularly egocentric poet. His favourite subject was himself. From his poetry and especially his political songs, literary historians have been able to outline broadly the external circumstances of Walther's life.

Shortly before 1200 the young Walther left Vienna after a bitter literary and personal feud with his preceptor in the art of courtly love, Reinmar von Hagenau. Reinmar's verse is the foppish art of a master of sophistry. In his school there was little room for original poetic invention, and much less for an agitator like Walther. The rebellion against the art of his teacher and the imported troubadour tradition of courtly love left Walther with only one choice, the open road. In 1203 we find him in the company of Bishop Wolfger of Passau, whose expense accounts in the years 1203-04 have made him something of a Samuel Pepys of the Middle Ages. Bishop Wolfger had a rather unorthodox habit of sharing church funds with those his superiors called "the limbs of Satan", the Goliards or wandering scholars. One entry has made his account book particularly famous. Amongst the numerous hand-outs to vagrant scholars and minstrels we find a sum of five shillings being paid to a *Walthero de Vogelweide* for a fur coat. Walther found the new environment stimulating. It brought him into contact with the native *Frauenmonolog* tradition, and he began to write lyrics which one would find hard to exclude from any anthology of German love poetry *("Under der linden", "Nemt, frouwe, disen kranz")*.

Walther von der Vogelweide also wrote poetry of a political nature. The international and internal politics and issues of the day, in particular the struggle between the Pope and the Emperor, provided ample material for his satirical ingenuity. Whether it was a question of personal involvement or mercenary propaganda, literary historians have been unable to decide. At any rate, Walther's contemporaries must have found it easy to forget the poetry and concentrate on the political victims and the reasons for the malice. For us today it is easier to appreciate Walther's poetry as poetry, for invariably positive poetical creation came out of his destructive political intent.

Walther later returned to the troubadour tradition, only to renounce it again like so many of his predecessors for something which seemed more permanently rewarding. He had in the past supported the cause against foreign political intervention. He had attacked papal exploitation of German lands, with a vehemence that anticipated Martin Luther and his Protestant colleagues. He had set himself up as judge of German education and society and he had tried to encourage politicians to support the arts (by that he invariably had himself in mind). But old age found him in a renunciatory mood. He rejected the world to become a devotional poet of medieval Christianity *("Fro Welt, ir sult dem wirte sagen", "Ir rein en wip, ir werden man", "Owe war sint verswunden alliu miniu jar")*. After 1230 nothing more was heard from him.

Among Walther's great contemporaries were Hartmann von Aue, Wolfram von Eschenbach and Gottfried von Strassburg. Although they all wrote lyric poetry, they are better known for their romances, a literary genre just as much a product of courtly culture as the troubadour lyric. And like the courtly lyric, it also had its rough-edged precursors.

Morolf disguised as a minstrel, from a 15th century manuscript of
Salman und Morolf *in Stuttgart.*

First of all there was the body of religious verse, mainly of Austrian (and
monastic) provenance, dating from 1070 to 1170. It takes its themes from the Old
Testament, particularly the Pentateuch, medieval Christian theology, eschatology,
legends of the saints, Mariolatry and to a lesser extent the New Testament. One of
the most striking characteristics of this body of verse is its radical and almost sadistic
hostility to temporal life, a hostility which an author like Heinrich von Melk (*fl.* 1150-
60) did not hesitate to express in the stark image of a putrefying corpse:

nu sich in wie getaner häite
diu zunge lige in sinem munde
da mit er diu troutliet chunde
behagenlichen singen,
nune mac si nicht fur bringen
daz wort noch die stimme . . .
nu sich, wie recht undare
ligen die arme mit den henden
da mit er dich in allen enden
trout unt umbevie . . .

(Now see how his tongue lolls in his mouth, with which he used to sing love-songs so pleasantly. Now it cannot bring forth either words or voice. And see in what hideous fashion his arms and hands lie there, with which he used to stroke and embrace you.)

It has been suggested that by his very choice of sensuous imagery, Heinrich von Melk is in fact affirming what he sets out to deny. Be that as it may, the overriding theme of *memento mori* was not to the taste of the times. It was shelved, later to become one of the main preoccupations of the waning Middle Ages, the *danse macabre* or dance of the dead. In the meantime the centre of interest had shifted to the fabulous East, the new world beyond the limits of Christendom which had been discovered for Europe by the Crusaders.

As military ventures the crusades were, of course, disastrous. But the ferment in the imagination produced by contact with the East was of far-reaching consequences. A testimony to the indirect secular influence of the crusades are the five anonymous epics, the *Spielmannsepen: König Rother, Herzog Ernst, Salman und Morolf, Oswald* and *Orendel,* all written after 1150. Their authors are presumed to have been travelling gleemen. The common theme is *Brautwerbung.* The epics tell how a certain king goes awooing, how his bride runs away or is stolen from him and how he gets her back again. For the first time a woman ceases to be a mere object and becomes a moving force in imaginative literature. Here, she is very often a faithless wife with a mind and a will of her own, and therefore usually in league with the infidels. The figure of Solomon is also interesting, to use *Salman und Morolf* as a further illustrative example. In earlier interpretations of the "Song of Solomon" (Williram's *Hohes Lied,* the Vorau *Lob Salomonis* and the *St. Trudperter Hohes Lied),* he had appeared as the heavenly groom; his bride was either the Church, Christendom or the Virgin Mary, and his kingdom was God's kingdom, a second paradise. But here he cuts a rather sad figure. He is still the ruler of all of Christendom, but he is no match for his unfaithful wife, who is finally brought to heel and killed by his brother Morolf, a trickster-figure who is a master at disguise and invents all sorts of shady plans.

The middle of the century also saw the appearance of the imperial chronicle, *die Kaiserchronik.* In over 17,000 lines of verse it gives an account of secular history from the founding of Rome to the beginning of the second Crusade in 1147. Although history is still viewed in terms of the Augustinian dualism between good and evil, the imagination of its monastic author runs riot and the result is a *pot-pourri* of pseudo-historical anecdotes, novellistic tales and legends of saints and emperors.

A further historical work belonging to this period is the *Alexanderlied,* which tells the life story of Alexander the Great in three different versions. For the Middle Ages the Greek hero was just one more chivalrous adventurer who finds his way beyond the known limits of the world, even to the gates of paradise. In literary history this becomes the first work to give the hero's early education detailed treatment.

The Alexanderlied is also the first German adaptation of a French source. From this time epic-writers and *Minnesinger* alike became French in their literary taste. One romance after another is translated into German: *Flore und Blancheflur,* a love story that ends in a mixed (heathen-Christian) marriage; Eilhart von Oberge's *Tristrant,* a tale of two lovers bound in adulterous passion by a magic potion, a work which was soon overshadowed by Gottfried von Strassburg's *Tristan;* Heinrich von

Veldeke's *Eneit* (from the French adaptation of Virgil's *Aeneid*); Meister Otte's *Eracles*, a saint's legend set against the background of classical antiquity and oriental fantasy; Herbort von Fritzlar's *Trojaroman* (a free adaptation of a French translation of a Latin summary of Homer's *Iliad*); *Athis und Profilias*, where a wife is lent to save a love-sick friend; *Morant und Galie*, in which Charlemagne's wife is accused of adultery with a vassal; *Moriz von Craun*, a variation on the theme of the woman surprising the lover asleep at the appointed time and place. German Francomania, it seems, knew no bounds, for in about 1170 even the Middle French paean to *la douce France*, the song of Roland, received a German rendering.

Although these are not all literary masterpieces, they are generally acknowledged as forerunners of the courtly epic or romance, and as such claim a place in literary history.

The era of the classical courtly epic began in Germany with Hartmann von Aue (*fl.* 1180-1200), an innovator and one of the most versatile of German writers of the time. His works perhaps best illustrate the difference between the pre-courtly and the courtly romances, as practised by himself and his great contemporaries Gottfried von Strassburg and Wolfram von Eschenbach. The themes are still borrowed. But poets were now faced with the task of inventing the new ways of using words which were necessary for contemporary literature to exist. And so the use of language became exploratory and creative, which is something more than just a command of idiom or any other process that consists of merely putting thoughts, ideas or plots into words. This type of linguistic invention sets a work like Hartmann's *Gregorius* or *Der arme Heinrich* apart from say, the *Wiener Genesis* or Albrecht von Halberstadt's adaptation of Ovid's *Metamorphoses*.

But Hartmann also tapped a new source for literary endeavour by introducing into German literature the *matière de Bretagne*, a collection of legends of Celtic origin revolving around King Arthur, the knights of the Round Table and the quest for the Holy Grail. The undisputed master of the courtly romance and the "matter of Britanny" was Chrestien de Troyes (*fl.* 1160-80), who became the source for Hartmann's two Arthurian epics, *Erec* and *Iwein*, and for most of Wolfram von Eschenbach's *Parzival*.

By this time the new ideal of the literary hero had already crystallised and was embodied in the knight-errant. He had his forerunners in the earlier epics: the itinerant trouble-shooter Morolf, the dauntless adventurer of Alexander's mould, who undertakes even impossible tasks; and the self-sacrificing Roland, facing the enemy horde. In addition, the knight-errant had been nurtured by the ethos of medieval Christian society, which like every warlike aristocracy needed an ideal form of manly perfection. The ascetic element is always present in this ideal. William James states that the noble warrior has to be poor and without ties. "Owning nothing but his bare life, and willing to toss that up at any moment when the cause commands him, he is the representative of unhampered freedom in ideal directions." For centuries this product of medieval chivalry remained a main-spring of energy and at the same time a cover for a whole world of violence and self-interest. The knight-errant still flits today across film and television screens in the guise of the Western gunfighter, the samurai or the American war hero.

But the aspirations and imaginings that have shaped the idea of chivalry are not entirely ascetic. As J. Huizinga has pointed out, the erotic element is always present. The sublimative urge and the combative instinct in knight-errantry would

The slaying of the dragon, from a 13th century manuscript,
of Gottfried von Strassburg's Tristan *in Munich.*

never have formed so solid and sturdy a framework "if love had not been the source of its constantly revived ardour." The knight-errant will not be content merely to uphold justice and to suffer; he will want to serve for love and to rescue the object of his love from danger or distress. Here a primitive motif is added, "that of defending imperilled virginity—in other words, that of ousting the rival." And this is the main theme of courtly romance: "the young hero delivering the virgin". The sexual element is always there, even if the rival is a harmless dragon.

Hartmann's epics, like those of Chrestien, are variations on this basic theme of

discovery and deliverance. And in Gottfried von Strassburg's *Tristan* (*c.* 1200-10), the dragon again raises his head, only to be slain and have his tongue cut out.

Today the story of Tristan's illicit love affair with Isolde, the bride of his uncle, King Mark, does not have the same passionate urgency it had for Richard Wagner's generation. Wagner's opera is now often interpreted and performed as yet another variation of the ancient Oedipus drama, and present-day literary critics see its source in much the same light. But before them, a contemporary, Wolfram von Eschenbach, had seen what Gottfried was driving at.

The hero of Gottfried's poem is an orphan at birth. By the time he reaches maturity he has acquired not only a foster father, but also an adoptive father (his uncle King Mark), both of whom go to extremes in showering him with privileges. His uncle even offers to abdicate in his favour. But the deprivation inherent in the circumstances surrounding his birth and the acquisition of two over-indulgent fathers result in the absence of a natural father-son rivalry. There is nothing in the environment to make competition worthwhile, so Tristan embarks on a series of deliberatively provocative attacks directed both against King Mark and other substitute father-figures of his own making. He kills the child-stealer Morolt, making it perfectly clear to everyone that he is performing Mark's duty. He chooses and, by killing a dragon, wins a bride for his adopted father. He even sleeps with her and invites discovery in the Love Grotto. But all to no avail, for King Mark will not be provoked. To his own dismay, Tristan is spared the retribution that befell the original Oedipus. But he still refuses to grow up. At the end Isolde and Mark are reconciled as marriage partners, leaving the hapless knight-errant to pursue giants in other kingdoms.

The person who was provoked by Gottfried von Strassburg's *Tristan* was his great contemporary, Wolfram von Eschenbach. Their bitter literary feud is one of the favourite subjects of German literary historians. Wolfram was incensed by Gottfried's impolite attack on knight-errantry and replied with his *Parzival* (*c.* 1200-10). The knight-errant *can* grow up, he claimed, even if he starts out with no other characteristics than exceptional *tumpheit*, that is naiveté and foolishness. Given just this, Parzival is set the task of exploring the religious foundations of Christian chivalry and its function in society, a task which he finally accomplishes after countless setbacks and failures (anticipating those of Goethe's Faust) to find favour with God and become the Grail King. Unlike Gottfried, Wolfram was not the enemy of medieval Christian society, but quite consciously its representative and its voice. Summing up his work, Wolfram said:

swes leben sich so verendet,
daz got niht wirt gepfendet
der sele durch des libes schulde,
und der doch der werlde hulde
behalten kan mit werdekeit,
daz ist ein nütziu arbeit.

(He who at life's end does not through his worldly actions deprive God of his soul, and yet on the other hand can still retain favour in the eyes of the world by his example—he has not laboured in vain.)

There can be no doubt as to which work the German public has always preferred. Wolfram's *Parzival* is extant in almost four times as many manuscripts as Gottfried's *Tristan*.

Wolfram's final works are called *Titurel* and *Willehalm*. The former treats

a theme from his first work, while the latter revolves around a typical Wolfram problem, that of the warrior-saint. Both however are incomplete and are overshadowed by his *Parzival*.

Towards the end of the eleventh century, that is, some time before the Provençal and French poets began converting Europe to the courtly way of life, the older Germanic languages underwent a change. It was as if they were preparing to meet the sophisticated challenge of French ideas. Trained for centuries on Latin translation, a Latin incapable of life, these languages attained in a very short time flexibility and a self-assurance that banned anonymity from literature. Henceforth, most poets were known by name and can be differentiated by their individual style and thematic idiosyncracies. In professional philology, the new Germanic languages after 1050 are called Middle English and Middle High German, as distinct from Old English and Old High German of the Dark Ages or the early Middle Ages.

The Romance languages in the Dark Ages have very little to offer in the way of poetry. The largest and richest body of vernacular literature before the twelfth century existed elsewhere. It belonged, despite the genius of Celtic imagination, to those nations who are generally held responsible for the darkness.

The Germanic tribes brought not only new languages into European literature but also fresh subject matter. This becomes evident when we compare their contribution with that of the largest corpus of literature extant from this period, the writings in Latin, which was the principal and common language of the early Middle Ages. The Latin authors from Boethius (d. 524) to Ekkehard (d. *c.* 1036) had a different task to perform. They revived and continued the classical heritage; they taught the seven liberal arts; they wrote hagiographies and civil histories; they compiled material for Biblical commentaries and encyclopedias of the natural sciences; and they served the church and state in administration and in continuing the missionary work begun in Germany by St Boniface (675-754).

Of course some concession was made to imagination. The works of the first German woman dramatist, Hrotswitha von Gandersheim (*c.* 935-*c.* 973), and the anonymous epics *Waltharius, Ecbasis Captivi* and *Ruodlieb* immediately come to mind. Nor can we omit the rhyming hymns and lyrics which constitute the most original and imaginative poetry of the Latin Middle Ages. But generally speaking, the Latin writings are conservative, imitative and insufferably dull. Moreover, they do not belong exclusively to this period, beginning before it and continuing without a break right down to the Renaissance proper. On the other hand to say that the vernacular literature of the Dark Ages was all fresh and original would be a gross distortion.

The Christianisation of European society, inaugurated by the papacy and carried out by the Benedictine order with the support of the Carolingian dynasty, spread the dogmas of the Christian faith in a language readily understood by ordinary people. The materials and the methods of recording the language were a monopoly of the missionaries and monastic scholars. They were of course not interested in recording and perpetuating the pagan Germanic tradition, and much less so on the mainland than on the periphery. It is only by chance that anything at all is preserved.

Old High German literature is therefore mainly translation and exposition of Latin knowledge by the followers of the great Alcuin, men like Hrabanus Maurus of Fulda and his pupil Walafrid Strabo of the Reichenau. The oldest German "book",

The first side of the Hildenbrandslied *manuscript, 9th century in Kassel.*

for example, is the *Abrogans* (*c.* 750), a Latin-Old High German glossary, so named after its first entry. And by far the greater part of the body of Old High German literature belongs to the Latin world, the common Christian educational tradition: the glosses, confessions, catechisms and baptismal vows; the translations of the Benedictine Rule and of Bishop Isidore's treatise; the Gospel Harmonies of Tatian and of Otfrid von Weissenburg; the legal and medical documents; the hymns, rhymed hagiographies and Vulgate adaptations; the works of Notker Labeo (d. 1022) and the Bestiary. All are German in speech and all deserve a place in the history of German literature. But they are not German, or more appropriately, Germanic, in the same way as the *Hildebrandslied* or the *Merseburger Zaubersprüche.*

Germanic verse is not rhymed, but alliterative. The line is divided into two parts, each with two accented syllables, with alliteration in the first three of the four heavy syllables. The third syllable always alliterates, the fourth virtually never. This metre is found in one of the oldest Germanic inscriptions on the golden horn of Gallehus in Schleswig-Holstein, now lost, but dating from the fifth century:

 Ec H́ lewagastiz H́ oltingaz/h́ orna t́ awido
 (I, Hlewagast Holting, the horn made)

This is the metre of the *Hildebrandslied*, a heroic poem of a father-son encounter in which the son is slain. It is also the metre of the pagan charms for freeing prisoners of war and for curing sprains (*Merseburger Zaubersprüche*); of the *Wessobrunner Gebet,* a hymn on the Creation, and of the *Muspilli,* a poem about the Last Judgement; all together, about two hundred lines of alliterative verse. These are the only German remnants of the poetry least affected by Rome and all it stood for (although the last two mentioned have not escaped contamination). Germanic alliterative verse fared better in England, where 30,000 lines are extant (including *Beowulf*); in Old Norse literature with its 10,000 lines (chiefly consisting of the *Poetic Edda*); and in the Old Saxon with over 6,000 lines (*Heliand*).

It is debatable whether the German tradition has any claim at all either to the form or the content of Old High German alliterative poetry. German poets succumbed very easily to the temptations of the end rhyme, which was first used by Otfrid von Weissenburg (*fl.* 870). Even the basically Germanic theme of the *Ludwigslied* (881) could not avoid it. In contrast to the tradition in Scandinavia or England (one has only to think of *Piers Plowman*), alliteration was an anachronism in Germany by 900 A.D. Alliterative verse or *Stabreim* is perhaps a Germanic product, but not necessarily a German one. And the same applies to the plot of the *Hildebrandslied,* the heroic poem German philologists hold most sacred in their literary tradition. The father-son conflict, as narrated in this epic, has been a favourite theme for tragic authors since time immemorial.

But whatever its national allegiance, a poem like the *Hildebrandslied* is the starting ground for something which can be called the German tradition in medieval literature. For this we shall have to return to the twelfth century, and to the *Nibelungenlied.*

In contrast to the Arthurian romances, the authors of German heroic poetry are anonymous. Another difference is that its protagonists can clearly be traced to the most turbulent period in German and European history, the wars of the Great Migration between the fourth and sixth centuries. Names such as Ermanaric, Attila and Theodoric that appear in these epics are known to historians of the

period. But the historical characters appearing in heroic poetry are freely conceived and bear little resemblance to the historical persons whose name they carry. The epic "is cut loose and set free from history, and goes on a way of its own", picking up myths here and there and transmuting them into poetry (W. P. Ker).

Although the extant German heroic epics treat quite a number of different cycles (for example, the Hilde saga in *Kudrun*, that of Wolfdietrich in *Ortnit* and the Theodoric saga in over a dozen different epics from the second half of the thirteenth century), the *Nibelungenlied* is the only one that possesses literary merit.

The anonymous poet of the *Nibelungenlied* (*c*. 1200) had to face and overcome the same sort of problem as his contemporaries Hartmann, Gottfried and Wolfram. There was nothing new in his story, which had already been exploited by Scandinavian poets. And yet by his unpredictable and ironic use of language he produced a unique piece of literature. In their *Interpretative Commentary* to the *Nibelungenlied*, D. G. Mowatt and H. Sacker have demonstrated that in this work positive literary creation is synonymous with the conscious and sometimes unconscious development of the borrowed plot by structural imagery and symbolism: words, characters, episodes and scenes are all inexhaustively subtle in their interplay and each itself reflects in some significant and relevant way the main course of the story.

The story of the *Nibelungenlied* is that of a complex, decadent society which tries to rejuvenate itself by absorbing primitive forces. Its failure to do so leads directly to self-destruction. Its end is annihilation, unmitigated by any hope or thought of a pagan or Christian after-life.

In the opening scenes the Burgundian court at Worms is ironically presented as a model of perfection. Titularly lead by three ineffectual brothers, Gunther, Gernot and Giselher, it is actually run by the sinister Hagen. Kriemhilde, sister of the three kings, seems a typical Burgundian princess, but occasionally shows signs of individuality, especially in her emotional life.

The situation is very much the same at the court of Santen. Here the misfit is Sifrit, who has a rather unusual past. He was born with super-human strength and has killed a dragon, thus acquiring a magic cloak and treasure.

The Wessobrunner Gebet, *early 9th century manuscript in Munich.*

ᴅᴇ ᴘᴏᴇᴛᴀ·

Ɗaᴛ✳ freʒin ih mit firahim
firi uuizʒo meiſta· Ɗaᴛ eᵣo ni
uuaᵣ· noh ufhimil· nohpaum
noh peᵣegniuuaᵣ· ninohheiniʒ
noh ſunnu· niſtein· noh mᴂno
niliuhᴛu· noh dermᴂᵣʒoſeo·
Ɗo daᵣ niuuihᴛ niuuaᵣ enᴛeo
ni uuenᴛeo·⁊ do uuaſder eino
almahᴛico coᴛ manno miltiſto·
⁊ daᵣ uuaᵣun auh manake miᴛ
inan· cooᴛ lihho ʒeiſta·⁊ coᴛ
heilac· Coᴛ· almahᴛico du

⁊ du mannun ſomanac cooᴛ
for✳ pᵢ· for gipmir indino
ganadᴇc ᵣehᴛa ʒalaupa·
⁊ coᴛan uuil leon· uuiſtom
enm ſpahida·⁊ crafᴛ· ᴛiuflun
ʒa uuidar ſtanᴛanne·⁊ arᴄ
ʒapi uui ſanne·⁊ dinan uuil
leon ʒa✳ uurchanne·

Quinon uult peccaᴛaſuapenᴛeᴘᴜ
ille uenᴛ ᴛᴇpim ubi· ᴇᴄ mampliuᵣ
illum non penᴛᴇbunᴛ· nec illoᵣ̴ꜱ

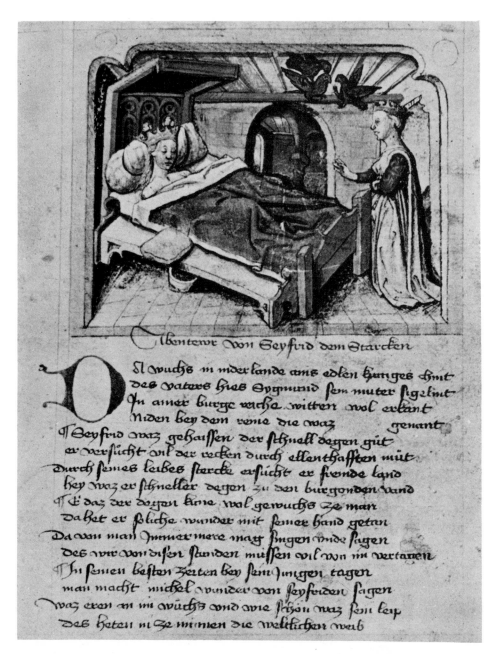

Kriemhilde's falcon dream in the Hundeshagen codex of the Nibelungenlied, *15th century, in the* Staatsbibliothek Preussischer Kulturbesitz.

In contrast, the ruler of the court at Isenstein is the redoubtable Brünnhilde. She equates kingship with strength and is resolved to remain single until she is subdued in a contest of physical strength. King Gunther decides to take a wife, but is, of course, unable to fulfil her conditions. However, when Sifrit arrives at Worms to woo Kriemhilde, Gunther strikes a bargain with him. With the aid of his magic cloak, Sifrit wins Brünnhilde for Gunther and Kriemhilde for himself. The deceit, however, cannot remain hidden for long and the quarrel between the two women leads to the ritual murder of Sifrit. Blaming her kinsmen for her husband's death, Kriemhilde assuages her loss and grief in vengeance. In the ensuing holocaust, the whole Burgundian way of life is completely destroyed. The final chilling scenes show what happens, and what can still happen in our own day:

> The last magnificent tournament ends in a brutal killing; the elaborate political speeches are reduced to childish defiance; the subtly interlocking loyalties and prohibitions to blind tribal solidarity; the splendid feasting and drinking to the final macabre meal of blood, with corpses for benches. (D. G. Mowatt, *The Nibelungenlied*, p. ix.)

The breakdown of the medieval world order was well under way by the middle of the thirteenth century and had a concomitant effect which can only be described as devastating: for the next four centuries German literature as literature ceased to exist. This is not to say that nothing was produced in this period. On the contrary, the output reached a quantity and variety that has resisted the codifying efforts even of German literary historians. Horror of vacuum and intellectual debility were the attendant features of dissolution.

A starvation of impulse had already become evident in Heinrich von dem Türlin's *Crone* (1220-30). Intended as a capping "crown" to Arthurian romances, it ran to 30,000 lines of verse. By the middle of the century Ulrich von Türheim had added an ending to Gottfried's *Tristan* and 36,000 lines to Wolfram's *Willehalm*. Henceforth the value of omission is disregarded, the accidental and the essential are confused, and accumulation and abuse of detail become synonymous.

Rudolf von Ems (*c.* 1200-*c.* 1253), who had previously taken the unprecedented step of making a merchant the hero of his *Der guote Gerhart*, broke off his *World Chronicle* with the death of Solomon after 33,000 lines of verse. This sort of sterile activity soon became a vogue with writers like Albrecht von Scharfenberg in his *Jüngerer Titurel* (*c.* 1270), a gigantic summation of the whole Grail complex; or Heinrich von Freiberg, who also attempted a *Tristan* conclusion (*c.* 1290); and Ulrich von dem Türlin, who, by way of variation, wrote a preamble to Wolfram's *Willehalm*.

Chivalry and feudalism had long ceased to be vital forces in society. But writers still promoted the overdeveloped and stagnant idiosyncrasies of the Arthurian romance in an idiom that was just as foreign to contemporary life as its subject matter. The culmination of this deadlock was reached in Ulrich Füetrer's *Buch der Abenteuer* (*c.* 1490), where Parzival, Lancelot, Iwein and Wigalois are once more resurrected and paraded in revue. Like its many predecessors it was a monotonous pastime for exhausted minds. The same applies to the numerous collections of heroic material from earlier periods which were quickly pilfered by the chapbooks or popular dramatists like Hans Sachs: *Karlmeinet* (*c.* 1320), the *Dresdner Heldenbuch* (1472), the *Gedruckte Heldenbuch* (1477) and the *Ambraser Heldenbuch* (1512).

Similar odd extravagances can be observed in the development of the courtly love lyric, particularly in the verse of Ulrich von Lichtenstein (*c.* 1200-75) and Oswald von Wolkenstein (1367-1445). *Minnesang* also became an increasingly popular medium for social satire. Neidhart von Reuenthal (*fl.* 1215-35) widened the breach in the courtly convention which Walther had made, and, once started, the fashion rapidly increased. The heroes of Neidhart's so-called courtly village poetry (*höfische Dorfpoesie*) anticipate the grotesque farmer-knights of *Meier Helmbrecht* (*c.* 1260) and of Heinrich Wittenweiler's *Ring* (*c.* 1400).

The distinction between the artist and the artisan tended to disappear with the works of Konrad von Würzburg (*c.* 1220-87), particularly his *Goldene Schmiede*. According to tradition, Konrad was one of the founding fathers of *Meistersang*. From the middle of the fifteenth century the exponents of this literary-musical genre, the mastersingers, formed singing guilds or fraternities (*Singschulen*) in some of the larger southern German towns like Mainz, Strasbourg, Freiburg, Nürnberg, Augsburg, Ulm and Memmingen. They developed and then codified elaborate rules of composition, which were based on the techniques of the acknowledged early masters in the art. Their members, like Hans Folz (d. 1513) and Hans Sachs (1494-1576), were for the most part master craftsmen who naively and self-righteously churned out massive quantities of mechanical verse in much the same fashion as they did their cloth, metal and leather goods. Of all the literary genres of the late Middle Ages, only *Meistersang* is an exclusively German phenomenon. Goethe's and Wagner's homage to Hans Sachs and the mastersingers is no more an accident than the long life of some of the fraternities. The one in Ulm closed down in 1839, and the last *Meistersinger* of Memmingen died in 1922.

Amongst the acknowledged masters of the *Meistersinger* were Frauenlob (*c.* 1260-1318), Heinrich von Mügeln (*fl.* 1355) and Michael Behaim (1416-74). All wrote gnomic, didactic and religious verse, including the ever popular songs in praise of the Virgin Mary.

Pious fantasy had been set loose by Konrad von Fussesbrunnen in his religious epic *Kindheit Jesu* (*c.* 1205). By the end of the century it had invaded the domain of literature to such a degree that an anonymous preacher felt sufficiently inspired to compile a composite hagiography in 100,000 lines of verse, the *Passional*. Gnomic and didactic poetry was no less popular a genre in the thirteenth century. Thomasin von Zirclaere's *Der Welsche Gast* (*c.* 1215), Freidank's *Bescheidenheit* (*c.* 1230) and Hugo von Trimberg's *Der Renner* (*c.* 1300) had in addition given it a basis of learning. Frauenlob and Mügeln brought more learning, gained from the works of Alan of Lille (*c.* 1125-1203). Alan was destined to sow the seeds of all great allegorical poetry of the Middle Ages—Jean de Meung's *Roman de la Rose* and the poetry of Dante and Chaucer. Allegory was the medieval way of making abstract concepts more tangible and more clearly intelligible. Placed beside the allegorical poetry of Chaucer, the works of Frauenlob and Mügeln seem completely insignificant, obscure and repellent from the beginning to end. Nor could one pass a less negative verdict on the love allegories of Hadamar von Laber's *Die Jagd* or the anonymous *Minneburg* (*c.* 1345).

The late Middle Ages showed little compassion for the weaknesses of women or priests or the dangers that love had in store for them. Wherever they appear in literature, they are the target of satire and ribaldry. As stereotypes they become the protagonists of the "merry tale" in verse, the *Märe*, the counterpart of the

French *fabliau* and a favourite form among authors from Der Stricker (*c.* 1200-*c.* 1250) to Hans Sachs.

With the *Osterspiel von Muri* (*c.* 1250), drama made its first appearance in German literature. Its origins can be traced to the early representations of the Resurrection within the Easter church service. But by the fifteenth century the enactment of the passion and other liturgical mysteries had to give way to the buffoonery and farce of the carnival play or *Fastnachtsspiel*.

Long before the English scholastic philosopher William of Occam (1299-1350) had destroyed the Thomist harmony between science and revelation, people like the Beguine nun Mechthild von Magdeburg (d. *c.* 1285) had found their way to a personal religion based on simple faith and mystical experience. Her *Fliessendes Licht der Gottheit* (*c.* 1255) was the prelude to the mystical prose writings of Meister Eckhart (*c.* 1260-1327), and his pupils Heinrich Suso (*c.* 1295-1366) and Johannes Tauler (*c.* 1300-61). In an age of despondency and spleen, their preachings seem to have fulfilled the spiritual hunger of the laity.

An age that is characterised by prolixity, intellectual atrophy and a need for visual detail must sooner or later find its way to prose. A pioneering effort in this respect was an early thirteenth-century translation of the French romance of Lancelot. Slowly and hesitatingly at first, vernacular prose gradually gained ground at the expense of verse and Latin prose. The books of common law (*Sachsenspiegel*, *c.* 1230; *Schwabenspiegel*, *c.* 1260), and the prose chronicles and the sermons of the greatest preacher of the thirteenth century, Berthold von Regensburg (d. 1272) gave impetus to this development. After the mystics came the more polished style of the *Buch der Liebkosung* by Johann von Neumarkt (*c.* 1310-80) and Johann von Tepl's variation on the Dance of Death motif, *Der Ackermann aus Böhmen* (*c.* 1401). *Bible* translations followed, leading to the first printing of a German *Bible*, the so-called *Mentel-Bibel* (1466). By the middle of the fifteenth century two ladies of the nobility, the Countess Elizabeth Nassau-Saarbrücken and the Archduchess Eleanore of Austria, were kept busy translating popular French literature of the day. Humanism brought more translators. Albrecht von Eyb's (1420-75) translations of Latin and Italian authors show a language and style that no longer looks backward. By the time of the Reformation the new German language had become a powerful medium of expression and was exploited to its fullest advantage by Martin Luther.

But German literature had to wait another one hundred years before it was recreated, again along foreign models.

If after this brief survey we are to pin-point and summarise the German tradition in medieval literature, we must focus our attention on those aspects which persist or continue to reappear in the post-medieval period.

The first, most important feature we discussed was Germany's literary dependence on foreign influences, in particular Latin and French. It would indeed be hard to find another Western European literature whose dependence so frequently reached a comparable degree of servility.

On the other hand, the greater the dependence, the more articulate become the voices of protest and dissent. It is against this background of foreign models and vogues that we can best distinguish the enduring German contribution. In this connection we have mentioned three great poets of the Middle Ages, Walther von der Vogelweide, Gottfried von Strassburg and Wolfram von Eschenbach, each

responding in his own way to the foreign challenge. Walther von der Vogelweide broke with the Provençal courtly conventions by turning to the existing folk tradition, a strong tradition which was to remain one of the cornerstones of German lyric poetry right up to the nineteenth century.

Gottfried von Strassburg's response was twofold. On the one hand, he attacked the chivalric concept of knight-errantry. On the other, he demythologised the Celtic legend of Tristan and Isolde, which in the literature of Western civilisation is usually considered to be the representative expression of tragic passion. Gottfried's version of the myth, as we have shown, had very little to do with ill-fated romantic love. The German tradition in literature had little time for tragic pairs of the Romeo and Juliet stamp. Instead it showed preference for a Faust, a Sifrit or a Hamlet whom it has always claimed for its own.

Wolfram von Eschenbach's heroes also belonged to this category. In contrast to Gottfried, Wolfram affirmed the concept of knight-errantry, but placed it in the service of a higher ideal. By equating Parzival's mission in life with the fulfilment of this ideal, Wolfram's work anticipates the novel of education (*Bildungsroman*), a peculiarly German literary phenomenon.

In the history of Western civilisation, progress often allies itself with barbarism. Sometimes however a relapse into almost prehistoric barbarism can occur without being attached to any progressive idea. The anonymous poet of the *Nibelungenlied* seems to have been aware of this possibility, for as we have seen this is the central theme of his poem.

Finally, the German tradition would be unthinkable without the *Meistersinger*. In the literary field Germany was unable to rise to the challenges of the declining Middle Ages. It did not produce a Dante, a Chaucer, a Petrarch or a Villon. But it had a solid backstop in the mastersingers. It is not because of their poetry or approach to literary creation, but because of their respect for the authority of tradition, that Richard Wagner could say: *"Verachtet mir die Meister nicht, und ehrt mir ihre Kunst!"* (Do not scorn the Masters, and honour their art!)

Modern Authors

Marion Adams

Modern German literature emerged as a literature of world significance in the last quarter of the eighteenth century. The period which brought forth some of its greatest works and established many of its main characteristics coincides approximately with the life span of Johann Wolfgang von Goethe (1749-1832). In these years a new corpus of great modern European literature was created in the German-speaking countries, ranking alongside the already well-developed national literatures of England and France.

Popular sixteenth-century authors like Hans Sachs had retained continuity with late medieval themes and types of writing, and the humanist scholars in Germany contributed satires and some translations from antique and foreign authors. Prose instead of poetry became general for narratives. But there was nothing like the flowering of imaginative literature which took place in the countries to the south and west of Germany. At this time intellectual activity in central Europe was dominated by theological disputes arising from the Reformation. The energy of most writers was directed into religious polemic, and the most important literary monument of the century is the translation of the *Bible* which Luther completed in 1534. The persuasive naturalness and force of Luther's language, not only in this translation but in his polemical writings and hymns, was of the greatest normative influence in Germany for generations.

Language itself, however, remained problematical for German-speaking writers for some time. In the sixteenth and seventeenth centuries the language of learned and artistic expression was still mainly Latin, and as late as the end of the eighteenth century it was very often French. In 1780 Frederick the Great wrote that German was not yet a language fit for literature, and even Goethe composed as a child in French as well as German and regarded French as almost a second mother tongue. Moreover, in spoken German, dialects have persisted strongly into our time. From 1617 language societies were formed throughout the German-speaking areas to standardise orthography and grammar and to reach a consensus about provincial, archaic and foreign words in order to create a language of serious expression "for all Germany". The puristic attitude of these societies towards language and their dislike of foreign words have since recurred intermittently in Germany, and have to be understood in terms of the competitive position faced by standard German until relatively recently.

Title-page of first edition of Luther's Bible *translation, illustrated by Lucas Cranach.*

In spite of this, there is a large and artistically ambitious *oeuvre* of lyric, dramatic and narrative literature from the seventeenth century in German. On the whole this writing is formal and impersonal, obeying strict artistic conventions. Its centres were mainly courts, religious academies and university towns, and although there were links with the older literature, especially in religious and mystical writing,

the Baroque period in German literature marks a deliberate break with medieval and popular traditions. It produced a wealth of religious and political drama, which tended to be conservative and absolutist, some intense and sombre religious poetry, much stylish occasional and gallant verse, and a few arcadian novels, conventional adaptations of foreign models which brought the German landscape into prose fiction for the first time.

The two greatest writers of the century, Andreas Gryphius and H. J. C. von Grimmelshausen, are tragic authors who wrote out of their experiences of the Thirty Years' War. Poems of Gryphius like "Tears of the Fatherland" are powerful formulations of despair over a devastated country, and Grimmelshausen's novel *Simplicissimus* (1669) narrates with drastic realism and brooding reflectiveness the extreme reversals of fortune of a peasant boy in war and peace, ending in renunciation of the world.

This sense of human life as tragic and subject to an arbitrary and uncanny fate persists and is probably the most obvious general characteristic of German literature. Of course there are exceptions among the authors, and the main authors are themselves many-sided. There are also some periods in which the tragic mood is not dominant, for example the early eighteenth century, when the most accomplished and popular writing was more cheerful and idyllic. But on the whole German literature is the great tragic literature of Europe.

Under the influence of rationalist thought the early eighteenth-century grammarians, most notably J. C. Gottsched in Leipzig, put a new emphasis on achieving lucidity in expression. They criticised the rhetoric of the earlier writers as irrational and their heaping of catastrophes as barbarous; and the Baroque authors sank into a state of low esteem and neglect from which they have only recently been rescued. However, a lengthy polemic soon developed between Gottsched and the Swiss critics Bodmer and Breitinger, who in the 1730s were in the forefront of the new European recognition of spontaneous and powerful feeling as a main-spring in the arts, and who were opposed to all canons of correctness as mere pedantry and irrelevant to great literature. They played off their enthusiasm for English literature, especially Shakespeare, against Gottsched's admiration for the recent neo-classical literature of the French court. They are usually thought to have had the best of it, especially when Klopstock's *Messias*, a great poem of the literature of feeling, began appearing around 1750 and when the attack on Gottsched was joined by the formidable polemicist Lessing.

It is to Klopstock that we owe the splendid long line of German classical poetry, with its surging ecstatic hexameters, and the irregular short line spilling down through the free verse stanza, following the natural cadences of exalted language. This is the line of the young Goethe's hymns, of Schiller and of Hölderlin, and it reappears in the twentieth century in the poetry of Rilke and Trakl and their followers. The cosmic scale and liberated imagination of Klopstock's vision, his personal involvement with a great event of human history like the passion of Christ, and his aspiration to synthesise a very large range of experience within a single work, remain as further constants influencing later German authors.

Gotthold Ephraim Lessing is one of the great intellectual heroes of Germany, a bold and independent critic and moralist who gave the German stage the place it has held ever since as a debating ground for social issues. All the later social

18th century drawing for Lessing's Minna von Barnhelm.

critics, including Heine, Nietzsche and Brecht, had a particular admiration for Lessing. Goethe and Schiller as dramatists were much in his debt, partly for the example of his very successful plays, partly for his analyses of Shakespearian and Greek drama. In *Minna von Barnhelm* (1767) Lessing set personal feeling against a code of honour; in *Emilia Galotti* (1772) he attacked an arbitrary and self-indulgent ruler; and in *Nathan der Weise* (1779) he opposed religious and racial intolerance. His theoretical work, the *Laokoon* of 1766, made clear an important distinction between the static character of visual art and the onward movement of description proper to literature. This overcame often tedious attempts to paint scenery in words and gave peculiar dynamism especially to landscape as it appears in classical German poetry and drama.

In some ways, however, both Klopstock and Lessing were conservative authors in their time. By comparison with their contemporaries in France, for example Voltaire, they were intellectually much less *avant-garde*. In content though not in language, Klopstock's *Messias* (which takes up Milton's themes) is a conservative masterpiece, like the religious music of his great contemporary J. S. Bach. In his theatre criticism Lessing played off Shakespeare's freedom, vitality and scope against the French dramatists, and is himself Shakespearian in the warmth of affections among the characters in his major comedies. But his plays follow the French neo-classical canon, observing unity of time, place and action, and as a didactic dramatist he belongs to the school of Molière rather than Shakespeare. It was in the next generation, in the circle of young writers around Goethe and the historian and thinker Herder in Strasbourg and Weimar during the 1770s, that German literature shook off all restricting conventions and became for a time the most original and forward-looking literature in Europe.

Goethe, Herder, Lenz and Klinger asserted the rights of inner feelings as opposed to social norms. These emotions were sanctioned by man's links with universal energies; they resulted in tragic conflicts, which were expressed in language of great fervour and a new colloquial strength; and they were dramatised with a sure and often satiric grasp of social and psychological realities. It was especially drama that developed imaginative realism in the 1770s and this was taken further by Schiller, by Goethe himself and after 1800 by Kleist. Their writing was more akin to the European realism of the nineteenth century than to non-realist fantasy, which was the other main tendency of the period in German literature. But both realist and anti-realist literature at this time in Germany began to show a tendency of lasting consequence: the organisation of a work around a convincing and highly suggestive symbol.

For example, in its simplest form, as in Goethe's early poems, this symbol can be the movement of a river, intellectualised as the career of a prophet or as the life process. An example of his complex symbolism is Faust, the man of soaring ambition and hunger for knowledge who goes through the world with the devil at his side, a symbol which was so rich in dramatic possibilities, and so suggestive of the relations between intellect and energy, intellect and evil, that only at the end of his long life was Goethe sure that he could finish the work and do justice to the subject. His great novel of education, *Wilhelm Meisters Lehrjahre* (1795), draws on several symbols, in particular the stage and the journey, which are fused through Wilhelm's association with a touring theatrical company. Since this work largely determined later German novels, and also because the symbolic structure of German

Goethe's sketch for the apparition of the Earth Spirit in his Faust.

prose fiction is perhaps the most difficult or unusual part of the literature for English-speaking readers, it is worth indicating how Goethe uses these two symbols.

The *journey* as a main source of action in a novel was an old popular conven-

tion of European fiction which had been given artistic standing in Germany by novels like *Simplicissimus*. In the eighteenth century it had the further meaning of a cultural journey, with the experience of antique art and landscapes in Italy as its goal. Under the influence of Pietism it had been further elevated by Goethe's friend Karl Philipp Moritz in his autobiographical novel *Anton Reiser* (1790) to the status of a spiritual journey. Goethe's novel combined all these elements: the journey as adventure, as experience of the arts, as a means towards insight and as a spiritual quest; the journey is even projected beyond the end of the book with wanderings in Italy ahead.

The idea of *theatre* is also exploited in the novel to concentrate and criticise a large range of social experience. Since the theatre was one of the few places where class and occupational barriers could be suspended, this milieu enables the author to bring very different people together in a natural way. It is part of young Wilhelm's drive for self-improvement, as well as a sign of his initial naiveté, that he sees the stage as the only place where he can hope to get beyond the virtues and duties of his middle-class background and acquire the poise and grace otherwise possible only for the aristocracy. Conversation about drama itself, and its role in social life, can be introduced as part of the action. So can experiences of all levels and periods of theatre as an exploration of the range of artistic consciousness, from the puppet plays that had kept alive Biblical and antique themes, to guild plays, folk plays and baroque allegory, culminating in Wilhelm's own production of what is for him the summit of all theatre, *Hamlet*. But after Wilhelm reads a testimony of religious experience involving long illness and instances of early death, the analogy of theatre as life, or the world as a stage, is increasingly shown as inadequate. The final judgment of the work is that the actor's playing out of roles, and the dramatist's preoccupation with illusion, endanger rather than fulfil personality.

Some of Goethe's younger contemporaries also writing in the 1790s, Novalis, Tieck, Clemens Brentano and the Schlegel brothers, are the first "romantic" authors. They themselves, as well as Goethe, gave the word its modern meaning; except that they have to be thought of as completely unsentimental authors who were still very much bound by the strenuous intellectualism of the period, and were active theorists, critics and translators. Their romanticism was altogether different from the more popular form it began to take on in Germany in the 1820s. They extended and refined the legacy of their predecessors, Lessing's social criticism and Goethe's symbolism, and especially Novalis and the Schlegels gave new life to Herder's historical and aesthetic ideas.

The German romantic authors again took up the intense individualism of the 1770s, looking for old and authentic forms of life and expression in the villages and forests and in folk poetry. They explored more subtle states of mind, including fears, dreams and intuitions. They also included realisations of fantastic events, scenes and kingdoms which owe something to older utopias and preserve the hope of founding a new human order in the world, but which press constantly against the limits of what is known and thought to be allowable or at all possible. In Novalis' *Heinrich von Ofterdingen* (1799) the symbol of the journey is extended in space and time; its direction is undefined and its goal is left open. A far greater demand for knowledge of the arts, history, remote landscapes and natural science is imposed on the hero than on Wilhelm Meister. In comparison with the theatre as a symbol, the main symbol in Novalis' novel is the blue flower, not something

Title-page of the folk-song collection Des Knaben Wunderhorn *of 1808.*

Title-page for Schiller's first drama, The Robbers.

at hand which can be known and got beyond, but something which disappears or changes as soon as it is seized. It is sometimes identical with the object of Heinrich's strongest affections, and then again is lost or remote.

Novalis' novel was meant as a criticism of the limitations of concepts of life and art in *Wilhelm Meister*, and Goethe gradually moved away from the best of the younger authors. However, they all knew very well that he was the greatest living German writer, and he never doubted their originality and talent. In his old age, long after the early death of Novalis, he incorporated in the second part of *Faust* the romantics' shifting symbols and metamorphoses, their interest in primal sources, free treatment of space and time and their refusal to set any goal, limit or end to the possibilities of life.

Between 1794 and Friedrich Schiller's death in 1805, a very productive friendship linked Goethe and Schiller in Weimar. Together with the nearby university town of Jena, through ducal patronage, Weimar had become the most important literary centre in Germany and it attracted Lenz, Herder and the novelists C. M. Wieland and Jean Paul. In these years Schiller encouraged Goethe to complete some of his major works and they collaborated in others. At the same time Schiller continued his great series of tragic political dramas, culminating in his *Wallenstein* trilogy of 1799.

For the German public in the later nineteenth century Schiller became a pillar of orthodoxy. The *avant-garde* attitude has often been grudging admiration for his achievement but impatience with his unbroken moral idealism; and few critics today appreciate the unrivalled conciseness and spare impersonal grandeur of his poetry. Schiller's subject, Goethe said, was always freedom. After some initial enthusiasm, he had the same reserved attitude towards the French Revolution as nearly all the German authors of the time; and after his first rebellious plays of the 1780s he is sometimes said to have become conservative in deference to his patrons in Weimar. However, his *Wallenstein* is after all a sympathetic portrayal of high treason, his late play *Maria Stuart* sets a transfigured individual against the state, and his last completed play, *Wilhelm Tell* (which became the national epic of Switzerland), shows undiminished revolutionary fervour. One of the rare German critics of our time who is wholeheartedly for Schiller has called him "the metal mouth" (in a phrase from Schiller's own poem "The Bell") dedicated to earnest and eternal things.

The nineteenth century in German literature throughout the German-speaking areas was in part a continuation of the language, themes and ideas of Weimar, and in part a reaction against its immense prestige in satire, parody and attempts to express opposed views of man and reality. The oppositional tendency was present in Goethe's own time, not only among the circles of romantic authors in Jena, Heidelberg and Berlin but also in three great contemporary writers who had a strained relation with Goethe and Schiller—Jean Paul, Hölderlin and Kleist.

Johann Paul Friedrich Richter called himself Jean Paul in honour of the French philosopher Jean-Jacques Rousseau. He brought to the novel Rousseau's intense emotionality and sympathy with humble life, combined with cosmic sweep and an intimate, somewhat wilful narrative manner and structure which he derived from the English novelist Sterne but gave a more serious and sensitive treatment. Anti-classical by temperament and intention, Jean Paul was able to maintain himself successfully against his great rivals, and Goethe admired his "Chinese" style.

The literary careers of Kleist and Hölderlin were brief and tragic. Heinrich von Kleist was able to control new extremes of violent passion, presented with grim wit and classical concision, in both the novella and the drama. His subjects are usually historical and the locations often exotic, but all his writings were in response to the major problems of his time: the disruption and chaos of war and the ideological ferment of the French Revolution. Friedrich Hölderlin, whom some critics put above even Goethe as a lyric poet, wrote great laments of a poet who felt himself born out of his time. He invoked ancient Greece and a future which would reconcile Christianity with the pagan gods, and provided the south German landscape with something of the heroic scale and mythical pervasiveness of the landscape of Greece. Kleist and Hölderlin, both immensely proud and ambitious authors, could not establish themselves. Hölderlin sank into insanity in 1806, and Kleist shot himself in 1811.

The originality of their contemporary E. T. A. Hoffmann is that he set the romantic challenge to common sense and norms of polite behaviour in a context of strict realism—German city life as he observed and satirised it. In the novellas of his *Phantasiestücke* of 1813 Dresden exists alongside Atlantis, infinite ideal possibility is suddenly present in a lane or a library; the result is comic and uncanny, sometimes demonic. Hoffmann's technique is to present a series of puzzling incidents which suggest strange events and forces at the start of each novella, and to delay until near the end a psychological or mythical explanation and revelation of the benign or destructive character of the other-worldly influences. The result is a remarkable impression of the confusion and irrationality of the world as his young heroes experience it.

The legacy of romantic literature was popularised and dissipated by two gifted writers who were otherwise quite unlike each other: Joseph von Eichendorff, a favourite with the German public, and Heinrich Heine, who has never been popular. The formal variety of their predecessors, and of the folksong as Brentano and others had collected and presented it, gives way in their poetry to the endless facile jingling four-line rhymed stanza which was the dominant German verse form throughout the nineteenth century. Most of the themes and problems of the previous thirty years appear in their writings in a slackened form. For example, one can follow the motif of the journey. In Eichendorff's very charming *Taugenichts* of 1826 a naive hero travels rather pointlessly and effortlessly to and fro between Austria and Italy. The novella is a tribute to the beauty and rightness of the world, with a hint of danger in the background; but the moral tension and cultural aspirations of the theme are lost. In Heine's *Harzreise* of the same year the journey shrinks to a walking tour as a change from a university town. It becomes a vehicle for anti-academic satire, random irony, often at the author's own expense, and a contrast (by now conventional) between the artificial town and the unspoiled landscape. Heine has always been admired abroad, especially in France and England, as a lucid and entertaining writer. But he is unsustained, and too fond of whimsy and innuendoes that are not particularly witty. He is at his best as a literary critic, and his book *Die romantische Schule* of 1833, although very partisan and hostile, is still an outstanding summary of the rank and characteristics of the German romantic authors.

The frustrations of a reactionary period which drove Heine into exile in Paris were expressed with uncompromising radicality and great boldness of linguistic

invention by his younger contemporaries Georg Büchner and C. D. Grabbe. In Büchner's plays *Woyzeck* and *Dantons Tod* (1835) the tone, themes and style of the authors of the 1770s are heard again—the vehement rhetoric, satire of social abuses and the anti-classical structure of a series of rapid scenes. Now, however, they are given a new dimension of introspection, detachment and doubt which Büchner owes to the romantic authors. In his grasp of popular idiom and crowd psychology in historical dramas Grabbe is often very like Büchner, but with a stronger element of grotesque farce and deliberate anachronism. This did not endear him to nineteenth-century audiences, which took history very seriously, but was interesting to young authors in Germany just before the First World War and influenced later European theatre.

The mid-nineteenth century saw some promising beginnings in German writing which ended disappointingly. It appeared for a time that the centre of serious literature might move from Germany to Vienna, which had an old popular tradition of theatre mingling fantasy, comedy and moralising in the manner of the libretto for Mozart's opera *The Magic Flute*. This tradition was continued by Nestroy and Raimund, whereas Franz Grillparzer took up the elevated mode and language of Weimar. However, until the twentieth century the Austrian contribution to literature in German is altogether rather slight. The success of the Austrian dramatists was challenged by the German author Friedrich Hebbel, who worked for a time in Vienna. Hebbel had the makings of a great realist dramatist like Ibsen (whom he influenced), and in his grasp of the effects of milieu on human action he pointed forward to the naturalists at the end of the century. But like Grillparzer he became immersed in historicism, and reacting against the idealism of Weimar he developed a manner of brutal starkness that makes him a significant but repellant author.

In general there has been a lack of ease and persistence with realism among German authors. This may be due to sociological factors like their restricted opportunities in public life and consequent lack of knowledge of the world, or to problems of censorship. Another cause might be factors within the literature itself, in particular the overwhelming idealist and symbolist legacy of Weimar. Authors like Büchner whose writings successfully challenged and later modified the tradition were unknown for decades.

The difficulty is evident in the work of Germany's most widely-admired woman writer, Annette von Droste-Hülshoff. She began, like Hebbel, with a sure grasp of poor rural life and an unflinching sense of its grimness that should have led her into the ranks of the great nineteenth-century realists. But she wrote mainly poetry, apart from her early sketches of Westphalia and her one major novella *Die Juden-buche* (1842), in which sceptical realism, a symbolic beech-tree and an idea of divine justice form an uneasy alliance. In the poems the natural world is closely observed, but they represent a further dwindling of the scale and aim of poetry that had begun with Eichendorff and continued throughout the nineteenth century.

In Switzerland the pull towards regionalist realism with a didactic purpose is represented by Jeremias Gotthelf's tales of peasant life. His two greater contemporaries, C. F. Meyer and Gottfried Keller, resisted provincial limitations and addressed themselves to the German-speaking world at large. In this they are obvious and conscious heirs of the artistic aims and universalising tendency of Weimar. In Meyer's novellas the historical imagination of the nineteenth century (especially the interest in the Italian past) appears in a finely-wrought form. Keller was able to raise the Swiss rural life of his time to a high level of symbolic significance, and

his novel *Der grüne Heinrich* (1855) belongs to the series of very moving German novels about the struggles of talented poor young people, sometimes students, usually artists, and their experiences with books and ideas. In Austria at this period a high level of prose fiction is represented by Adalbert Stifter, who combined a strong response to his native landscape with an unusual ethic of passivity and innocence. Within Germany the later nineteenth-century novelists, most notably Wilhelm Raabe and Theodor Fontane, although also conservative in attitude, were rather more critical of social conditions. They expressed the unease of the German intelligentsia over the rapid industrial and political changes of the period in Germany.

This unease turned into protest with the naturalist drama of the 1880s. Before and during the First War there emerged writing of revolutionary fervour and expressive freedom that represented a new peak of achievement in German literature. Gerhart Hauptmann, rediscovering Büchner, provided a drama of the dispossessed in *Die Weber* of 1892 that again made theatre a controversial social forum. This was paralleled from 1890 by Holz and Schlaf's dramatisation of the misery of the urban proletariat, and followed from 1909 by the comedies of Carl Sternheim, who put on the stage middle-class realism about money and status and the emotional response of the German bourgeoisie to the reality of financial power. In the 1920s this new drama of social criticism successfully held the stage in Germany: Ernst Toller, Georg Kaiser and Bertolt Brecht dramatised events of the 1918 German revolution, problems of workers and returned soldiers, and struggle and crime in the cities. This type of drama, with its strong documentary basis, was

Etching by Käthe Kollwitz for Hauptmann's play The Weavers.

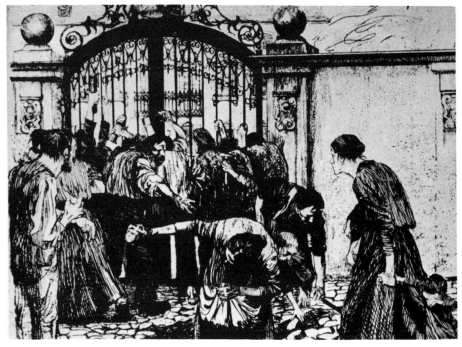

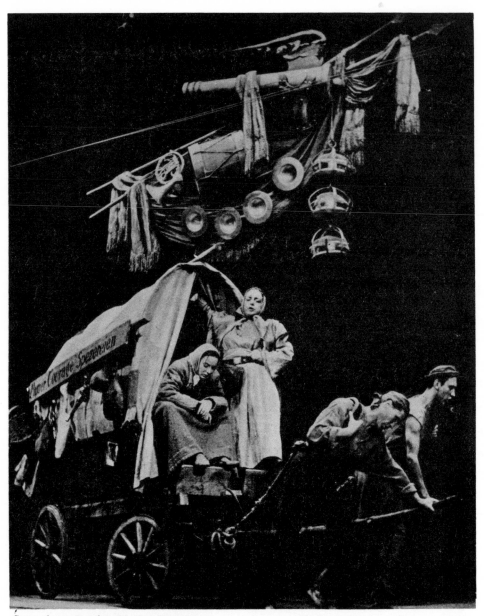

Scene from Brecht's Mother Courage.

taken up again by writers in the fifties. Meanwhile from 1912 Ernst Barlach and Hans Henny Jahnn were writing symbolic dramas which like so much German writing juxtapose surreal fantasy with social and psychological realism. These plays are as much moralist theatre as the social drama of Brecht. Barlach is nearly always concerned with a decision of conscience by an individual and its effect on a group, and one of Jahnn's themes is the frustration of talent or feeling by poverty.

The most famous of these dramatists is Bertolt Brecht, who stands apart from the other dramatists of his time mainly in the vitality and point of his language, in which only Jahnn is his equal, as well as in the warmth of the relations among his characters and his capacity to create examples of radiant goodness, like Grusche in *The Caucasian Chalk Circle* and Kattrin in *Mother Courage*. These figures have the same kind of moral force combined with grace as Lessing's Nathan and Minna. But Brecht's theatre, very good though it is, has been over-praised, particularly outside Germany. His dramas are open to the same criticism as Lessing's—they are constructions around a slight fable, didactic set pieces of a smaller scope than great drama.

Brecht has always been more highly regarded by some critics as a lyric poet than as a dramatist. He is part of the extraordinary concentration of talent that makes German poetry perhaps the most significant poetry in Europe in this century. Several authors, in particular Stefan George, R. M. Rilke and Alfred Mombert, had re-established an ambitious claim and largeness of vision in poetry around 1900. Their contemporary, Else Lasker-Schüler, and the younger authors Georg Heym, Gottfried Benn and Georg Trakl applied this vision to an intensified personal expression and to an indictment of their time. These authors mark a recovery of purpose and nerve in poetry and a response to two main kinds of experience— the great city, seen as fascinating but often sinister; and the distant horizons in space and time opened up to Germany in the late nineteenth century by explorers, contact with primitive peoples in the colonies, and expeditions and archaeological discoveries in the Near East and Asia.

The whole German-speaking area contributed to these new directions. Rilke came from Prague, where Franz Kafka was writing his profound and melancholy allegories. Kafka's tales, highly esteemed by fellow writers but not widely known before his early death in 1924, first achieved world fame in English translations. Together with Brecht, and the much more conservative novelist Thomas Mann, he is probably still the best known recent German author in English-speaking countries. He is an heir of the romantics, especially E. T. A. Hoffmann, in his association of ironically viewed reality with non-realist and usually macabre fantasy. There were good satirists in Vienna at this time, most notably the combative editor Karl Kraus and the shrewd observer Robert Musil. Austria produced as well a good deal of polished and civilised writing in the essay and for the stage, the most accomplished being perhaps the work of Hugo von Hofmannsthal. In the small but magical opus of the poet Trakl the Austrian landscape is transformed by a haunting sense of transience and by a fusion of the poet's personal sorrow with antique and Biblical memories.

Between 1910 and 1933 the vital centre of this literature was Berlin, which drew in authors and other artists from the German cities and Vienna. With its stages, journals, films and exhibitions it became one of the great creative centres of Europe. The city itself was celebrated as well as criticised by a number of authors, most extensively by Alfred Döblin in his novel *Berlin Alexanderplatz* of 1929.

The Nazi take-over had an immediate effect on theatre and the journals. All publication was soon controlled and censored and only authors admitted to a centralised corporation could publish at all. A great many writers, editors and publishers fled under threat to their lives, and an exodus of talent continued until

the outbreak of war. The Nazis sponsored some nationalist literature, with much harking back to German heroes from Roman times on, as well as a great deal of conservative rural and regionalist writing of an optimistic tendency. The position of the ageing Gerhart Hauptmann and of a number of other well-known authors remained ambiguous, but the only significant author whom the Nazis won as their spokesman for a time was the very good poet Gottfried Benn, whose public enthusiasm in 1933 for the national moral regeneration was at first welcomed. But Benn was the very type of city author or *Asphaltliterat* whom the Nazis most disliked, and he was soon attacked and excluded.

Since the re-establishment of normal publishing in the Federal Republic in 1948, and of the centralised and directed press of the D.D.R., there has been a steady output of modest, careful imaginative writing in German. In West Germany the young author Wolfgang Borchert became known just before his early death in 1947 for his dramatisation of the plight of a generation that had known nothing but Hitlerism and war. In his social criticism, his use of allegorical figures and his fascination with the modern city, Borchert is very like the young writers earlier in the century, whom he read in secret, since they were banned during his school-days in the Hitler period. Borchert is unusual among serious modern authors in his interest in family relationships, and in his portrayal of the family as an essentially stable institution which is able to overcome crises caused by privation or adolescent revolt. He also has a tenderness of feeling and a stylishness in a slight format that are both rare in German fiction. His carefully simplified, repetitive, insistent narrative style indicated to other writers new possibilities in the short story. This is not a common form in German writing, where authors have long preferred the *Novelle,* an extended story in which the action is often followed over many years, with special structural conventions and an elaborate play of symbols.

Rather less moving than Borchert's stories is the writing of Heinrich Böll, who is perhaps the most successful and in many ways the most representative West German author of the fifties. In Böll's fiction, as in other stories and novels of the period, themes from the immediate past are not avoided, but the war and Nazism appear muted by indirect allusions. Two aspects of the literary tradition had an unfortunate effect at this time. One is the use of symbolism, which should reinforce explicit statement, but can instead become evasive and escapist where plain statement is in order. The other is the appeal to fate (*Schicksal*), always latent in German literature, as in all tragic literature. It is a concept that rationalist authors in Germany have vigorously fought—Lessing, for example, and above all Brecht, whose later theatre is intended as a demonstration that social processes are completely comprehensible and social disasters preventable. East German literature of the post-war years, though often clumsy, has a better social feeling than West German literature and is less marked by self-pity. Literary critics in the D.D.R. have rightly pointed to the tendency in post-war West German literature to confuse issues of responsibility for the purely man-made enormities of war and genocide by pushing them off on to an inscrutable destiny.

The writers of the D.D.R. do not see themselves as departing in any way from the mainstream of German literature, since in their interpretations of the great works of the past they emphasise their content of social criticism. Their own aim in literature is to use social analysis more consciously, aided by the Marxist theory of history,

The Investigation *by Peter Weiss, 1965.*

with the aim of immediate and obvious service to the state. Up to a point their theory is compatible with the general German approach to literature, which has always been historical. The academic study of literature in Germany and of German literature abroad means mainly biography, non-evaluative interpretation and textual study of an archival kind. Literary criticism as separating the major from the minor works of the tradition is unknown in the universities and is scarcely a respectable practice in the German-speaking countries. Criticism is rather more a function of

the leading newspapers and reviews, where the articles on literature are of a far higher standard than in similar publications in English. But the newspapers tend to follow fashions in authors, especially living authors, and their judgements are unstable. Value judgements are regarded by German literary historians as rash and subjective. However, with their very solid training and wide knowledge they should be in the best possible position to discriminate between the great literature and the merely mediocre writing of the present as well as the past.

Austrian literature, after its brilliant period before the First World War, has relapsed into its old provincialism. But in the post-war period Swiss authors have again become interesting, particularly in the drama: plays like Max Frisch's *Andorra* and Friedrich Dürrenmatt's *The Visit* have reached international audiences. These plays are related to classical German theatre in their carefully constructed demonstration of a striking idea, and to the drama of the twenties in their use of allegory and their urgent social message. But they are cynical and world-weary, anti-activist and socially unhelpful, since they present malevolence and corruption as universal and inevitable: they are decadent examples of German social drama.

In the sixties imaginative writing and the essay took on a new sharpness in West Germany. H. M. Enzensberger and Günter Grass emerged as authors with a new boldness of tone and approach. Grass had an immense success in 1959 with his novel *The Tin Drum,* which is a version of the scurrilous picaresque compendium of experience in the line from *Simplicissimus.* However, it is an emotionally sterile work, with little insight into the political events and *Zeitgeschichte* involved in the narrative. But Grass, like Borchert, views the writer as addressing the nation, as a publicist with a duty to rouse, warn and admonish. The prophetic note is often sounded in German literature, which has a more overtly political reference at most periods than English literature. One consequence has been that in the German-speaking countries, as in Central Europe generally, censorship has always meant mainly political censorship; suppression of imaginative writing on the grounds of indecency has been much rarer than in the English-speaking world. The concept of the writer as the denunciant and conscience of the age is at least as old as the Reformation in Germany, and is ultimately religious; and the only adequate representation of the concentration camps in German literature is Peter Weiss' documentary drama *The Investigation*, which consciously draws on the format and tone of the oratorio.

In the Federal Republic it has been easy even for oppositional writers to become absorbed into the active and liberal publishing industry and into work for newspapers and for government organisations like radio, where an author is inclined to show too much deference to public attitudes. The literary tradition itself is also to some extent an inhibiting factor in countries like Germany where the authors and the public are very well read. Goethe's hard-won concepts of ultimate harmony and unity and their reflection in his style imposed an inert post-Weimar classicism on many writers until well into the twentieth century. One can in fact see the history of German literature from the seventeenth century on in terms of tension between a marked formalism and periods, works or authors who asserted opposing values of spontaneity and recklessly free invention and expression. Some characteristic forms of German literature like the *Novelle* and the novel of education can seem artificial when the intensity of feeling slackens. Altogether, this literature stands between the more strictly formal literatures in the Romance languages and the more casual, less formally self-conscious literature of the English-speaking countries.

The
Philosophers

Gershon Weiler

Deutschland war durch Kant in die philosophische Bahn hineingezogen, und die Philosophie ward eine Nationalsache. — Heine.
Germany was drawn by Kant into the philosophical path, and philosophy became a matter of national importance.
The classical period of German philosophy extended over the eighteenth and nineteenth centuries. However, the creative peak lasted a mere fifty years: from 1781, with the publication of Kant's *Critique of Pure Reason,* to 1831, the year of Hegel's death. It was in these decades that philosophy came to occupy that pre-eminent position in German culture which has made German philosophy unique in the West.

Why and how philosophy became a central concern of educated Germans irrespective of their profession or occupation has long interested philosophers and historians, especially the Germans themselves. Philosophy has always treated itself as its own subject-matter—the question "what is philosophy?" has always been an important philosophical question. Why German philosophy took the course it did has always been recognised as a central question of German philosophy. This concern with the philosophical tradition of one nation brought with it a certain extension of the field of philosophical problems. German culture, and by implication culture as such, became philosophical problems, with solutions necessary for an understanding of the greatest of totalities: the universe itself. On such grounds, German philosophers would claim that by immersing themselves in their native philosophical tradition, they simultaneously descended deeper into the secrets of all reality. Of the many attempts to make this development comprehensible, the best account available is still Heine's short and brilliant fragment on *Religion and Philosophy in Germany,* published in Paris in 1834, shortly after Hegel's death.

Heine argued that philosophy in Germany grew out of a general acceptance of the Protestant principle of freedom of thought. Prevented by their social and political circumstances from engaging in major political action, the Germans invested all their revolutionary energies in the realm of pure thought. This explains why philosophy became more for them than just one academic discipline among others. What philosophers had to say bore an immediate relation to the condition of Germany, and philosophers spoke in full consciousness of the weight and importance of their complicated theorising. Philosophy, together with poetry and music, constituted what

the Germans called *Kultur* in contrast to the 'civilisation' of the West. Kant himself distinguished between philosophy as an occupation of the schools and philosophy in the universal sense which constituted a social and moral obligation. Hegel too held that the effort which produced religion and art on the lower levels yielded philosophy on the highest level. Most German philosophers proclaimed that the teachings of philosophy are the most profound attainments of the human mind.

If one contrasts this outline of the German development with philosophy in England, two obvious differences emerge. The first is that in the corresponding period in England, philosophers were not barred from political activity and in fact Locke, Hume, Bentham, Mill and many others either occupied public office or participated in politics in other ways. The other difference, more important for the inherent nature of the development of philosophy, was that English philosophers of the period never lost sight of the day-to-day achievements of natural science. Indeed, they would have regarded their own work as not merely useless but fraudulent had they not tried to take into account the accumulation of human knowledge that was taking place in the rapidly growing natural sciences.

German philosophy ultimately became not only divorced from the natural sciences but positively anti-scientific in its orientation; that is perhaps the most important single fact about it. Two facts make this development even more remarkable. One is that German philosophers of the period, with the notable exception of Leibniz, were university professors. Thus one would assume they were in contact with what was happening in various fields of knowledge. English philosophers, by contrast, were mainly men of affairs; this is true even of Locke, the only one who remained a don for most of his life. The other consideration which makes the anti-scientific spirit of German philosophy so interesting is that the beginnings of German philosophy contained the seeds of scientific orientation. Leibniz and Kant were not only informed about and concerned with the development of natural sciences but both of them contributed to that development. The philosophers who followed Kant, however, by trying to 'go beyond' him became increasingly committed to an anti-scientific position which ultimately became the hall-mark of German philosophy. In the context of this position, not surprisingly, the very existence of natural science became a permanent and vexing philosophical problem.

Gottfried Wilhelm Leibniz (1646-1716), with whom the classical period can be regarded as beginning, was quite unlike any other German philosopher. For one thing, he was not a professor; having spent his life in the service of princes and of other men of action, he was involved in the public affairs of his time. For another thing, he wrote in Latin and in French. He was also thoroughly conversant with the scientific problems of his age and advanced their solution himself. He not only discovered the differential calculus independently of Newton, but he had theories of his own on the nature of matter, motion and causality, all of which were issues at the time among philosophers and scientists in England and France. Especially noteworthy is his lengthy debate with Newton's spokesman Clarke on the nature of space, in which Leibniz denied the absolute space and time demanded by Newtonian physics. Space and time must be conceived relationally, he argued. For if there were no objects in space and events in time there would be no sense in talking about space and time at all. It is a tribute to the genius of Leibniz that philosophers and scientists of our own time are inclined to credit Leibniz with having worked out on a purely logical basis what was discovered by physics in the twentieth century.

Christian Wolff.

There was, however, another side to Leibniz which makes him a true pioneer in the classical period of German philosophy. His physical theories became part of a vast metaphysical system, constructed as a logical edifice, which held out the promise of solving all problems. His famed doctrine of monads is a logical model of the universe. It was his hope that once this model was sufficiently worked out, it would be possible to construct, on strictly logical principles, a perfect language, in which the answers to all properly formulated questions could be calculated. Even about matters of conduct, he said in a much quoted remark, there will be no need to argue. The disputants will instead say: "Let us calculate."

This systematising tendency, which is so characteristic of German philosophy

in general, is perhaps the most German thing about Leibniz. His work reached the larger public through the agency of Christian Wolff (1679-1754), who was the first philosopher to write in German and who created a substantial part of the German philosophical language as well. Wolff was a born systematiser and his work, though not at all original, stamped his mark on the future of German philosophy; henceforth it became accepted that to be taken seriously a philosopher must have his own all-embracing system. Although Wolff contributed a great deal to the diffusion of the discoveries of modern natural science in Germany, his own example certainly pushed German philosophy in a non-scientific direction. Putting it most generally, what characterises a scientific theory is that it is limited to explaining a narrow and methodologically defined range of phenomena; that it does not explain everything else as well is not a valid criticism of a scientific theory. The idea of a system with pretensions to explaining everything is clearly contrary to the open spirit of patient and piecemeal scientific work. Wolff made no discoveries but he constructed a system.

The achievement of Immanuel Kant (1724-1804), the greatest of all German philosophers, lies in his having made the most radical and profound philosophical appraisal of the situation that arose because of the emergence of modern natural science. Paradoxically, he also set German philosophy on an anti-scientific course. Kant was a professor at Königsberg, and he spent his life in that town. Yet he made philosophy a matter of national concern in Germany. The quiet professor was a revolutionary, or, as Heine put it, a Jacobin. Kant left his permanent mark in every field he worked in; not only German philosophy but the whole of European philosophy was irrevocably changed as a consequence of his writings.

Like Leibniz before him, Kant was thoroughly acquainted with the scientific work of his time. Indeed, in his earlier years he occupied himself with natural science and in 1755 published his *General History of Nature and Theory of the Heavens*. His theory was substantially similar to that of Laplace and became known as the Kant-Laplace theory of the evolution of the physical universe. With some modifications, it is still the theory most favoured by scientists of our time.

However, philosophically, Kant's most important achievement came from facing the consequences of Newtonian physics. He accepted without question that the Newtonian theory was true. The question he raised was: how can Newtonian theory be known to be true? This question led him to a thorough examination of the assumptions upon which Newtonian physics rested and to a systematic exploration of the human capacity for knowledge as such.

Only what appears to us through the medium of the senses, Kant argued, can be known. However it does not follow from this that appearance to the senses alone is sufficient to give us knowledge. In order to gain this, it is necessary for there to be some presupposed concepts by which the raw material that is communicated to us through the senses can be ordered. For example, when I see a tree by looking out of the window as I write this, I must already have presupposed the concept of a *permanent thing* (substance), because only by making such a presupposition can I say that it *is a tree,* that it is the same tree that I saw yesterday and so on. Most importantly, the concept of *substance* is not given to me in the same way in which the tree is given: I cannot see it, indeed, I cannot sense it at all. On the grounds of such considerations, Kant set out to define the limits of that which can be known as contrasted with that which cannot be known.

Immanuel Kant.

The title of his book, which inaugurated the most exciting period of German philosophy in 1781, is self-explanatory. *The Critique of Pure Reason* is the critique of reason as a means of attaining knowledge. Kant draws a sharp line between thinking and knowing. Thinking leads to knowledge only if there is sense-experience of that which one thinks about; by knowledge Kant meant scientific knowledge. In the absence of appropriate sense-experience, thinking leads to delusions. At the same time, knowledge is equally impossible if there is only sense-experience without concepts and thoughts. Both conditions, sense-experience and presupposed concepts, are therefore necessary for having knowledge at all.

This was a devastating criticism of the empiricist interpretation of science favoured by British philosophers since Bacon. The central thesis of the empiricist interpretation is that all our concepts can be accounted for by showing that they derive from sense-experiences. Kant, while granting that without sense-experience knowledge is impossible, maintains that there are some fundamental concepts without the presupposition of which sense-experience could never be understood. Therefore, there is philosophical knowledge in addition to science: it consists of an analysis of the conditions of scientific knowledge. The *Critique* itself is devoted to a detailed examination of these conditions and their inter-relationships. Leibniz and Newton had violently disagreed about the nature of space and time. For Kant they became preconditions of knowledge and not something the nature of which could ever be discovered by the usual methods of science. Only phenomena can be known, and space and time, together with concepts like substance and causality, are not phenomena but preconditions of the knowledge of phenomena.

However, when one speaks of phenomena one seems to imply that these phenomena are phenomena of something. The tree I see is the joint product of something out there under my window and the fund of concepts that I bring to bear on whatever there is under my window. But what is there, really, under my window independently of its being conceptualised by me or someone else? When we ask this question, Kant says, we are no longer speaking about what can be known, for we have ceased to speak of phenomena and are speaking instead of noumena. Heine regards Kant's distinction between phenomena and noumena as the most important contribution he made. Noumena cannot be known, nothing can be said about them which we could claim and establish to be true, and although we can think about them we shall certainly never know anything about them. In this way Kant rules out of court all those metaphysical questions which cannot be treated by the methods of science. Whether the soul survives the death of the body, whether God exists, whether there is some thing which underlies certain physical properties but is not in itself physical but, say, spiritual, and many similar questions are not only unanswerable: they ought not be asked as if they were questions to which answers are possible.

Kantian critique thus sets the limits to human knowledge. Kant recognised only too well that the human mind naturally hankers after all-embracing answers and that the limits of the senses are an embarrassment in this project. In his lectures on psychology (his work on *Anthropology)* he listed the overwhelming desire to reach absolutes as a mental illness. He also recognised that the compulsion to seek answers to all questions, even in the absence of scientifically acceptable evidence, is an unavoidable one. He recognised that we must think even about those things that we cannot know. Part of the problem with the idea of an all-embracing system was that it treated different kinds of questions as if they were the same kind of question with an equal promise of a true answer. Many philosophers assumed, for example, that it was possible to proceed from a theory about what the world is like to some other theory about what is right conduct. Kant's critical work is devoted to correcting matters here by establishing the defining characteristics of various kinds of discourse —the scientific being only one type.

The two works which complete the critical enterprise after the *Critique of Pure Reason* are the *Critique of Practical Reason* (1788) and the *Critique of Judgement* (1790). The first of these books is devoted to an analysis of morality. What can be

known is expressed in a proposition. For example "water $=$ H$_2$O" is something known and the proposition expressing it is true. Morality, however, is not like that. There is no sense in saying that it is known that "thieving is wrong" for what method is there to establish the truth of that proposition? Indeed, Kant argues that morality is not propositional and that the imperative form of expression is the proper one for moral utterances. Not any imperative but a special kind. Saying "If you want a cheap camera, buy Japanese" is not a command to buy a Japanese camera, for you may not want a camera at all. However, the moral imperative (which Kant calls categorical) is such that it has no preconditions attached to it. "Always help those in distress" is addressed to everyone, irrespective of whether one wants to attain certain ends or not. Saying that it is "addressed" to us is, of course, misleading. For Kant's point is that in acting in a certain way the agent determines for himself the principle on which he is to act, the source of this principle being his will. The will is rational (that is, moral) only if it is impartial. I shall say that a principle is in accordance with the categorical imperative only if I can will that the principle upon which I am acting should apply impartially to all, even if it affects me adversely. If I make an exception in my own case then the principle on which I am acting is irrational and thus morally wrong. Clearly, this theory demands that the will of the individual be free. We cannot make decisions if our will is not free, nor, more importantly, can this legislating will take any instruction from anything outside itself. Man, possessor of will, becomes for Kant his own law-maker, just as the citizen of Rousseau's state was free because he was a legislator and subject (to himself) at the same time.

Heine was not mistaken when he perceived the revolutionary implications of this doctrine. Here was the charter for the liberated will which legislates for itself and for all other wills at the same time. But it also follows from this that the Kantian doctrine is compatible with any course of action provided that the will is ready to pursue that course of action universally. Heine, to mention him once again, spoke with the inspiration of a prophet when he warned against the terrible applications that Kant's will might some day be put to.

The *Critique of Judgement,* Kant's third critical work, aims to define the logical nature of yet another kind of discourse. Knowledge is expressed in propositions, moral laws in imperatives and what we say about purposes is expressed in judgements. In the second *Critique* Kant showed that morality is not a matter of scientific knowledge; in the third he undertakes to establish that the same is true of purposes. Although Aristotelian physics, which employed the concept of purpose for scientific explanation, was by that time rejected, there remained areas of scientific discourse, notably biology, where it was still very tempting to slip back into talking about purposes. What is more natural than to say that the eye is made for seeing? And yet, in a scientific description of the eye that purpose must not be mentioned.

This creates a difficulty and Kant offers a solution to it. In the third *Critique* he treats art as well as biology. What these two have in common is just the point mentioned: both employ the same notion of a purpose. What we say both about a painting and about a part of a living body is that we see them as having some purpose. More precisely, we see them *as if* they had some purpose. When I say that the harmony of colours in a painting fits in well with the lines, then I am saying that I see that object *as* having harmonious colours and fine lines. It is possible for someone else to say that the painting is life-like, thereby indicating that he sees it *as* that. None of these statements, whether they are about the purposes of living things or about

works of art, can be established as scientifically true because there is no method available for doing this. There is only seeing from various points of view, with the significant proviso that some of us see better than others. Seeing better does not mean that some see in a way more correspondent to reality, but rather seeing with greater imagination. The artistic genius is a person who sees most imaginatively. The critic or appreciator of art must be something of an artist: his comments must be imaginative.

Thus Kant assigned proper function and limits to each kind of discourse. His successors, while inevitably under the influence of his vast intellectual achievement, attempted in their various ways to prove him wrong. They were aiming at abolishing the Kantian limitations. The different philosophical and intellectual movements in Germany that followed Kant can best be understood if one sees them as developments of various objections to Kant. The idealistic philosophy of Fichte and Hegel, for example, rests on a rejection of the Kantian limitations of what can be known and on a conscious abolition of the dividing line between what can be thought and what can be known. These philosophers held that whatever can be thought to the end, without self-contradiction, can be known to be true.

Another group of thinkers whose spiritual roots go back to the subjectivist movement of the 1770s derived a new impetus from Kant. Had Kant not said, in the third *Critique*, that imagination has no limits? Friedrich Schlegel and others who had studied Kant now proceeded to assert that the vision of totality which is denied to science on the grounds that Kant gave can be attained by feeling, by means of an unfettered imagination, again on the grounds of the licence that they believed Kant to have given. So it came about that besides absolute idealism Kant became the father of the philosophically more sophisticated romanticism.

With Johann Gottlieb Fichte (1762-1814) German philosophy enters a course which is thoroughly German. His work is nourished from native German sources and there are no points of contact with the leading ideas of the West. Unlike his great contemporary Goethe, who had welcomed Napoleon in the hope that he would bring Germany into liberal Europe, Fichte became one of the main inspirations of the German national struggle against Napoleon. There was in Fichte himself, as Heine remarked, something Napoleonic. He was a commanding personality, completely honest and unbending on matters of principle. In his philosophical work there are all the signs of a great will determined to go as far as possible by the sheer power of thought.

Kant's warnings about the varieties of discourse and what can and cannot be accomplished by thinking were rejected as leading to an impossible dualism. More specifically, Fichte rejected the distinction between phenomena and noumena and proceeded to answer the question "how do we know that there are things corresponding to our phenomena?" by saying that all things have existence only in our minds. This is the high point of German idealism. The fundamental reality is the Ego, and the non-Ego (all reality outside oneself) is posited by the Ego. The technicalities of Fichte's thesis need not detain us here. It is worth noting, however, that Heine described Fichte's idealism as "one of the most colossal mistakes ever begot by the human spirit". What was the mistake?

In Fichte's philosophy the world is a necessary part of the Ego. It is the Ego which becomes overridingly significant, and the piecemeal discovery of aspects of

reality fades into the background. Whatever is to be known about the world becomes now a function of the self, and therefore the really important discoveries are to be made in discovering things in the self. Fichte's philosophy in this respect was not only part of the general turning inward which began to prevail in Germany, but was one of its main inspirations. This cult of inwardness (*Innerlichkeit*), in the various forms of its long career right up to the present, remained one of the dominant features of German philosophy. It is rooted in a disenchantment with the world of reality and scientific experience. Idealist philosophers no longer needed to take notice of the real growth of human knowledge that was taking place in the sciences. Philosophy became an autonomous discipline where worlds can be built and destroyed at will, which obeys at best only the laws of logic, but cheerfully ignores all information that may be available about that real world which is independent of human agency. From now on there was nothing to prevent systems from rising and falling according to the inherent logic of philosophy schools, nor was there any sense in asking what these systems are really about. For whatever they are about is not experienced, only thought. Experience is always particular but thought can be directed to totalities. So mere facts can find no place in philosophy, indeed, they are held to have no bearing whatever on what philosophers say and write.

This tendency reached its peak in the work of Georg Wilhelm Friedrich Hegel (1770-1831), the greatest system-builder since Aristotle, if indeed the latter can be regarded as a system-builder in the German sense. The important thing about Hegel in the present context is that he goes not only beyond Kant but also beyond Fichte. He too rejected the Kantian limits of what can be known, but instead of Fichte's mere subjectivism, he attempted to interpret the objective world by retaining the primacy of the spirit. Philosophy is the highest degree of all knowledge; it is the knowledge which the spirit gains of itself after it has traversed the lower stages of religion and art.

Hegel's philosophy specifically can be said to take its point of departure from Kant's moral philosophy. We have seen that according to Kant the agent and his actions are not phenomena in the way natural objects or occurrences are. Does it follow from this that nothing illuminating can be said about actions? After all, at any one time a society which is the real background of human action emerges out of those countless individual actions. Hegel's point is that it is quite wrong to treat actions as isolated occurrences; one must seek some more general concept in terms of which it can be understandable how interrelationships and their institutionalisation arise out of those countless individual actions. The view he put forward could be expressed, with much simplification, as something like this: the individual act is not something isolated but an expression of a Spirit (*Geist*), also expressed by all other actions at that time and place. Human actions fall into patterns and the pattern is the Spirit. It is not the individual act which is important but the prevailing Spirit. By understanding the latter one gains a philosophical understanding of the individual action.

This approach leads, naturally enough, to a philosophy of history and a philosophy of culture. For the Spirit is not something static but changes with time and varies with place. Thus each historically unique culture has its separate Spirit. However, these cultures are interrelated either by being ancestors or successors of each other, or by being contemporaneous and therefore having dealings with each other. So the philosophical effort is directed at understanding how the varieties

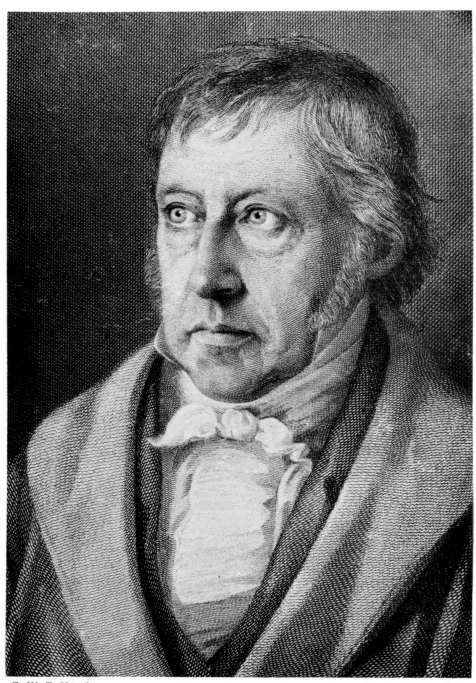

G. W. F. Hegel.

of *Geist* hang together. Hegel's most comprehensive concept is World-Spirit (*Welt-geist*), and all historical variables of reality are but successive stages of the self-realisation of this World-Spirit. Each stage in this development is beset by contradictions and the resolution of these contradictions is the motive force which brings about the next stage, with its new Spirit. The final resolution of all contradictions, Hegel thought, was achieved in his own philosophical system. "So far has Spirit come", he said.

One important consequence of the Hegelian philosophy of history and culture was that the problem of Germany could now be raised as a genuine philosophical problem. The philosopher lives at a particular time and place, and therefore, if his task is to espy the stages of the evolution of the World-Spirit, it is part of his task to determine at what stage of this great process he himself happens to be living. A German philosopher of the early nineteenth century thus had to give an answer to the question of the role of Germany in his time. This problem-situation was the origin of the doctrine of the world-historical nations. In Hegel's view, at any one time in world history there is one nation which carries on its shoulders the burden of the advance of mankind, that is the burden of advancing World-Spirit yet one more step. To his own satisfaction, Hegel found that Germany was a world-historical nation, but he did not answer the troublesome question of what a person should do if it is not his good fortune to have been born into the world-historical nation of his time.

The dissolution of the Hegelian school is the central story of the decades following Hegel's death. We shall touch on it only as it concerns the central theme of this essay: what is typically German about German philosophy. I have already referred to a certain disenchantment with reality. This disenchantment involved a rejection of scientifically experienced reality and a locating of reality in the mind or self, and also an ideological position of which that reality was the essence. The reality needs to be unmasked so that it can be revealed in its true character. Whatever appears is misleading and false; only the idea, if properly grasped, is real. And the idea by its very nature does not appear; is gained by an effort of thought. The origins of this position can be found in Leibniz, who had asserted against the sensualism of Locke that some ideas are innate, and in Kant, who spoke of concepts which are not derived from experience. In the hands of Kant's successors the tables were turned: all concepts derived from experience became suspect on that ground alone.

Philosophy must concern itself with pure concepts and if the facts fail to conform to these concepts, then so much the worse for the facts. This unmasking tendency became another permanent characteristic of German philosophy. It is the one which creates the impression that behind endless, frequently incomprehensible sentences there is a hidden depth which perhaps requires grace and not mere thought to explore. I am not saying, and in the light of my account of Kant I could not say, that some German philosophy is not profound. But I do say that the familiar comparison between 'pedestrian' British philosophy and 'deep' German philosophy rests on a readiness to be over-impressed by this concentrated effort of German philosophy to unmask reality. We are all aware, in one way or another, that "things are not what they seem to be" and German philosophy satisfies a very real need by its wholesale rejection of things as they seem to be. A. O. Lovejoy, in *The Great Chain of Being*, once remarked that there is a great satisfaction in

saying "All is One". He called this "the metaphysical pathos". German philosophy offers metaphysical pathos on a grander scale than the philosophy of any other nation.

When Hegel set out to seek Spirit he set the tone of much that is especially interesting in German philosophy for the remainder of the nineteenth century. The themes of culture and collective action increasingly occupied the centre of philosophical attention. Even F. W. Schelling (1775-1854), the third (beside Fichte and Hegel) and least known representative of post-Kantian classical idealism, who occupied himself with a philosophy of nature, could only present nature as something which is fundamentally the same as Spirit. Schelling was closely associated with the romantic authors, and his doctrine that intelligence attains its full realisation in art was just the kind of philosophical, quasi-rational support that this basically irrationalist movement needed. Hegel himself made endless fun of the romantics, and he remarked on one of Schelling's more extravagant romantic theses that it was a night in which all the cows were black. However, it seems to me that Hegel and Fichte, with their concentration on the Spirit and the Ego, contributed at least as much to the generally irrationalist tone of German philosophy as the romantic authors and their philosophical supporter Schelling.

Of course, in the period under discussion there was academic philosophy in Germany, which consisted largely of studying the works of the great masters. But the really interesting developments were those which took seriously Hegel's dictum that reason was purposeful activity. Thus arose the various philosophies of action. When Marx said, in a celebrated remark, that philosophers hitherto have only interpreted the world while the task is to change it, he spoke with the voice of his age. Arthur Schopenhauer (1788-1860), Hegel's junior contemporary and opponent, began from Kantian foundations by accepting the distinction between the phenomenal and the noumenal, but then proceeded to say that the noumenal, the true essence of all reality, is something totally blind and irrational: the will. Not surprisingly, Schopenhauer assigned art the highest position in his hierarchy of human postures, since only the artist is a pure contemplator, a person who has succeeded in subduing the will.

Schopenhauer's ideas strongly influenced the critique of science of Friedrich Nietzsche (1844-1900). Nietzsche is one of the most exciting philosophers that ever wrote, not least on account of his literary genius. His influence on German intellectual life was vast and his ideas can still fascinate contemporary readers. He is claimed as one of the ancestors of the existentialist movement. His way of philosophising was entirely new. He argued that science is an autonomous activity to which an individual becomes subservient without being personally enriched thereby. The purpose of human life and the nature of human existence are not even touched by that piecemeal investigation which leads to the discovery of one particular truth after another. Science is harmful because it does not serve life. Indeed, the value of everything is measured by this criterion. The role of the philosopher, Nietzsche says, is to be a physician of culture.

Academic philosophy took full account of this general shift of interest from nature to action. The work of Wilhelm Dilthey (1833-1911) is a very good illustration of this trend. Dilthey, having taken to heart the Hegelian lesson about the varieties of Spirit but without accepting that Hegel's was the last word, maintained that philosophy must be viewed within the historical context that gave life to it.

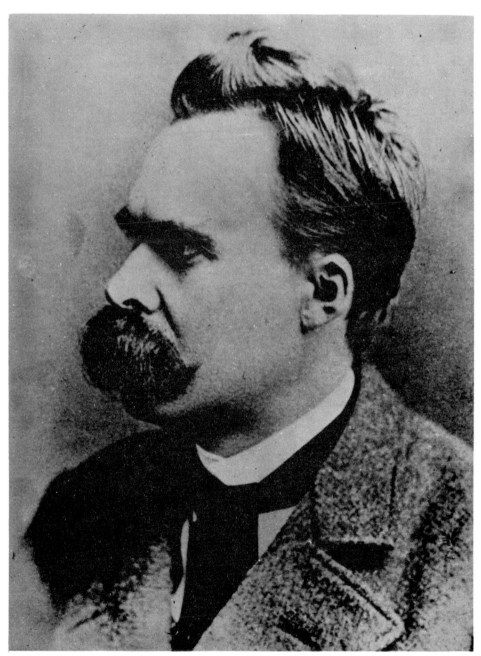

Friedrich Nietzsche.

There are various philosophies at various times and places, each expressing a *Weltanschauung*. This is a relativistic position. There is no question about one *Weltanschauung* being more true than another; all *Weltanschauungen* are historically given. Hegel could still hope for attaining a way of looking at the world, a point of view, which would be more true than all others. Dilthey had no such hope. The best the philosopher can do is to understand the role of philosophy in various times and places and the general relativism of all *Weltanschauungen*.

Relativism is, of course, logically self-defeating. But as a doctrine of history or, to refer to a modern discipline, of social anthropology, it can be not only interesting but fruitful. However, adherence to historical and cultural relativism creates its own special problems. While it is interesting to compare the *Weltanschauung* of ancient Greece with, say, that of Cromwell's England, the person who makes the comparison will soon come to the disturbing realisation that this very act of comparison is largely determined by his own time and place. He too has a *Weltanschauung*, and knowing that in some timeless sense it is as relative as all others does not yet do away with the need, imposed on him by life itself, to make a commitment to his own or to some alternative *Weltanschauung*. History, as it has often been said, is always written from the point of view of the present.

The period under discussion, the middle decades of the second half of the nineteenth century, were decisively important for Germany. Liberalism failed and German unity was attained by force of arms. Thus historical circumstances forced Germans to think about themselves, and they did so in terms that had been bequeathed to them by their great thinkers. Hegel's doctrine about the world-historical nation became perverted into a slogan of German imperialism, Schopenhauer's blind will metamorphosed into the Nietzschean will to power which became the legitimisation (again by perversion) of the German will to state-power (*Staatsmacht*) over ever-increasing areas. Nietzsche's quest for what serves life became a quest for what serves the life of the German nation. The fruits of classical German philosophy, especially of the Kantian concept of the will, were ripening.

The philosophical terms in which the matter was argued derived again (not surprisingly) from Hegel. The Hegelian reason was embodied, according to Hegel himself, in the state, which must be worshipped, as he said in his *Philosophy of Right,* as an earthly deity. Whatever the real intentions of Hegel might have been, and there is a great deal of evidence that Hegel himself did not mean to deify the Prussian state of his own time, there is no doubt that his successors, known as the Right Hegelians, were in the forefront of opposing social reforms along liberal lines and were the chief defenders of the cohesive authoritarian state. Their opponents, the Left Hegelians, also became important because of their activities in social and political life. The more academic issues between Left and Right Hegelians, such as the question of Hegel's theism, soon lost their importance. Thus the most significant aspect of German philosophy in the period of the growth of German power was its influence on and attitude to the political and social problems of the age. Philosophy of life and philosophy of culture became fused in political ideology.

Of course, academic philosophy, with its varieties of schools, continued to flourish in the universities. There were neo-Kantians who made valiant efforts to deal with the problems posed by natural science, but whose results bore the marks of the idealistic past. There were also materialists and positivists and there were even

scientists with a keen philosophical interest, the most significant of whom was the physicist Hermann von Helmholtz (1821-94). The Austrian school of philosophy, which retained throughout a marked difference from the mainstream of German philosophy, is especially noteworthy. Franz Brentano (1838-1917) and Ernst Mach (1838-1916), to mention only the two most outstanding figures, concerned themselves with problems which grew out of their interests in particular fields of discourse. For Brentano this was psychology and for Mach it was physics. The logical positivism of the early part of this century originated, significantly, in Vienna and not in one of the many German universities. Ludwig Wittgenstein, who in this century became the most influential philosopher in Britain, was an Austrian.

Despite the wide dispersion of German intellectual life in the universities in local centres, there has always been one dominating philosophical influence in Germany, one system in the framework of which most philosophers at any period thought and taught. It remains only to say something, very briefly, about the dominating system of the twentieth century. This is called phenomenology, and its founder was Edmund Husserl (1859-1938). He began as a mathematician and his quest for precision marks off his philosophy from that of his predecessors, even when he is at his most complicated. The phenomenological doctrine, if one were to put it into a nutshell, is something like this: the task of philosophy is not to inquire into the existence or non-existence of any particular thing, nor is it its task to concern itself with facts. Its task is to inquire into the nature of concepts by way of a special 'operation' which Husserl called *Wesenschau*—a seeing of essence. This is the method of phenomenology. Husserl's later work proceeded to a theoretical construction on the basis of this methodology which, in its essentials, is very much in line with the traditional position of German idealism. Although the Ego recognises that there are not only other Egos but also objects, it retains its primacy, and thus everything outside itself is ultimately seen as a construction of the Ego or of a community of such Egos. As for the *Wesenschau*, it is not difficult to recognise in it yet another attempt to strip the mask off reality.

Husserl's philosophy had one important issue: the existential philosophy of Martin Heidegger (1889-). From the 1920s to the present time Heidegger has dominated German philosophy. His personal record is bad. He was an enthusiastic supporter of Hitler and became the first Nazi Rector of the University of Freiburg. In the philosophy of Heidegger many of the typical themes of German philosophy discussed in this essay come together. Heidegger carried the prevailing cultural attitude of earlier times to its extreme. Although this attitude produced scientific achievements of the first order, it did not regard scientific work as an intellectually worthy enterprise. Heidegger's sneers at natural science as mere technology are the distorting mirror in which German anti-scientism can view itself. There is also in Heidegger a cult of inwardness, mysticism and a passionate will. This will, unlike its ancestor in Kant and Hegel, no longer has any message for mankind; Heidegger found it natural to support the blind self-assertion of the German will personified in Hitler. The philosophical method of Heidegger derives from Husserl. Heidegger wants to unmask, to see the essence of the reality which is a specific existence pertaining to human beings only. Humans exist differently from the way objects exist. This specific notion of existence is independent of historical and cultural determination. For Heidegger ultimate reality is the basic reality of human existence.

Our story stops at a point when German philosophy has come full circle. We have seen that its increasing concentration on human affairs came about after Kant showed that actions are not part of nature. As a consequence, Kant's successors tried to establish intellectually satisfactory ways of dealing with actions and agents. In Heidegger nothing is left but human existence stripped of all natural determination, which is no longer of philosophical concern. Heidegger's best book deals with Kant. Is Heidegger the ripe fruit of the Kantian tree? Kant would have contemplated Heidegger with horror, and yet could he entirely disclaim responsibility? These are interesting questions but there is no answer.

Naturally enough, in this situation, there is a vast gulf at present between German philosophy, dominated by Heidegger, and the philosophy of the English-speaking countries. Leibniz felt isolated in the Germany of his time and had hoped to accompany the Elector of Hanover to London when he became George I of England. There are many philosophers in Germany today, especially younger philosophers, whose efforts are directed towards bridging the gulf which became wider and wider during the period we have been surveying. But they have not yet found the one dominating figure required by German tradition to challenge successfully Heidegger's supremacy.

Psychology and Psychiatry

Herbert M. Bower

The Oxford Dictionary defines psychology as "the science of nature, functions and phenomena of the human soul or mind." It is not only an excellent definition of the subject but also suggests the various disciplines which contributed to its development in different periods and to different degrees. The theologians claimed the soul, the philosophers phenomenology, the psychiatrists the science of the mind and the physiologists the functional approach.

One fundamental question has always occupied psychological thinking. Is the brain a complex yet mechanically explicable machine, or is there a subtle, intangible substratum of the psyche or soul which eludes definition yet is essential for the working of the machine?

This argument, fiercely fought between different schools, has invested psychology with enormous vitality. It has also led it into long culs-de-sac, from which psychological thinking escaped only after decades and sometimes centuries of blind belief.

Eventually psychology emerged as an independent science in the nineteenth century, an amalgam of theology, philosophy, physiology and psychiatry, leaning heavily on the exact sciences such as physics, chemistry and mathematics. We shall speak here exclusively about German psychology, the contributions of individuals who expressed their thoughts in the German language, irrespective of their ethnic origin or birthplace. In fact, nearly all of them lived and worked in Germany, Austria or Switzerland. The list is by no means complete; only the most eminent have been included in this essay.

The story begins arbitrarily in the Middle Ages. Men with "psychological" insight undoubtedly existed long before this period in German-speaking countries, but we have little documentation of their work. Next, the "prepsychology" of the sixteenth to the eighteenth centuries will set the stage for a more detailed discussion of psychological streams of thought in Germany during the nineteenth and twentieth centuries. The main body of this chapter will be reserved for psychoanalysis and its impact on western thought.

During the Middle Ages the church insisted on its exclusive right to speculate and to pronounce on the human mind. Psychology then was theology. In the thirteenth

century, there were still men in the western world who interpreted human behaviour and values realistically, who asked bold questions, expressed doubts and even proclaimed the right of the individual to freedom of thought. One of them was Meister Johannes Eckhart (1260-1327), scholar, mystic and "prehumanist". He wrote about the human mind, the universe and the rights of man. Unafraid of the wrath of the church, he expressed his doubts clearly when he said: "If I did not exist, God would not exist."

During the fourteenth and fifteenth centuries, any remnants of freedom of thought disappeared. This was the age of demonology and witch-hunting. Theology was occupied exclusively with the exploration and exploitation of the human soul. Using the mantle of righteousness, it fought heresy and sin and suppressed all original thought and speculation on the functioning of the mind.

A "psychological" document from this period that bears witness to the terrifying power of the church is the *Malleus Maleficarum*, the hammer against witches. It was submitted to the University of Cologne by two Dominican monks, Sprenger and Krämer, in 1487. A reference book for prosecutors of witches, it skilfully proved the existence of witchcraft by arguing that "beyond doubt, anyone who does not believe in it acts contrary to good faith." The work became a recognised textbook during the Middle Ages and condemned thousands of innocent human beings, some mentally ill but most of them sane, to death by torture and burning. Strangely enough, the *Malleus Maleficarum* made sexual thoughts responsible not only for witchcraft but for other abnormalities of thought and action, thus anticipating a Freudian theory by some four hundred years.

During the sixteenth century, courageous men appeared throughout Germany who defied orthodox beliefs in the vulnerability of the human soul and its frequent possession by the devil. Heinrich Cornelius Agrippa (1486-1535), who taught in Cologne, Metz and Bonn, was a doctor of theology, law and medicine, like so many learned men of his time. His early writings on occult philosophy were completely in keeping with traditional teachings and beliefs. We do not know what caused a reversal of his views, but suddenly he aggressively opposed the church and current opinions concerning witchcraft and the mind. Agrippa began to speak of mental illness and its manifestations in an almost modern way. Under attack by the clergy and orthodox academics, he wandered from place to place, fearlessly denouncing the already dying world of the Middle Ages. Agrippa became the teacher of Johann Weyer, the first German psychiatrist.

Like Agrippa, Paracelsus (1493-1541), or to give him his full name, Theophrastus Bombastus von Hohenheim, was a man of the Renaissance and a stormy petrel all his life. Professor of medicine at the University of Basle at the age of thirty-three, he attacked conventional beliefs and medical knowledge in such a ruthless way that academics of his time turned against him. He always wrote simply and often in the vernacular German, not in Latin, the accepted language of learning. This iconoclast saw his first duty to be to his patients and wrote: *"Im Herzen wächst der Arzt, aus Gott geht er, des natürlichen Lichtes ist er, der Arzneien beste ist die Liebe."* ("In the heart grows the healer, he comes from God, of the natural light is he, the best of all drugs is love.")

Paracelsus saw the human being as a biological unit, an individual almost independent of heavenly influence. He maintained that man is the master of his destiny and in fact represents the universe on earth. Those were dangerous pro-

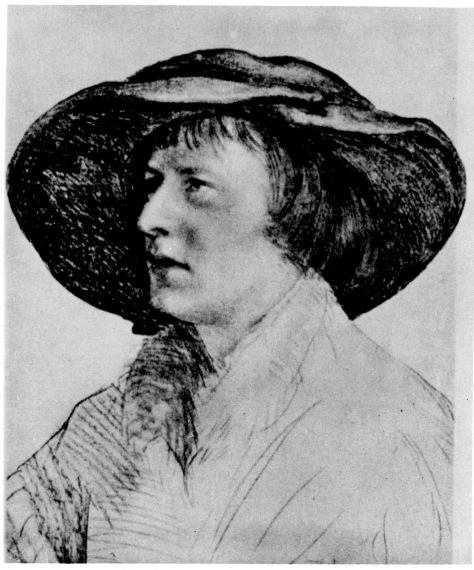

Holbein the younger: Portrait of a man, thought to be Paracelsus (1526).

nouncements for the early sixteenth century. Yet there were contradictions in his writings. While he saw the healing of the sick as the main duty of a doctor, he still believed in obstruse astrological causations of human illness. Paracelsus wrote extensively on mental disorders, and with remarkable insight attributed hysterical illness to sexual disturbances.

The foremost German physician and psychiatrist of the sixteenth century was Johann Weyer (1515-88). Gone is the violent and polemical style of Agrippa and Paracelsus. Weyer was a man of science, observing and studying patients and building his theory of mental illness on facts, not on speculation and prejudice.

Weyer, who came from the Rhineland, wrote and thought in German, although he often used Latin to give scientific status to his investigations. He was fascinated by mental illness, which he completely divorced from satanic possession. His explanations of mental symptomatology were rational and his clinical descriptions of case material lucid and factual. Weyer once and for all removed from medical psychology all theological as well as legal concepts, which until then had weighed heavily on the sick individual. He created psychiatry as a specialty within medicine for the first time. His attack against demonology and the *Malleus Maleficarum* was subtle and at the same time most effective. Using the weapons of the church itself and speaking as a good Christian, he denounced the witchhunting priests as "possessed by the devil themselves." Weyer shrewdly interpreted hallucinations as probably brought on by drugs and not by the devil. He used a combination of understanding, sympathy and support in the treatment of mental illness which closely resembled the "moral treatment" of the early nineteenth century. His courageous and at the same time detached and scientific approach to abnormalities of the mind engendered violent attacks from traditionalists, who considered Weyer a defender of Satan. For almost a hundred years after his death, demonology and the belief in the intrinsic wickedness of the mentally afflicted continued to exist in the western world.

With the seventeenth century, the age of science was born. All over Europe rational explanations of natural phenomena replaced blind belief in dogma and Biblical interpretation. Galileo shattered belief in the central and static position of the earth; Newton, Leibniz and Boyle utterly changed physics, chemistry and mathematics; Vesalius, Harvey and others explained some of the mysteries of the human body; the philosophers turned rationalist and like Descartes saw the human mind as a thinking machine. This scientific revolution gathered momentum and continued well into the eighteenth century.

In psychology, theology as one of the avenues of approach to a theory of the mind had been jettisoned. But a rational, mechanistic explanation, so well suited to explain the circulation of the blood or the movement of the planets, still failed to provide a satisfactory model for the forces motivating human behaviour. Faced with a rational, biological orientation in medicine, the psychologists now turned towards the search for a life force, a special element which was to provide the fuel and flame for the functioning of the brain. German psychologists, probably more than those elsewhere in Europe, were much attracted by this theory. They hoped that it would not only explain the smooth running of the normal mind but that it could also be adapted to include mental abnormalities by the assumption that this life force was either in short supply or running in the wrong channels.

George Ernst Stahl (1660-1734), professor of medicine first at Jena, then at Halle and finally in Berlin, saw the human soul not as a religious concept but as a life force, or as he later called it, a "motus tonico-vitalis". He thought this life force was present in all living material, and produced disturbances of mental functioning if its flow was disturbed. (We have only to replace his term with libido to have a modern psycho-pathological interpretation of psychiatric disorders.) Stahl further believed that a division between body and mind was impossible and postulated close interaction between them. He anticipated the theories of emotion and psychosomatic medicine by some two hundred years, clearly recognising a primary organic aetiology in some mental disorders and a functional or emotional

one in others. Were it not for rather quaint terminology, Stahl's writing would strike us as remarkably fresh, modern and full of penetrating insights.

Rationalism continued in the eighteenth century. For the first time the doctrine of the inalienable rights of man was formulated, humanitarianism entered the mental hospital and the chains fell at last. In psychology, the influence of the great philosophers of this era (Hume, Berkeley and Kant) was enormous. Particularly in Germany psychiatry as a medical specialty was left to physicians, but philosophy claimed all rights to hypothesise on the psyche and its aberrations. This was also the century of scientism and quackery in psychology.

Johann Christian Reil (1759-1813) was a man of many contradictions. A neuroanatomist of world renown, he was also a psychiatrist with great clinical experience. Reil perceived the close correlation between psychology and physiology, defined the psychoneuroses as a distinct entity and recognised the role of sexuality in the aetiology of hysteria. His treatment programme included a form of psycho-drama which helped the mentally ill to act out their hidden conflicts. Reil also envisaged the ideal mental hospital design and treatment pattern, sensing the tremendous effect of therapeutic surroundings on mental illness. Yet he included physical punishment and even torture in his repertoire of psychiatric treatment, and considered any speculative theories of thought and emotion to be strictly the domain of the philosopher.

In the latter part of the eighteenth century in Germany a number of psychologists and psychiatrists appeared whose speculations on thought processes and on the aetiology and treatment of mental disorders became increasingly vague and unscientific, eventually bordering on charlatanism.

With Anton Mesmer (1734-1815), psychology completely abandoned scientific principles and became faith-healing. Mesmer attributed magnetic properties to body fluids, which could be influenced by the planets. Eventually he claimed to have a special magnetising power which could influence and heal nervous disorders. Although Mesmer exploited his own "magnetic" influence over suggestible and mostly neurotic patients for personal gain, he nevertheless introduced to psychology the genuine and hitherto unexplored phenomenon of hypnosis. In the following decades, both charlatans and physicians experimented with hypnotic suggestion until a hundred years later Breuer and Freud used hypnosis in the treatment of neurosis and made it a respectable medical procedure.

After sweeping away the accumulated superstitions and illogical beliefs of the past, rationalism came to a halt in the first half of the nineteenth century. A certain disenchantment had set in. While the materialistic approach had enormously increased our knowledge of the physical world, it had failed to bring about an ordered and happy existence for mankind. The exploration of the human mind along mechanistic pathways had failed. Therefore psychology was ready to abandon the search for special fluids, anatomical localisations and superficial descriptions of mental phenomena. It now rejected all physical and organic hypotheses as "not coming to grips with the complex problem of the psyche." In this decision it was strongly influenced by the prevailing climate of romanticism in literature and philosophy. This literary influence was particularly strong in Germany. Goethe, Kleist, Schiller and Fichte all spoke and wrote about the emotions, the passions, the inner meaning of life, the responsibility of the individual and the metaphysics

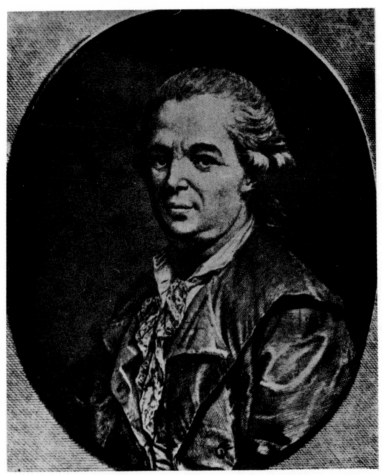

Franz Mesmer.

of the soul. Between 1800 and 1850 a romantic philosophical school of psychology emerged in Germany. Its terminology was unfortunately loaded with moral, theological and metaphysical concepts. Nevertheless it came close to formulating a depth psychology which in its dynamic insight far surpassed anything that experimental psychology and organically oriented psychiatry produced later in the nineteenth century. Reil was a forerunner of the romantic psychologists; in Heinroth, Haindorf, Ideler and others this school reached its full flower.

Johann Christian Heinroth (1773-1843), although he wrote in almost theological terms, was an excellent clinician and observer of mental illness. From the abnormal he developed a dynamic theory of the mind which anticipated psychoanalytic concepts in many ways. He recognised conflict as a central phenomenon and described three psychological levels of the mind, the lowest concerned with instinctual drives or feelings, the next an intellectual level and finally a highest, idealistic level, which he chose to call conscience and to which he attributed a

controlling function. Heinroth invested the thought processes of psychotic patients with some meaning and attempted a symbolic interpretation of their content. Psychologists who followed him elaborated on his ideas of a structure of the mind. Instinct began to emerge as a new and important force and man and his brain came to be regarded as a psychobiological unit.

With Haindorf, Beneke, Ideler, Feuchtersleben, Kerner, Groos and Carus the romantic school of psychology gradually worked towards an integrated theory of personality development and a concept of the unconscious. The description of interaction between organ systems, their functions, and thinking processes closely resembled psychosomatic theory. However, in the years between 1850 and 1900 this stream of psychological thought was almost totally driven out by a descriptive, organically oriented and materialistic German psychology.

The materialism of the later nineteenth century was largely a reaction against romantic idealism and its incursions into the realm of science. Technological advances and the resulting improvement in industrial and economic conditions helped to encourage a special interest in the pure sciences. A generation that had witnessed the experiments of Helmholtz in optic physics, and that saw Joule establish the principle of the conservation of energy and Schwann prove microscopically that the cell was the true unit of the animal organism, had no patience with the romantic fancies of idealists and their rejection of the reality of matter. It was the extreme materialism of this era that provoked Vogt's famous statement: "the brain secretes thought as the liver secretes bile."

In 1859 Darwin published his *Origin of Species*, in which he set out the main lines of evidence on which he based his theory of the evolution of species by natural selection. The great significance of Darwinism lay in the fact that it helped to support the naturalistic and positivist tendencies of his age. The concept of a struggle for existence and of survival of the fittest by natural selection seemed to do away with the need to employ ideas of purpose and design to explain biological phenomena. Darwin appeared to offer a purely mechanistic explanation for a fundamental question which before him had been regarded as the stronghold of idealistic philosophers or defenders of the faith. In Germany the impact of the new intellectual climate on psychology was far-reaching, producing a virtual rebellion against the romantic-philosophical school and replacing it with an empirical-scientific psychology. This was a science in its own right, completely removed from its sources in philosophy and psychiatry. Paradoxically, this new science was engendered by empirical philosophers like Herbart and Lotze, developed by physiologists like Johannes Müller and Weber and only later established by experimental psychologists, particularly Fechner, Helmholtz and Wundt. Although this era of psychology was developed after 1850, its roots extend far back—both Herbart and Müller were born and worked in the so-called romantic period.

Parallel with the foundation of psychology as a well-defined discipline, there flourished in Germany a school of psychiatry which looked on its predecessors (romantics like Heinroth) as spinners of fairy tales and philosophers in the most derogatory sense. Men like Griesinger or Kräpelin were organically oriented; they believed only what they could observe, describe and classify. This organic, materialistic approach was supported not only by the new school of psychology but even more so by advances made in neurophysiology and pathology during the second part of the nineteenth century.

J. F. Herbart (1767-1841) was professor of philosophy at Königsberg. For him the mind was very much a mechanical apparatus, and he urged accurate measurements of "acts" or products of the mind. Herbart disregarded everything except the conscious content of the psyche. He argued for a complete separation of psychology from philosophy and also from physiology. Hermann Lötze (1817-81) received medical training but soon turned towards philosophy as his life's task. For him, phenomena such as memory, cognition or sensation could be described and defined only in physiological terms. In opposition to Herbart he urged a complete union between psychology and physiology as one closely-knit scientific discipline. Lötze's view proved to be more or less correct and until the beginning of the twentieth century physiological knowledge contributed enormously to psychology. E. H. Weber (1795-1878), who held the chair of physiology at Leipzig for most of his life, introduced the detailed experimental approach to psychology. His studies on the sense of touch, muscle sensation and visual discrimination gave future psychologists the essential tools for their experiments. Johannes Müller (1801-58), the professor of physiology in Berlin, wrote a monumental textbook of physiology which was psychologically oriented. His description of central nervous system activity, particularly the reflex arc and the formulation of the law of specific nerve energy, stand as classic studies in physiology. Müller's institute in Berlin taught a whole future generation of German psychologists.

An important milestone occurred when, freed from philosophical interference by Herbart and Lötze, but now in danger of being absorbed by physiology, German (and to some extent European) psychology was rescued by three men. All were born in the early nineteenth century and all were medical graduates who refined experimental psychology as suggested earlier by Weber and fashioned it into an exact science. These were Fechner, von Helmholtz and Wundt.

Gustav Fechner (1801-87) studied medicine in Leipzig. Disillusioned with the unscientific methods used in this field, he turned to physics as an exact science and produced outstanding research in this field. In 1839 Fechner suffered a nervous breakdown, almost certainly schizophrenic in nature, which was accompanied by pseudo-philosophical ruminations, withdrawal from the world and a deep hatred for materialism and its pernicious influence on the sciences of his day. His attitude was indubitably psychotic. And then an extraordinary thing happened. In order to prove the evil consequences of a materialistic viewpoint, Fechner embarked on a series of psycho-physical experiments which pioneered the quantitative measurements of sensation following external stimulation. Fechner was furthermore able to demonstrate a close correlation existing between stimulus and ensuing sensory experience. Experimental measurements of this stimulus-response relationship extended from simple sensation to human reaction and behaviour. Needless to say, Fechner did not in fact discredit the scientific approach, but he did enable exact measurement of human response to stimulation and the formulation of certain laws in this field of psychology.

Hermann von Helmholtz (1821-94) studied medicine like all the great psychologists of his time. Like Fechner he then turned his interest to physics. He formulated a theory of the conservation of energy, held two academic chairs of physiology and was finally appointed professor of physics in Berlin. His experiments in physics, physiology and psychology were brilliantly designed. He studied the speed of nerve impulses, worked on auditory sensation and wrote a classical handbook of physio-

logical optics. Helmholtz was a firm believer in empiricism and for him perception remained a strictly mechanical process. The stimulus passes through a receptor organ and is interpreted centrally on the basis of previous experience, which is again seen as a conglomeration of memory traces. He regarded the mind at birth as a total blank, which gradually fills up with preceptual experiences.

Wilhelm Wundt (1832-1920), often called the father of experimental psychology, was a man of formidable teutonic thoroughness and organisational talent. Academically he moved from medicine through physiology to become professor of philosophy at Leipzig. Although psychology was an independent science by then, it still apparently needed at least the mantle of philosophy. Wundt's work, less original than that of Helmholtz, whose associate he was for some years, dealt with subjects such as perception, sensation and association. None of it was epoch-making, all of it was sound. What was more important was his construction of a firm framework of experimental psychology dealing with the study of individual consciousness through the analysis of cortical experience and measured by precise instrumentation. Wundt's Leipzig school became famous and influenced a great many psychologists in Germany, England and the United States.

Simultaneously with Wundt, a number of more or less empiricist, academic psychologists (Ebbinghaus, Stumpf, Külpe) taught at German universities. With the exception of Külpe, nineteenth century experimental psychology as a science essentially stressed conscious thought content, broken down into items such as sensation or feeling, which it measured precisely either by instruments or through the process of introspection.

German psychiatry of the same period parted ways with psychology. Alienists like Griesinger, Kahlbaum and Kräpelin were exclusively medical men, shrewd observers and classifiers of mental disorders. Wilhelm Griesinger (1817-69) held that organic lesions alone are responsible for all mental disorders. His essentially descriptive and systematising approach was certainly needed in psychiatry at that period, but it eventually led to sterile classification for its own sake and therapeutic nihilism. Karl Kahlbaum (1828-69) outlined with painstaking orderliness so-called symptom complexes (*Krankheitsformen*) characteristic for certain mental disorders.

Emil Kräpelin (1855-1926) was probably the outstanding psychiatrist of his time. To him only the clinical picture was important. His classification of mental diseases was based on a vast number of case studies, and his description of symptoms was extremely detailed and supported by statistical evidence. However, Kräpelin's approach to the aetiology of these closely-observed disease processes was vague and speculative. "Inherited constitution" was thought to be responsible as the causative factor in most disorders. He held in utter contempt the "philosophical" contribution to psychiatry, which he saw as a branch of medicine dealing with physical disorders of the brain.

In these years, a number of neurophysiologists and pathologists (Waldeyer, Meynert, Wernicke) mapped out the brain with its pathways, nuclei and cortical layers, providing added support for an organic, mechanistic theory of the mind and its diseases. However, two Swiss psychiatrists, Bleuler and Meyer, did not conform to the psychiatric orthodoxy which prevailed in Germany at the turn of the century. Eugen Bleuler (1857-1939) achieved fame for his penetrating study of schizophrenia and autistic thinking. He favoured a psychological interpretation of mental symptomatology and was deeply interested in Freud's writings. Bleuler forms a link between the organic and psychoanalytic schools of German psychiatry.

Adolf Meyer (1866-1950), also Swiss, spent most of his working life in the United States and had a profound influence on American psychiatry before the Second World War. He saw the individual patient as a psychobiological unit exposed throughout his life to a field of environmental forces. He preferred not to speak of diseases but rather of reaction types as a result of life experience.

German psychiatry before 1900, with its formal, rigidly organic orientation, left many questions unanswered. In fact, it often neglected to ask them. Yet it brought order and system into a chaos of diseases of the mind. Its influence was so great that even during the twentieth century orthodox psychiatry in Germany and Austria remained organically oriented; not even Freud's new theory of psychic functioning had much impact in academic circles.

As the nineteenth century passed into the twentieth, man felt he had almost mastered the outer world. There was only one more door to be opened and the secret of life would be his. The door opened but to man's amazement it revealed the sphinx of the human mind, resisting the rational interpretation that had been so successful in other fields of human enterprise. So the pendulum again swung away from materialism and a mechanistic, "conscious" oriented psychology towards a law of instinctual demands and primitive forces—a theory which incorporated the unconscious part of our psyche. The search for a mainspring of life, liberation from conventionality and a more penetrating explanation for human behaviour expressed itself throughout Europe in art, literature, drama, poetry and philosophy. Bergson spoke of the *élan vital*, Nietzsche of the beast in man, German expressionist painters like Nolde or Marc exploded in a riot of colours, projecting their innermost feelings on canvas. All this was inexplicable in the language of traditional psychology. Even the earlier naturalism in literature and drama had looked for inner meaning, no longer believing that the world is an orderly place and man a rational being. Dostoevsky, Zola, Hauptmann and Ibsen all wrote in a "psychological" style and hinted at unconscious processes in the human mind, at motivating forces so far unknown and almost certainly dangerous.

German psychology had been flowing comfortably in two streams: a Wundtian school studying phenomena such as sensation or perception which had little relation to man's inner life and deliberately ignored instinctual processes; and an orthodox and classifying type of organic psychiatry which showed little interest in either the aetiology or the treatment of mental disorders.

To interpret and understand human behaviour meaningfully, a new kind of psychology was needed. The psychoanalytic hypothesis of Sigmund Freud (1856-1939), the deviants (Jung, Adler) and post-Freudians (Fromm, Horney) provided a radically new approach. Gestalt psychology, existentialism and ethology represent other new schools of thought, although it is too early to evaluate their lasting influence on modern psychology.

Isolated observations indicating the presence of unconscious thought-processes and related mechanisms have been recorded throughout all periods of history. At times descriptions were extremely accurate and almost "psychoanalytical": Reil's hidden conflicts and particularly Heinroth's division of the psyche. It all emphasises the fact that Freud did not discover the "unconscious" in the jungle of the human mind as Du Chaillu discovered the gorilla in the rain-forests of the Belgian Congo. No attempts had been made, however, to co-ordinate these observations or to

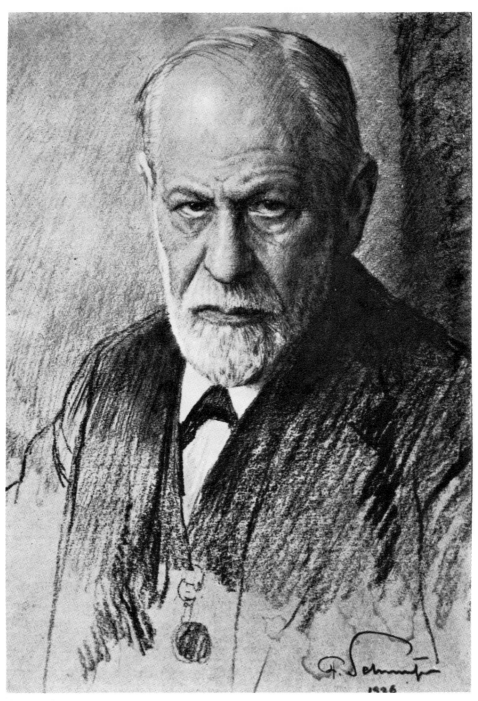

Sigmund Freud.

establish a coherent theory involving the unconscious. Consequently psychology and psychiatry before Freud had remained unaffected by those sporadic impressions.

From the beginning, psychoanalysis was concerned with the thoughts and emotions of individuals struggling with the difficulties life presents. Although it started as a method for the treatment of psychological disorders, it soon opened up important fields for psychological research and threw new light on almost all phenomena of human life. Directly and indirectly psychoanalytic theory has had an enormous influence on modern thought.

Freud's scientific success was probably due to a number of factors. The time was ripe for a rebellion in psychology; from his early research in neurology he was able to transfer certain scientific principles which he successfully applied in the measurement of abstractions of behaviour; his theoretical framework, constantly tested by clinical experience, was soundly constructed; and finally, over a period of some fifty years Freud consistently showed a brilliant speculative mind.

His work falls into two divisions: firstly, scientific observations of phenomena of the mind constituting the body of psychoanalysis, which has become a school of modern psychology; secondly, the formulation of hypotheses which extend into religion, anthropology, mythology and art. These were repeatedly reformulated in the light of new observations and belong properly to philosophy.

Freud's fundamental theory of the unconscious was the product of several factors. As a neurologist he saw a great number of mentally ill and usually neurotic patients. At that time, medicine had no worthwhile therapeutic measures at its disposal to help these unfortunate people. Secondly, while working in Paris under Charcot and later at Nancy, Freud saw how patients clearly exhibited thought processes during hypnosis of which they were not consciously aware and which influenced their behaviour. Thirdly, and here chance played a part, a fellow practitioner in Vienna related to him how under hypnosis a female patient suffering from hysteria had "brought up" a number of forgotten memories, some obviously distasteful to her. After these memories had been released with a strong emotional outburst, a dramatic relief was experienced. Freud initially experimented with this form of therapy. Soon, however, he gave up the hypnotic approach and chose a method of letting the patients speak freely and without any suggestions from him about their past and present life. In free association, as in hypnosis, forgotten memories and pleasurable or distasteful experiences dating back even to childhood then emerged. As some of this material was presented in disguised and symbolic form, an interpretation or analysis of its psychic content was necessary—hence the name psychoanalysis. The material which emerged during these interviews invariably contained some clues to the cause of the neurotic breakdown. To Freud's astonishment, a sexual component was always present in the patient's story.

Freud gradually formulated the concept of the unconscious as a part of our mind inaccessible to conscious exploration and filled with impulses and memories which are unacceptable to us. Furthermore, these thoughts, wishes or memories, which are normally anchored firmly in our unconscious without even reaching awareness, emerge in disguised form during a mental illness and are either felt as anxiety or expressed as a bodily symptom. The mechanism which prevents unconscious material from reaching consciousness was called repression. This shields our mind from bombardment with unpleasant or disturbing ideas and conflicts. Once the language of the unconscious was understood, the utterances of severely disturbed and psychotic patients, which had been previously incomprehensible

because of their symbolic disguise, became meaningful and pointed towards a possible cause for the illness.

During psychoanalysis, patients frequently spoke of their dreams, and a close scrutiny of the content revealed that unconscious material seemed to reach a conscious level during the process of dreaming. The dream acted as a kind of wish fulfilment or release phenomenon and protected normal sleep. In order to escape self-analysis, the dream appeared in the memory of the sleeper in a distorted and highly symbolic form and was moreover rapidly forgotten after awakening.

While undergoing analysis, many patients not only spoke of their sexual experiences but also linked them with their own childhood and adolescence. Eventually Freud postulated a theory of infantile sexuality with certain phases of development (oral, anal and genital) through which each individual has to pass during normal maturation. He also outlined the oedipal situation as the sexual love of a child for the parent of the opposite sex. Freud considered any disturbance of these developmental phases as highly significant for future personality structure. He also observed a regression of the adult personality to infantile levels during certain phases of mental disturbance.

Freud was now ready to construct a working model of the mind as a psychic apparatus functioning on both conscious and unconscious levels and consisting of three psychic (not anatomical) structures.

1) The Id is an obscure, inaccessible part of the psyche, functioning at an unconscious level and concerned with the instinctual needs of the individual. It provides the driving force (libido) necessary for normal life, ignores the laws of logic, the passage of time and reality and is bent on obtaining pleasure at all costs.

2) The Ego is the conscious self. It is in constant contact with the external world, receives stimuli and acts protectively. It has a high degree of organisation, and unconscious demands are expressed through the ego and modified by it.

3) The Superego, our conscience, is concerned with ideals, acting as a censor, critic and controller of instinctual demands. It develops as a psychic structure in childhood through gradual acceptance of parental standards of behaviour. The superego is partly conscious and partly unconscious.

Thus the ego maintains a nice balance between id-demands and superego control. Normal mental functioning depends on smooth interaction between the three psychic structures.

Freud next outlined the existence of so-called mental mechanisms, envisaged as convenient defences against the onslaught of instinctual forces on a vulnerable ego. The key concept here is anxiety, which is engendered by the conflict between instinctual demands and socially acceptable behaviour (id against superego). Anxiety is obviously undesirable, as its presence severely disturbs normal ego functioning. The psyche therefore develops protective mechanisms, of which one is repression or the holding down of distasteful or undesirable wishes or ideas in the unconscious. Another mechanism is called sublimation, by means of which a desire for an unattainable object is replaced with the similar desire for an available or easily obtainable one. In rationalisation, fictitious reasons are found for behaviour which is in fact quite unreasonable. There is a great number of mental mechanisms, practised daily by normal individuals and below the level of awareness.

Step by step, these explorations of the human psyche and its functioning brought Freud closer to a co-ordinated theory of instincts. A fundamental Freudian concept was libido, which is often equated with sexual drive or force, but which in

Max Ernst, Oedipus Rex (1922)

fact has a much wider connotation. In Freud's view, libido signifies all psychic energy. It is pleasurable in nature and differently organised and experienced at various stages of maturation. Freud went on to propose the existence of two primary instincts, one a life instinct or Eros, and the other a death instinct which he called Thanatos. The first is obviously concerned with self-preservation but also acts as a sexual drive and helps to propagate the race. The second instinct is destructive and aggressive and its aim is the death of the individual.

This was Freud's theory of the mind, biologically oriented and for the first time recognising unconscious processes which extensively motivate our behaviour. One important corollary of psychoanalytic theory is its removal of free will and its denial of man's dominance over his mind. It shows him as a biped with a highly developed cortex, sharing the same biological laws with his cousins of the animal world.

With Freud, the psychological rebellion against the organic and mechanistic approach began and also reached its peak. Psycho-analysts after Freud either refined his theories (Abraham, Ferenczi), opposed it (Jung, Adler), or modified it (Fromm, Rank, Horney). Brief mention must now be made of the two great dissenters, Jung and Adler, as Freud's most important contemporaries in psychology.

The Swiss psychiatrist Carl Gustav Jung (1875-1961) was a close collaborator with Freud for many years. Even as a young man he showed certain mystical leanings which ultimately led him to break with Freudian psycho-analysis. In 1900, when he was an assistant to Bleuler, he published a book called *The Psychology and Pathology of so-called Occult Phenomena*. He had already become deeply interested in Freud's theories and his studies in word association were based on the existence of unconscious mechanisms. Working with Bleuler at a large mental hospital, he constantly saw patients suffering from schizophrenia, which psychiatrists then thought was caused by an autotoxin. The clinical manifestations of this disorder, although well described, were ill understood. Jung showed clearly how the symptoms of schizophrenia could acquire meaning if interpreted psycho-analytically. At this stage of his scientific development, he accepted Freud's psycho-analytic principles and himself contributed extensively to the body of psycho-analytic knowledge. In his research into mythology, which was published in 1911 and 1912, he again applied psycho-analytic theory to a non-psychiatric subject with great success. However, Jung gradually moved away from psycho-analysis, rejecting in particular the sexual component of the libido theory. Later, he proposed the existence of two libidinal types, occurring in both normal and abnormal personalities, namely the "Introvert" and "Extravert". These types later became the basis for many personality tests.

Jung's psychotherapeutic technique was much more active than Freud's full psycho-analysis, and stressed self-realisation as an ultimate aim. But perhaps the outstanding contribution that Jung made to modern psychology was his concept of the "collective unconscious". While recognising Freud's personal unconscious, he postulated a psychic area containing "the mighty deposit of ancestral experience accumulated over millions of years, the echo of prehistoric happenings to which each century adds". Although an outstanding psychiatrist and scholar, Jung never attempted to create a systematic framework for his beliefs. His appeal to non-medical scholars, especially theologians and mythologists, and also to artists, has always been greater than to medical psychologists.

The Viennese medical graduate Alfred Adler (1870-1937) turned to psycho-analysis as an established medical practitioner. His first scientific contribution was the theory of "organ inferiority" or the tendency towards weakness in a particular organ, which Adler considered to be constitutional. He further believed that as a result, over-compensation of either the same organ (such as the heart) or of its fellow (for instance the kidney) occurred. Arguing by analogy with organ over-compensation, he maintained that psychological over-compensation due to psychological inferiority also occurs. He further challenged Freud's instinctual theory by elevating the aggressive drive to a primary position. According to Adler, aggression is used to overcome inferiority feelings and is the main defence mechanism against domination by environmental forces. He considered sexuality to be of secondary importance.

As in the case of Jung, a break occurred between Freud and Adler, who called his psychological theory "individual psychology". Adler further enlarged on the concepts of inferiority and over-compensation and taught "harmonious living and creativity to abolish the will to power". He believed neurotic development to be the consequence of over-compensation due to inferiority feeling dating back to childhood. His other important contributions to psychology consist of greater understanding of the doctor-patient relationship, and his influence on teachers and counsellors in the field of child guidance, which he initiated in Vienna.

The organic trend persisted in the academic psychiatry of the twentieth century. However, this discipline gradually emerged from its purely descriptive phase and became increasingly interested in aetiology and treatment. Kretschmer correlated body build with the occurrence of certain psychiatric disorders. Wagner-Jauregg successfully treated cerebral syphilis by inoculating patients with malaria. Sakel introduced insulin therapy in the treatment of schizophrenic illness. German mental hospitals were the first to use occupational therapy *(Arbeitstherapie)* to combat passivity and deterioration in patients. These important developments in psychiatry did not depend on psycho-analytic theory, and again show the ever-present dualism in the science of the mind.

Returning to experimental psychology and perception: these areas had been subjected to intensive research by Fechner and his contemporaries. A new school, Gestalt psychology, made its appearance just after the First World War. Its founders Wertheimer, Koffka and Köhler saw perception as a unit of experience, rather than as a product of sensory impulses. In other words, the total situation is perceived actively. Organisation takes place at a cortical level and every experience is said to be based on neurophysiological patterns, some of which may be innate. Gestalt, the German word for form or shape, thus becomes an important concept in learning theory, both cognitively and motivationally. Köhler is famous for his work with anthropoid apes and learning processes. According to him, animals see their environment in terms of the relationship between objects and as a total situation. Altogether the main achievement of Gestalt psychology was to throw doubt on the old beliefs of a dissecting experimental psychology, which it attempted to replace with a concept of total situation.

Existentialism must be mentioned briefly here, as it has significantly influenced the psychological thought of our age. With the exception of Kierkegaard, all its originators, Nietzsche, Husserl, and Heidegger, were German. It is therefore not surprising that the introspective, anti-scientific and highly speculative tenets of existentialism attracted a number of psychiatrists and psychologists in Germany, Austria and Switzerland. It seemed almost an extension of psycho-analysis not only to recognise and come to terms with one's unconscious conflicts but to make self-awareness the centre which gives real meaning to the life process. Existentialism has in fact many basic concepts in common with psycho-analysis. The despair of the existentialist about "being in the world" is very like the old Freudian anxiety, and the *Daseinsanalyse* (existential analysis) is akin to the psycho-analytic interpretation of the individual unconscious.

Existential psychiatrists like Jaspers, Frankl or Binswanger were all profoundly influenced by Freud, but they rejected the passive role they had to play in therapy and welcomed the existential sharing of values with others and the transmission of the psychiatrist's own philosophy and meaning of life to the patient. In this school the existence of the unconscious is not denied, but far more stress is laid on the description of psychic phenomena in the area of emotion and feeling.

Meanwhile the Austrian Konrad Lorenz returned to the study of animals in his search for a new interpretation of the fundamentals of behaviour. His theory of ethology expresses the basic principles of innate behaviour and maturation of animals in their natural environment. In his book on aggression, Lorenz applies the mechanisms of animal motivation to the human species. He regards the "causal

determination of all natural phenomena" as axiomatic and maintains that human conduct, like that of animals, is largely influenced by instinctual forces. In this he agrees with the orthodox psycho-analysts. The aggressive instinct, a basic concept in ethology, corresponds to the Freudian death wish. Lorenz put forward the theory that the innate inhibitions which control aggressive behaviour are strongest in the animal species most efficiently equipped to kill, such as the great predators. The weak and defenceless, so-called non-aggressive animals do not possess such inhibitions with respect to their own species. Man, relatively puny, with small teeth and no claws, has no effective natural killing weapons; consequently, he has not developed automatic control over his aggressive drive. As timid, fruit-eating anthropoids, our ancestors had little inclination and certainly no effective weapons to exterminate each other. But man's cortex grew and he invented in rapid succession the club, stone axe, bow, rifle and hydrogen bomb. In ethological terms, we have manoeuvred ourselves into an ugly position. Here is man, definitely not a rational being, but devastatingly well armed, without effective built-in taboos against intra-specific killing, and full of aggression for which there is no socially acceptable discharge.

Lorenz then sketches the field of forces which governs social conduct in our civilisation. First we are driven by our instinctual motivation towards aggression. Opposing it stands our conscience, morality or superego. To relieve the deadlock which would make normal ego functioning impossible, our "cultural ritualisation", by which Lorenz means our customs, ceremonies and creative activities, allows for a release of instinctual demands through culturally permissible channels. War belongs to this group of cultural ritualisations and permits intra-specific killing without guilt feelings. As the rapid emergence of instinctual taboos on killing seems unlikely in the foreseeable future, Lorenz sees man's only hope in the exploration of relatively harmless channels for aggression as a substitute for war.

Of the numerous psychological schools and systems of the past, only psycho-analysis has had a lasting impact on western society. In the appreciation of works of art, it has explained that art derives its energy and mysterious power from the Id, its formal synthesis and unity from the ego and its ultimate ideals from the superego. This kind of analysis has led to greater understanding particularly of non-representational art and of the "inner reality" unifying symbolic and seemingly incoherent works. Freud has affected not only critics but also artists and writers. In much modern writing, the regular structure of thought and language is broken down to allow direct expression of the unconscious and an unimpeded flow of images. The works of authors like Kafka and Döblin provide striking examples of associative and stream of consciousness writing, which stimulates the reader's own unconscious and has required new interpretative criticism. A realist author like Thomas Mann, on the other hand, is quite different, even when (as in his Joseph novels) he draws directly on psycho-analytic theory.

In the social sciences, the anthropologist's study of primitive thought processes embodied in the myths and practices of certain tribes and surviving among civilised races has provided striking confirmation for psycho-analytic tenets. One result has been scepticism about the likely success of a wholly rational approach in social questions and politics. In criminology, psycho-analysis has pointed towards understanding the unconscious motives of criminals, and it has helped educators in dealing with maladjustment, delinquency and actual neurosis in children and adolescents. The exploration of the early years of the individual is also now seen as a thrusting back into the primitive and mystical childhood of mankind. Freudian

theory has helped us to understand our distant ancestors, as well as showing us how instincts are sublimated into creative forces which serve social order and the perpetuation of culture.

Before attempting to look into the future of psychology, let us for a moment turn back the pages of history. The development of psychology has included Eckhart's courageous stand for the rights of the individual, the sadistic interpretation of the human mind in the *Malleus Maleficarum*, Paracelsus' love for his patients and the soul, Weyer's scientific approach to mental functions, Stahl's search for a life force in the era of rationalism, Heinroth's rejection of organicism and attempt to formulate a depth psychology, the overwhelming materialism of the hypotheses of Helmholtz, the classifying psychiatry of Kräpelin and finally Freud and the fundamental role of the instincts in human behaviour.

The pendulum of psychological thought has indeed swung wide and it almost seems as if the intervals between the extremes are becoming shorter. Already one can sense that contemporary psychological orientation (not only in German psychology but as a world-wide trend) is moving away from exploration in depth, from direct contact with the individual, from empathy, from a basic purpose of prevention and help; in short, away from humanism. We are again turning towards mechanical explanations of patterns of human behaviour. The mind is again seen as a vast machine filled with reverberating and self-steering circuits. Data is obtained through questionnaires and personality profiles. The statistics are impeccable and yet it almost seems as if the computer not only gives the answers but also asks the questions. However, this new era of disindividualisation in psychology may only be another phase in the stream of human endeavour and the pendulum will continue to swing.

The Educators

R. H. Samuel

Almost a century ago the American educationist H. Barnard claimed that

> Since the great ecclesiastical upbreak of the sixteenth century, and particularly since the social and political agitations which grew out of the action of the French Revolution on European institutions, German writers, statesmen, and teachers have bestowed more thought on the problems and discussion of education, than have the same classes in any, or all other countries together.

It is certainly true that education has been the subject of continuous debate in Germany for a long time, yet some trends can be singled out which have dominated educational discussion until this very day.

First there was the struggle between the state and the churches for the control of educational institutions and hence for the souls of young people. Further, there was the question of what should be taught. This meant for the elementary level whether a minimum of knowledge (mainly of the scriptures, then a little of the three R's) was sufficient or whether a maximum of education and culture should be granted to the common people. For the secondary system one of the main questions was what place to give to classical studies on the one hand and to the *realia,* or "utilitarian" subjects, on the other. This question brought into the debate the contrasting philosophies of "humane" and "national" education: all-round general education or education for citizenship. Problems of admission to universities and of the nature and function of the university evolved naturally from these debates. Thirdly, the social problem played a large part—who was entitled to education: only the aristocracy, or the middle class as well, or should education be granted to all. All these questions contain a large political component, which was never entirely absent in the history of German education.

In the Middle Ages the church was dominant in education in Germany as everywhere else in Europe, and clerics were the only educated class. From the monastic communities, schools arose attached to the monasteries themselves *(Klosterschulen),* to the great cathedrals *(Domschulen),* or to individual parishes *(Pfarrschulen).* This system had been conceived by Charlemagne and spread further in the course of time. The monastery and cathedral schools provided a kind of secondary education mainly for future members of the great religious orders. The subject matter was closely linked to the educational system of the late Roman Empire, and poets and philosophers like Virgil, Aristotle and Seneca were studied. The parish

Gutenberg's printing machine, c.1445 (reconstruction).

schools, however, were the predecessors of the elementary schools. The all-embracing system of scholasticism with its complicated dialectical method led to the founding of universities. Until the fourteenth century there were only a few in Europe: in Paris, Bologna, Oxford and Cambridge. As the German monasterial and cathedral schools were unable to cope with the new system, thousands of German scholars wandered abroad to seek instruction until some of the more powerful princes of the Holy Roman Empire established universities within their own borders. The Emperor Charles IV, who was also King of Bohemia, was strongly influenced by the humanist movement and founded the first German university in Prague in 1348. It was his wish that his "faithful subjects, ever hungry for the fruits of learning, should find a table for this meal in their own country and consider it superfluous to seek higher learning in foreign countries as beggars." Vienna (1365), Heidelberg (1385), Cologne (1388), Erfurt (1392) and Leipzig (1409) followed; altogether eighteen universities were established within the Empire before the Reformation. Life at these universities was still conducted largely on monastic lines and instruction remained very much in the strict tradition approved by the Church of Rome.

The Reformation was decisive for German education. The invention of the printing press by Johannes Gutenberg in Mainz (*c.* 1445) had already promised unheard-of new practical possibilities for instruction. Luther's translation of the *Bible* and its easy availability through the press gave new impetus to the central subject of all instruction—the Holy Word could be heard and understood by all and studied, provided they could read. Luther himself was interested mainly in elementary

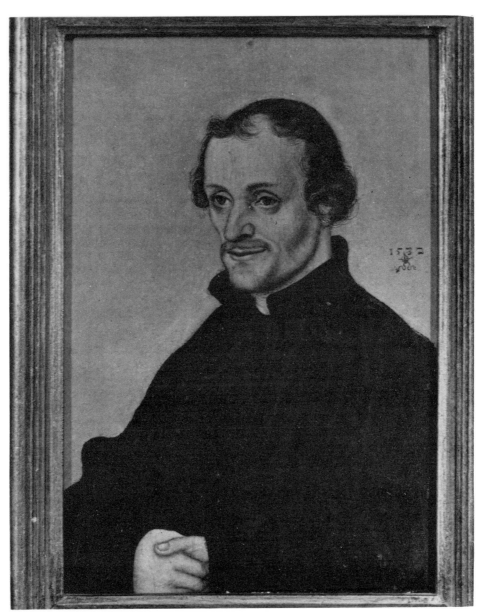

Lucas Cranach: Portrait of Melanchthon.

education, and wanted every child to be able to read and know the scriptures. One of his aims was to raise the office of teacher to a respectable profession. But his insistence on a purely religious education clashed with the main tendency of the time, the renaissance of ancient values and the humanists' desire for a broad education. Luther's educational views would have led to disaster had he not found a friend and adviser in Philipp Melanchthon (1497-1560). Melanchthon, steeped in the humanist tradition of the preceding century, was able to widen the reformer's

narrow outlook. He infused the humanist spirit into the secondary schools, reformed the universities of Saxony in an exemplary way, wrote numerous textbooks and was instrumental in introducing the first Saxon school plan (*Schulordnung*) in 1528. Melanchthon's great merit was that he blended the humanist tradition with the new Protestant drive for religious education and saved the educational principles of universal learning for Protestant Germany. He also reorganised the whole system of instruction from the elementary to the tertiary levels. For this he was acclaimed as the *praeceptor Germaniae*.

Luther's importance lay in his defence of education itself and in his tireless drive for more and better schools. He further implanted in the mind of the Germans the necessity for compulsory school attendance, comparing it with the compulsion princes imposed on their subjects to take part in wars. "With how much the more reason ought they to compel the people to keep their children in school," so as to have "preachers, lawyers, pastors, clerks, doctors, schoolmasters etc." in sufficient numbers. Of far-reaching consequence was his view that the secular authorities, as the "God-ordained" power in worldly affairs, should establish and maintain schools. This shift of responsibility was necessitated by the fact that in Protestant regions the churches and monasteries had lost their property and wealth to the states, so that an educational vacuum occurred. Luther insisted that the funds which the princes had thus acquired should be diverted to education.

Through Luther's admonitions and Melanchthon's practical achievements a feverish activity set in during the sixteenth century to reform existing schools and establish new ones, and to regulate instruction throughout the Protestant states and the many free Imperial cities that had adopted the new faith. Outstanding educators were called in as organisers.

Through its early adoption of Lutheranism and its part in the educational reforms of the sixteenth century, the Electorate of Saxony became the leading cultural power in Germany for centuries. Saxony attracted the most renowned scholars to its universities of Leipzig, Wittenberg (founded in 1502), and Jena (1556) and the best teachers to its many schools. It also became the centre of the book trade, so that Leipzig became dominant in publishing. In addition to other innovations, Saxony created a particular type of secondary boarding school, the Prince's School (*Fürstenschule*) or National School (*Landesschule*), for which pupils were selected from all parts of the country. These replaced the former monastery schools and they were designed to educate for service in the state or church the most gifted boys in the land, regardless of their social origin. Instruction and maintenance were free for these boys, for the time of their schooling and also for their subsequent university studies. Schulpforta, Meissen and Grimma were all founded by Duke Maurice of Saxony in 1543 and produced successive élites of German intellectuals until the Nazi régime abolished them after 1933. Lessing (Meissen), Klopstock, Fichte, Ranke and Nietzsche (Schulpforta) were some of their *alumni*.

But the division of Germany caused by Luther's religious rebellion created a lasting division in the field of education, with all its dire consequences and personal as well as political animosities. The large areas that remained Roman Catholic in the Rhineland, in the south and in Austria went different ways from the rest of Germany. Lacking the inspiration of the reformatory drive, education remained backward in these territories for centuries. The Jesuit Order took a strong hold on

Prince's School at Meissen, 1740.

higher education in the seventeenth and eighteenth centuries, but its programme was limited to a relatively small élite of highly intelligent students. Their colleges reached high academic standards, used comparatively advanced pedagogical methods and accepted pupils from the middle as well as the upper and aristocratic ruling classes. By 1700 the order had 612 colleges in the empire with about 180,000 students. Apart from Jesuit efforts, educational standards in the Catholic territories were low.

In the seventeenth century education also declined in Protestant areas, with orthodoxy gaining the upper hand, and rigidity and dryness prevailing everywhere. Higher education was so concentrated on Latin that "boys were forbidden, under severe penalties, to utter a word except in Latin at home, at school, or amongst their playfellows", although the Latin they did speak was execrable. The universities, although many new ones were founded, declined rapidly. The Thirty Years' War (1618-48) brought instruction virtually to a standstill. Only one teacher and eleven boys were left in Schulpforta in 1643 to celebrate sombrely the centenary of the great school which had been ravaged thirteen times by warring armies. When at last Germany awoke from the trauma at the end of the seventeenth century, a new intellectual era had dawned.

However, there was again division caused by two conflicting currents. The common target of opposition was Protestant orthodoxy, then ossified by insistence on the letter instead of the spirit of the Word, presumptuous authority and empty dogmatic formulas. Against this a religious revival arose in the Pietist movement, which stressed feeling and imagination in religious life and the individual's inner experience of God aroused by a mystical personal conversion. This religious experience had to be justified and activated by tireless social activity in the service of the materially and spiritually needy, especially among children of all classes. Almost every great writer of the eighteenth century was affected by the movement,

Halle University.

including Leibniz, Klopstock, Gellert, Lessing, Hamann, Herder, Wieland, Goethe, Pestalozzi, Novalis, and even Kant.

Leibniz, Lessing and Kant are usually considered to be representative of the other great current of the time that rejected Protestant orthodoxy: the philosophy of Enlightenment, which strove to give a rational foundation to religion, morality, justice and the whole range of intellectual life. However, there were some common denominators in Pietism and rationalism: on the negative side the common front against orthodoxy; on the positive the stress on the individual, the claim for tolerance, and an intense interest in religious life (hardly any of the German rationalists were atheists). In addition, both philosophies shared a social conscience which in the educational field inspired the institutions founded by the "Philanthropists" such as the *Philanthropin* of Johannes Basedow in Dessau (1772) and Christian Salzmann's institute at Schnepfenthal (1784).

The first confrontation of the two currents occurred in Halle, where the first King of Prussia, Frederick I, founded a university in 1694 which was destined to infuse a new spirit into academic life. Halle can be considered the first modern German university in that the principle underlying teaching was no longer that the truth is given and settled once and for all by the religious and philosophical tradition of the Church and Aristotle, but that truth has to be sought by critical examination of every phenomenon. The first two professors to be appointed were A. H. Francke as Professor of Theology and Christian Thomasius as Professor of Jurisprudence. Thomasius was the first German exponent of natural law and the

A. H. Francke.

first professor who took the revolutionary step of lecturing in German instead of in Latin. Francke, besides being a practising minister and academic teacher, devoted the greater part of his tremendous energy to building up an imposing system of interrelated schools known ever since as *Franckesche Stiftungen*. Beginning in 1695 with an orphanage and a school for the poor in his parsonage, he soon added an elementary school, a middle school for both boys and girls without academic ambitions (*Bürgerschule*), a Latin school, a college for children of the upper classes (*Pädagogium*) and a teachers' training college (*Seminarium Praeceptorum*). When Francke died in 1727 about 2,000 students were attending these schools, half of whom received free board and instruction.

Francke was, on the whole, greater as an organiser and administrator than as an educator. He certainly was no child psychologist. He granted his pupils neither vacations nor time for play, overloading them instead with religion and learning. Nothing was permitted to distract the children from God and finding "sweet pleasure of the heart in beholding our most charming Saviour". But Francke applied advanced methods of teaching through the practical application of all kinds of machinery, and had a botanical garden to give a realistic foundation to instruction. In addition he promoted instruction in German. His effect especially on the development of elementary education was far-reaching. But the Pietists gradually succumbed to bigotry and intolerance, and the initial co-operation between Francke and Thomasius (who energetically combated witches' trials and torture) in the development of the university soon ceased. When Christian Wolff (1679-1754), the great populariser and systematiser of Leibniz' enlightened philosophy, was called to Halle in 1706 he was constantly harassed by the Pietists. In 1723 they finally succeeded in extracting from the King an order for Wolff's expulsion as an atheist, a step for which Francke got on his knees and thanked God for "liberation from the great powers of darkness."

Yet Enlightenment prevailed. Like Pietism it believed in the supreme value of education, but for different reasons: not to make better Christians of the younger generation and to give it a firmer way of attaining salvation, but as the surest way to attain a rational and happy life in this world and to develop the mind for the purpose of human progress and welfare. Enlightened despots realised the possibility of using education for their own ends, for example to improve the economy of their states and to obtain better civil servants and recruits for their armies.

Frederick II's accession to the throne in 1740 heralded a shift in educational reform from Saxony to Prussia. In contrast to his father, Frederick William I, who had despised learning and sympathised with Pietism in its simplest form, Frederick was steeped in the philosophy of Enlightenment and the teaching of the French *philosophes*. Early in his reign he obtained the services of an able pedagogue, Julius Hecker (1707-68), for the reorganisation of Prussian education. A disciple of Francke, Hecker achieved a real break-through in modern German education. Extending Francke's comparatively limited attempts to introduce the realities of life into the school by way of perceptual instruction, he founded in 1747 the *ökonomisch-mathematische Realschule* in Berlin on the principle that "not mere words should be taught to the pupils, but realities, explanations being made to them from nature, from models and plans and of subjects calculated to be useful in after-school life." His was a multi-purpose school like Francke's; but its three branches, the *Deutsche Schule* (an elementary branch), the *Lateinschule* (a secondary branch) and the *Realschule* were interlocked in such a way that pupils

Frederick the Great of Prussia.

of the first two branches had to study some of the eight subjects offered in the *Realschule*. In the "Latin" school Hecker replaced Greek by French, thus anticipating the later *Realgymnasium*. The King was so interested in Hecker's experiment that he gave it the status of a Royal school (*Königliche Realschule*). Furthermore he made Hecker his adviser for the reorganisation of elementary instruction in the monarchy. Hecker was a firm believer in the state's sole responsibility for education. He was the author of the General School Regulations (*Generalschulreglement*) of 1763, the first basic school law for the whole Prussian monarchy, which paid particular attention to country schools. Its aim was to "combat harmful ignorance and to train better and more skilful subjects". The *Bible*, the catechism, Christian doctrine and scriptural knowledge were still central to all instruction, and inspections were still left to the Protestant clergy; yet the foundation of the Prussian *Volksschule* was laid here, though in Frederick's time only in a rudimentary form. The Empress Maria Theresa took a lead from these regulations in her General School Law of 1774 for all the Habsburg dominions. This was, in fact, more radical than Frederick's reforms and more consistently drafted in the spirit of Enlightenment. In it the state assumed complete control and supervision of all education on the grounds that religious corporations had failed to meet the needs of parents and of modern society. The law was rescinded after the Austrian reaction set in from 1790 onwards.

Frederick on the other hand did not provide sufficient funds for buildings and improvement of teachers' salaries; the Protestant Church found even small concessions to modern thinking execrable, and finally the Prussian nobles (the so-called *Junker*) resented any intellectual improvement in their tenants and workers. A notable exception was Friedrich Baron von Rochow (1734-1805), a remarkable philanthropist who established exemplary schools on his large estates, appointed educated teachers with an annual salary of 100 Thaler (as against the normal salary of seven to nine Thaler), and wrote a manual for teachers and textbooks, among which the *Kinderfreund* (1776) had a wide circulation in Germany and abroad and was even modified for Roman Catholic schools.

Rochow's endeavours were taken seriously by another *Junker*, Karl Baron von Zedtlitz (1731-93), a student of Immanuel Kant, who completed Frederick's reform work. In his lectures on the principles of education Kant had declared that man was educable because in contrast to animals he was destined to acquire freedom, and that he was capable of attaining humanity (*Humanität*) and developing from a person to a personality which acquires an innate autonomy to become self-reliant in freedom. Kant's dictum was that "man can become a true human being only through education". In 1771 Zedtlitz was appointed head of the Department for Church and School Affairs and became the first of a succession of capable Prussian Ministers of Education. His crowning achievement was the establishment in 1787 of a supreme schools board, the *Oberschulkollegium*. The duty of this board was to "direct and solely administer all educational institutions in the state." Zedtlitz concluded his career with the introduction in 1788 of a strict school leaving examination (the *Abitur*) to secure high qualifications for university entrance.

However deficient the reforms of Frederick the Great may have been, all the same they provided the framework for the entire development of education in the German-speaking countries during the nineteenth and early twentieth centuries. The *Realschule*, the *Realgymnasium*, the improvement of academic studies with the *Abitur* as a test, the check on church influence and the establishment of the

Oberschulkollegium as a unifying and directing force were significant landmarks. New intellectual and social forces had to come into play to give a deeper meaning to this framework.

The neo-humanist movement altered the whole concept of classical studies and widened spiritual horizons beyond the pure rationalism of the Enlightenment. Its main source in Germany was the new University of Göttingen, founded in 1737 by George II of England for his Hanoverian dominion. It led away from exclusive linguistic drill to the humane and universal values of ancient culture, and it marked the shift from Rome to Greece which J. J. Winckelmann had anticipated in his studies on Greek art. The activities of F. A. Wolf (1759-1824), whom Zedtlitz called to Halle in 1783, brought the movement to fulfilment. In his seminars, a form of teaching which he introduced, he set new standards of research and became the founder of classical—and indeed all—philology in the modern sense. He engendered enthusiasm for independent critical studies at all levels, recognising no intellectual authority without scrutiny, and he formulated a new educational ideal. Although nothing materially "useful" could be gained from classical studies, he ascribed an absolute value to them in that they achieve "through promoting a purely humane education and a heightening of all intellectual *and* irrational faculties a beautiful harmony of man's spiritual and physical energies." Wolf's exactitude and Winckelmann's imagination were the forerunners of that creative ideal of character formation through universal *Bildung* that inspired Herder, Goethe, Schiller and finally Hölderlin to see in "Hellas" the fount of all knowledge and artistic creativeness. It was foremost an aesthetic ideal infused with the liberal spirit of Enlightenment, a belief in the perfectibility of man, who can attain a fully developed personality through education and learning.

Berlin University, 1810.

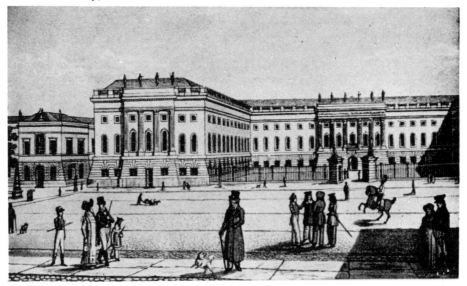

Wilhelm von Humboldt (1767-1835) gave the neo-humanist ideas their practical application. In his short spell as head of the education section of the Prussian Ministry of the Interior (1808-10) he set the course of German university and secondary education for over a century, imbuing them with the spirit of neo-humanism. With the foundation in 1810 of the University of Berlin, Humboldt established a new era of tertiary education. Its principles soon spread all over Germany and Central Europe, and influenced the form of English provincial and dominion universities and of American academic life. Strangely enough, the Prussian capital had had no university until then, and its foundation during the French occupation was considered by Humboldt as an integral part of the spiritual regeneration of the defeated nation. "At a time," he wrote to King Frederick William III on July 24, 1809, "when one part of Germany is devastated by war and another [Prussia] is dominated by a foreign language and by foreign rulers, German scholarship and learning might open a way to a freedom for which we hardly dare express hope at present." He demanded full freedom of teaching and learning for staff and students, as little interference by the state as possible, self-government by the academic body, decisive participation by the staff in the election of professors, the predominance of research for its own sake and abandonment of the idea that the university existed mainly to provide the state with civil servants, judges and members of the professions. Instead the aim was "to educate the student to inner independence and freedom". The King agreed reluctantly, and F. A. Wolf (who wrote the main preparatory memorandum), the theologian Friedrich Schleiermacher and the philosopher J. G. Fichte were among the first to be appointed, to be joined and followed by a host of eminent scholars. A new type of student developed under the discipline of the seminars and the laboratories, less rowdy and more responsible. Their old social corporations were replaced by new types of fraternities among which the *Corps* retained a feudal outlook, whereas the *Burschenschaften*, founded in 1817, strove—at that time—for liberal institutions and German political unity. However, a majority of students remained unorganised and fended for themselves after the old form of compulsory boarding in primitive hostels had been abandoned.

Of equal importance was Humboldt's reorganisation of secondary education. Its mainstay became the *Gymnasium* with a ten year (later nine year) academic course centred on classical studies and mathematics. All the subjects taught were to form an indivisible organic whole so that the "harmonious development of the mind would not be impeded." All subjects had to be studied by every student and were to be included in the *Abitur* (reformed in 1812) with the provision that "complete ignorance in any one subject" meant failure in the examination. The training of secondary teachers was divorced from church supervision and a teacher body (*Philologenstand*) was created which was highly trained academically and had to take two stiff examinations conducted by the state.

The *Gymnasium* with its strict academic discipline monopolised secondary education in Germany until the end of the First World War. Only its *Abitur* qualified for entry to the universities. Humboldt relegated all types of secondary schools with a six year curriculum run by municipalities, such as *Bürgerschulen* and *Realschulen*, to the status of elementary schools. The *Gymnasium* maintained a superior position even when the *Realgymnasium* (with Latin only and a stress on modern languages) and the *Oberrealschule* (without Latin and with a stress on modern languages and science) were established in 1882 with a nine year course,

and when their *Abitur* (from 1901) also qualified for university entrance.

Whereas the neo-humanist movement shaped the form of secondary and university education, the activities of Johann Heinrich Pestalozzi (1746-1827) vitally affected primary education. His forerunner was another great Swiss, Jean-Jacques Rousseau (1712-78). Rousseau's assumption that man is good by nature but corrupted by the evils of civilisation and society led him to the belief that only a reform ot education could improve these faulty institutions and bring out the good in man again.

Although a prolific writer, Pestalozzi was mainly concerned with the practical application of Rousseau's theories, including their social implications. Many of his writings inquire into the reasons for moral and social decay, and rebel against the excesses of the privileged classes. From the beginning Pestalozzi concentrated on the poor and underprivileged. Under the impact of Rousseau's novel of ideal education, *Emile,* and inspired by the activities of the Philanthropists, he established in 1774 a school for orphans and wayward children at Neuhoff which combined instruction with agricultural pursuits. In his quaint "novel" *Lienhard and Gertrud. A Book for the People* (1781) he laid down his "principles of the method of wise instruction for the people". At this time he still relied not only on the influence of the domestic virtues of an exemplary family but mainly on the goodwill of a feudal lord to bring about the moral conversion of a depraved village. His conservative, patriarchal attitude changed, however, during the French Revolution, and he served the Helvetian Republic (established in 1798) whose radical leaders supported his ideas and afforded him facilities for the last and largest of his institutions. This was a school for children of all classes with a teachers' training college at Yverdon (Canton Vaud), which he ran from 1805-25 and to which educators from many countries flocked to study his methods.

Pestalozzi's fundamental principles were that education must assist and not violate the course of natural development. Like Rousseau he demanded inducement to self-help and self-activity with limited assistance for the child's efforts, and he advocated the harmonious development of every faculty—the body was never to be in advance of the mind and the mind was not to be developed to the neglect of the physical and emotional powers. He paid close attention to the peculiarities and the environment of every child, so that it could be trained for its individual situation. Education was not, however, to aim at the individual alone but at his integration into the socio-political structure, which itself should be determined by legislation through the people. As for the teacher-student relationship, Pestalozzi strongly opposed the prevailing school despotism; the only principle he recognised was mutual affection. He expected teachers to make instruction so attractive that the exhilarating feeling of progress would be the children's strongest inducement to industry and good moral conduct.

Pestalozzi's impact on modern education is incalculable. In the course of the next one and a half centuries, whenever school life decayed and reformers cried out for change, they had to fall back on all or some of Pestalozzi's principles, which were often violated by state interference, social pressures or by the teachers themselves. Pestalozzi, gentle, amiable and God-fearing though he was, was a poor organiser and his successive institutions constantly suffered from economic difficulties. A host of disciples carried on his work and tried to put his house in order. Outstanding among them was Philipp Fellenberg (1771-1844) from Bern, who in his institution at Hofwyl established a self-contained and self-sufficient

"Education-State" that inspired Goethe's "Pedagogical Province" in *Wilhelm Meister's Years of Wandering* (1821; Book II, chs. 1-2, 8-9). Goethe absorbed many of Pestalozzi's principles, although his "three reverences" fundamental to all education are his own invention.

"Pestalozzism" gripped Prussia in the period of reform and regeneration and provided its leaders with the mainspring for a national education. The statesman Baron Friedrich vom Stein (1757-1831) saw in Pestalozzi's ideas the means of promoting the participation of all classes in the affairs of the nation. Humboldt sent his collaborator J. W. Süvern (1775-1829) to Yverdon. Süvern immediately began to reconstruct the elementary school system, now designated "school of the people" (*Volksschule*) on Pestalozzi's principles. For this he found enthusiastic support from the elementary teachers. Johann Gottlieb Fichte, on the other hand, ushered in an ominous new development. He met Pestalozzi in Switzerland in 1793, and embodied Pestalozzi's ideas in the blueprint for a "German national education" in his *Addresses to the German Nation* (1809). But he differed from his friend in important points. Pestalozzi had assigned the family a vital role in education as a prototype for every school organisation. His main concern was the dissemination of human warmth among children and he rejected undue interference by the state. Fichte, however, advocated separation from the family and strict institutional education from the earliest stage, organised by the state, which, "being responsible only to God and its conscience has, as guardian of all minors, the perfect right to coerce children to their salvation."

The reactionary mood which spread all over Germany after the defeat of Napoleon in 1815 brought increased bureaucratic control, although not the kind Fichte would have wished. Ludolph von Beckedorff, an influential official in the Prussian Ministry of Education, halted Süvern's efforts and maintained that "natural inequality, far from being an impediment, is the true bond of society and rather than removing it, it should be strengthened and secured." After the short-lived fresh breeze of the revolution of 1848, this tendency culminated in the infamous regulations for elementary education issued by the Prussian Ministry in 1854. These reasserted the absolute authority of a paternalistic state over every aspect of education, with the aim of eliminating the "destructive activities of an argumentative schoolteacher group." The elementary schoolmasters, however, faithful to Pestalozzi, passively resisted these directives for many years.

Meanwhile Friedrich Froebel (1782-1852) revolutionised the education of the pre-school child. Steeped in Pestalozzi's philosophy of education (he worked with him in Yverdon for several years) he was inspired by the view of the Romantics that the infant child bears in itself a close affinity to the divine order and represents the harmony of the universe, with an unspoiled oneness of body and soul, nature and spirit, imagination and premonition. Novalis' phrase "Where children are, there exists a golden age" drew Froebel's attention to the special needs of pre-school education. Fundamental to it was the cultivation of the urge to play. With great inventiveness he responded to Novalis' challenge that children's games should be regenerated. He founded a "Nursing-Play-and-Activity Institution" for infants in Blankenburg, Thuringia in 1837, the name of which he changed to *Kindergarten* in 1840. Realising that infant guidance needed professional training, he later attached to his institution, a training college for young women *and* men. *Kindergärten* soon spread all over Germany, indeed all over the world, though in 1850

Friedrich Froebel.

the Prussian Minister of Education, Karl Otto von Raumer, banned them in Prussia on the grounds that they formed "part of a socialistic system calculated to inculcate atheism in youth." The ban lasted for ten years.

Froebel's *Kindergarten* provided the basis of the German elementary school system. In spite of various impediments, educational standards rose and illiteracy was virtually wiped out (0.5% as against 1% in Britain and 4% in France in 1900). Whereas in 1849 the King of Prussia dressed down a large teachers' meeting one year after the revolution with the words: "All last year's misery was your fault, the fault of your false education by which you destroyed the faith and loyalty of my subjects and turned their hearts away from me," twenty years later the German elementary schoolmaster was credited with having beaten the Austrians in 1866 and the French in 1870. Whatever truth there may have been in these

startling and contrasting statements, the schoolmaster received some relief in the seventies during the ministry of Adalbert Falk, who liberalised curricula and teacher training, improved the material conditions of the badly paid teachers, and introduced state inspection in the place of supervision by the churches. However, his intention to deconfessionalise the elementary schools failed, because Bismarck made use of this liberalisation in his struggle with the Roman Catholic church. When Bismarck backed out of the *Kulturkampf* in 1879, Falk also had to go, though much remained to be done. The south German states were now ahead of Prussia in many respects, especially in introducing mixed denominational schools.

The secondary schools suffered politically less than the elementary schools because they had been secularised by Humboldt, and the majority of teachers were conservative and adopted a non-political position in their academic ivory towers. Hegel's dislike of Rousseau and Pestalozzi, and his ridicule of the "pampering" of the "childish" and the spontaneous in youth, spelt retrogression. For him, education was to integrate man into the objective spirit and its representative on earth, the state. His theory of "general education" perverted Humboldt's idea of "universal education". Classical studies retained their dominance but became formalised, and new subjects were added indiscriminately in a manner alien to Humboldt's vision of an integrated curriculum. The effect was an ever-expanding timetable, overwork and physical underdevelopment.

A chorus of indignation against these deficiencies arose in the last quarter of the nineteenth century. The first clarion call came from Friedrich Nietzsche in his lectures on *The Future of our Educational Institutions*, delivered in Basle in 1872. Speaking from experience in Schulpforta, he accused the *Gymnasium* of providing only formal instruction and preparing for erudition rather than for life. These schools developed only the intellect, he said, not the whole man, and led to mediocrity, not to originality and creativeness. He also extended his criticism to the universities. Nietzsche claimed, grossly exaggerating, that the professors were engaged in irrelevant research and "totally neglected their students". The whole nation, he maintained, was ridden with "cultural philistines" who foisted a surfeit of knowledge on it and overstressed the relevance of history, instead of freeing the mind for the present and the future. He derided the urge to emancipate the masses by giving them equal opportunities and advocated a return to the "aristocracy of the mind" and concentration on training only the best and the fittest for leadership. Whereas Nietzsche still considered the civilisation of Greece—if properly understood—the most valuable model for moulding an integrated personality, most other protesters regarded the preponderance of classical studies as the root of all evils in higher education. According to them these studies resulted in a one-sided cultivation of the intellect and prevented the growth of a full personality.

The debate for or against the classical *Gymnasium* raged right through the Imperial period. The noisiest of the hostile groups used all means of demagogic agitation under the leadership of the fiercely nationalist journalist Friedrich Lange (1852-1918) who founded the "League for School Reform" (*Verein für Schulreform*) in 1890. The supporters of classical values rallied a year later in the "Society for the Protection of the Gymnasium" (*Gymnasialverein*) which included among its members renowned scholars in many fields, most of them of liberal persuasion. However, the Kaiser, when summoning a national school conference

in 1890, sided with the League. Looking back at his own school days at the *Gymnasium* in Kassel, he summarily denounced this "ossified and spiritually most killing of all systems". In his speech of 4 December 1890 he coined the slogan: "We do not want to educate young Greeks and Romans, but young Germans." His address contained a number of reasonable points, but on the whole it had a nationalistic ring and unblushingly revealed the political tendencies behind it. The aim of higher education as he saw it was to counter the "false doctrines" of socialism. "I am looking for soldiers," he said, and to produce the proper species, the secondary school was "to lend all its support to Germanism (*Deutschtum*) and the newly created Empire."

The practical reforms subsequently introduced in 1892 and 1901 were in many respects beneficial. They included reduction of teaching periods, increase of physical training, German studies and history (albeit the latter to serve the fight against socialism) at the expense of classical studies, and equality of the three forms of secondary education with regard to admission to the universities. Some progress was even made in the availability of higher education to girls, though more slowly in Prussia than in the south German states. The first *Gymnasium* for girls was established in Karlsruhe in 1893, and in 1896 the Duchy of Baden, always the most progressive state in Germany, was the first to open its universities to women, soon followed by Bavaria. Up to the revolution of 1918, Prussia only permitted women to be "guests" at lectures subject to the approval of the professor. Whatever progress was made before the First World War, it was marred in the greater part of the Empire by an increasing politicisation of the educational system in the direction of an overheated nationalism, which sprang from the establishment's fear that its position and privileges were threatened by the rising socialist movement.

In these circumstances advanced educational thought developed outside Prussia in privately run pioneer schools. Among the truly original German educators was Georg Kerschensteiner (1854-1932), a Bavarian. He revived the spirit of Pestalozzi and permeated it with the results of modern child and youth psychology. At the same time he displayed a down-to-earth educational realism. Thoroughly trained in educational practice as a primary and secondary school teacher, municipal school inspector for twenty-five years and finally, though not until after the revolution of 1918, professor of education at Munich University, he regarded the fact that every child's destiny lay in its vocational future as the governing principle of his educational philosophy. He therefore believed that education should be concerned with the guidance of the individual child towards the best possible fulfilment of his vocation in life and towards devotion to the community. The school has a threefold task: training for a vocation, evolving the moral foundations for every vocation, and moral improvement of the community within which the teaching is practised. The means of achieving these tasks was the "activity school" (*Arbeits-schule*). As the "school of the future" it was meant to replace the prevailing *Lernschule*, which was considered to be a mechanical knowledge factory. The *Arbeitsschule* is not a type of school but an instructional method that "releases in the child, with a minimum of factual knowledge, a maximum of skills, talents, and joy for work in the service of the community." Kerschensteiner saw the educational process essentially as education for citizenship, which had to permeate every subject taught. In addition he created civics as a distinct subject, giving it the still current name of *Staatsbürgerkunde*.

Hugo Gaudig (1860-1923), teaching in Saxony, refined Kerschensteiner's methods through his concept of "activity-instruction" (*Arbeitsunterricht*) which the teacher applies to any kind of mental pursuit by arousing voluntary, spontaneous and independent activity in the pupil. Every achievement is accomplished by the pupil himself, although he has to work according to a defined plan in four stages.

Kerschensteiner's and Gaudig's concepts were brought to fruition in a number of experimental country boarding schools (*Landerziehungsheime*). After the days of the Philanthropists and Pestalozzi, independent boarding schools had been almost unknown in Germany. Even the surviving great boarding schools of the seventeenth century, like Schulpforta, were state-run. Therefore the establishment of a private foundation by Hermann Lietz (1868-1919) at Ilsenburg in the Harz Mountains in 1898 (followed by three further schools later on) constituted a new departure. Lietz' model was the English public school, in particular the New School at Abbotsholme near Derby, founded by Cecil Reddie in 1889, where Lietz worked as an assistant master for a time. He infused into his own schools the spirit and aims of the German Youth Movement, which gathered momentum at the end of the century. This movement rebelled against dependence on the older generation and against the excesses of industrialisation and of big city civilisation. It advocated the formation of free communities where young people could live their own lives independently. Rousseau's cry of "Back to Nature" was taken literally as the solution to the ills of the time. Hiking (the groups called themselves *Wandervögel*), cultivation of folk music and folk dancing, simple dress and a simple life were their means of expressing their separate individualities. All this was reflected in Lietz' experimental schools, where formal instruction was only part of the educational process. Of equal importance were practical activities such as agricultural work, handicraft work, games, music, and art education. A close relationship between teachers and pupils was achieved by the establishment of family-like groups living together in special quarters (like the "house" system of the English public schools), discussions and the general application of the self-activity method.

Two masters associated with Lietz left him because of his increasingly authoritarian and nationalistic outlook and established their own country boarding schools: Gustav Wyneken (1875-1964), who founded a "Free School-Community" in Wickersdorf (Thuringia) in 1906, and Paul Geheeb, who established the Odenwald School (Hesse) in the hills above the Rhine in 1910. Both Wyneken and Geheeb had a wider outlook and a more liberal, even radical, attitude than Lietz. Their philosophy of education differed in some respects, Geheeb emphasising the autonomy of the individual, Wyneken looking beyond mere individualism to engendering an "objective consciousness". But both broke new ground in many respects. Both introduced co-education in their schools, a novelty in the history of German education. Wyneken developed pupil participation in the government of his school. His "free school-community" was built on equal partnership between teachers and pupils with the concept of a common fellowship in a creative society. Geheeb created a unified school system in which no barriers existed between primary and higher education by building up an integrated curriculum from the elementary to the academic school-leaving level. This concept of *Einheitsschule* had first been mooted by teachers during the 1848 revolution and was succinctly defined by Johannes Tews (1860-1932) as bringing "the whole field of public instruction from the *Kindergarten* to the university with all its ramifications and affiliations into a vital relationship which unites all single parts to the whole." It was an explosive

issue because of the deep rift that had developed during the nineteenth century between the elementary and the academic teachers' bodies. This division had serious political implications, since the elementary teachers tended towards the left, the academic teachers, proclaiming themselves a separate profession, leaning towards the right. A unified school system implied a unified teaching profession. This was then demanded by the Elementary Teachers' Association in 1914 with the aim "of eliminating every social and denominational division."

The educational experiments carried out by the independent private schools exercised an influence on the further advancement of German education that was quite out of proportion to their numbers. The establishment of a democratic Republic after the fall of the Empire late in 1918 provided the opportunity for a thorough overhaul of the educational system. Among the many theories that clamoured for practical application the one devised by Paul Oestreich deserves attention. He proposed a thorough democratic reform on Marxist lines, though politically he occupied an independent position on the left. His instrument was the *Bund entschiedener Schulreformer*, the "League of Resolute School Reformers". Although influenced by earlier reformers as well as the Youth Movement, he was closer to Kerschensteiner and turned away from emphasis on the individual to the needs of society in order to bridge the alienation of man from his social environment and from his work. He linked education to the development of personality with an objective social ideal: the transition from "capitalist civilisation to co-operative culture". He pushed Kerschensteiner's concept of *Arbeitsschule* a stage further and transformed it into the "Productivity School", adopting Karl Marx's demand that the child should take an active part in productive work for the public good from the age of nine onwards. For Oestreich the aim of the "Productivity School" was to achieve the "totality of personality in the totality of society." His close collaborator Siegfried Kawerau defined its function as educating pupils "to a sense of responsibility, to productive and also economically productive activity through development of special talents in each child within the framework of society." Experimental schools of the League were the Scharfenberg Farm School in the countryside near Berlin and the municipal school in the proletarian suburb of Berlin-Neukölln, where Fritz Karsen as headmaster from 1921 to 1933 organised the model of an *Einheitsschule* from *Kindergarten* to *Abitur* with extended self-government by the 2,000 pupils.

However, the hopes for an integrated new educational system for the whole nation were not fulfilled. The Constitution for the Republic, adopted in Weimar in 1919, again left the responsibility for education to the individual states, thus excluding a comprehensive solution. The Constitution did stipulate some principles which were meant to be obligatory for the whole of Weimar Germany and echoed the demands of the reformers like "an organic educational ladder" for all children from the age of six to eighteen, participation of pupils and parents in school government, application of the method of *Arbeitsunterricht*, and elementary teacher training on an academic level. But the only Federal law enacted was the Foundation-School-Law of 1920, according to which every child in the whole of the Republic had to have the same instruction during the first four years of its school career in a public primary school called a Foundation School (*Grundschule*). Otherwise the nature of legislation depended on the momentary political complexion of each state. In Prussia Wyneken worked in the Ministry of Education for a short time,

but the dominant personality during the period of the Republic was Carl Heinrich Becker (1876-1933), the most impressive Minister of Education since Humboldt. Like him Becker was guided by far-sighted liberal principles and was as frequently frustrated. His lasting achievement was the Pedagogic Academies for the training of elementary teachers, which raised their academic as well as their social standing. Becker's greatest failure was his inability to carry through the reorganisation of the universities which he realised was urgently needed. He foundered on the rocks of the conservatism of most of the professors and the virulent nationalism of the students, especially those organised in fraternities. To both groups he was suspect as a democrat and liberal. These groups reflected the unrelenting hostility towards the Republic of the agrarians in eastern Germany, the industrialists of the western areas, and the officers' corps, as well as the many disillusioned ex-soldiers. All held the leaders of the Republic responsible for Germany's defeat and regarded democracy as an alien imposition. Whereas the older generation longed for the return of the old order, the younger generation adopted a kind of nationalism that seemed the fount of spiritual regeneration. The young nationalists hoped for a rebirth of the nation and a better society that would eliminate the excesses of the capitalist system, in short for a national socialism in a wider sense.

The new nationalism that pinned its faith in the mystique of the *Volk* and the superior quality of German culture was not new in educational thought. In the universities a swing from liberal thinking, especially among the students, had occurred in the 1870s under the influence of the historian Heinrich von Treitschke. In 1898 Friedrich Lange, the vociferous leader of the school reform movement, published a book entitled *Deutschtum* (Germanhood). This contains all the ingredients of the National Socialist doctrine of Hitler's party, which overthrew the Weimar Republic in 1933.

In his "principles of education in a race-conscious state" as set out in *Mein Kampf*, Hitler gave the "development of a thoroughly healthy and pure-blooded body" first place. Next came character formation to produce loyalty, silent obedience to authority and joy in responsibility as the supreme virtues. The development of will-power, strength of mind and military prowess acquired through physical training and hero worship followed, while ordinary instruction came last in his scale of educational values. According to Hitler, 95% of the knowledge that had been imparted to children hitherto was useless; the pupil should be taught only what is of positive benefit to him and the community. Research in universities was to be directed towards strengthening national pride, and educators at all stages had to "burn into the hearts and brains of their charges a sense of and a feeling for race and the purity of blood."

In accordance with these principles the Nazi régime made sweeping changes in the educational system of Germany and later of Austria and other annexed territories. Education was centralised under a National Ministry of Education which was headed throughout the period by Bernhard Rust (1883-1946), a former secondary schoolmaster and a rather unremarkable man. School administration was streamlined on a command system, and the *Führer*-principle was extended to every institution: all self-government and participation of students or parents, including the autonomy of the universities, was abolished and all authority vested in the headmaster or, in the universities, in the *Rektor* (Vice-Chancellor) who was appointed by the Minister. The unified school idea was adopted in principle. The

régime valued the elementary school more than the secondary school because it was free from intellectualism, because children could be more easily indoctrinated at an early impressionable age, and because they were allegedly closer to reality and—in the country—to the soil. The secondary system was simplified and its duration shortened by one year. The *Deutsche Oberschule* was made the focus of secondary education with German literature, history and culture as its core subjects; the *Gymnasium* was relegated to a minor place. All independent private schools were disbanded. In their place state boarding schools of a different type were established, run by the SS or Nazi Party, for a select élite destined, after thorough indoctrination, to become civil servants, party officials and highly-placed members of the professions. The training of teachers was down-graded in both elementary and secondary groups and was preceded by Labour Service and a special indoctrination course. The division of the two groups of teachers was eliminated by declaring the National Socialist Teachers' League (*Nationalsozialistischer Lehrerbund*) the only body to represent the whole of the teachers' profession.

Curricula and textbooks were reshaped in accordance with the official *Weltanschauung* proclaimed by state and party, although the majority of textbooks issued under the Republic, and indeed under the Empire, had already had a highly nationalistic slant. In order to create a homogeneous teachers' body submissive to Nazi doctrine, mass dismissals took place; first, of teachers with Jewish or even quarter-Jewish ancestry, or with a "non-Aryan" wife, and then of anyone who had democratic or socialist leanings. Hardest hit in this respect were the universities where, by 1939, almost half of all teaching positions had changed hands.

In spite of its comprehensiveness, the National Socialist educational system was not as monolithic as it appeared. Interference from extraneous bodies such as the Nazi Party, the teachers' organisations, the Hitler Youth and the Nazi Students' League, which all claimed a say in the educational process, resulted in confusion. There was also resistance, even if it was passive rather than active. The only public act of resistance ended in tragedy. After the disaster of the battle of Stalingrad two students, Hans Scholl and his sister Sophie, distributed leaflets in the University of Munich in February 1943 denouncing the régime and inciting their fellow-students to rebel. A clandestine organisation, "The White Rose", was unearthed and the Scholls, four other students and Kurt Huber, Professor of Philosophy, were executed for high treason.

Two years later, when the Nazi régime collapsed and left Germany in ruins, education had come to a standstill. The material difficulties to restart education were enormous. School buildings and basic supplies were lacking, textbooks were unusable for ideological reasons, libraries had been destroyed, and personnel was inefficient and liable to "denazification". The occupying powers, however divided among themselves, proclaimed as their common aim the "re-education" of the German people towards democracy through a genuinely democratic educational system.

When a new Germany finally emerged in 1949, it was divided into two states opposed to one another ideologically as well as socio-economically: the Federal Republic of Germany, or *Bundesrepublik*, a democracy on western lines, and the German Democratic Republic (D.D.R.), a "people's democracy" on Soviet lines. Accordingly, entirely different principles underlay the reorganisation of education

in the two Germanies. The D.D.R. fell back on the more radical theories and practices of the previous German reform movements, such as Kerschensteiner's vocational and Oestreich's "productivity" school, and merged them with Marxist-Leninist pedagogy, according to which a total change has to be effected in man by awakening in him consciousness of the conditions for a socialist society.

The Education Law of 1965 constitutes the latest effort so far in building up an all-embracing unified socialist school system. It introduced an "all-round-educating polytechnical Upper School" (*allgemeinbildende polytechnische Oberschule*) of ten years' duration which is compulsory for every child between the ages of seven and sixteen, preceded by crèches (age one to three) and *Kindergärten* (four to six). Instruction is permeated with the "polytechnical" method which keeps the students close to the "workshop" (one day a week is entirely devoted to this) and introduces them to the principles and practice of "socialist production". This method is also applied to tertiary education. According to the law of 1965 the universities and institutions of equal rank have to produce "highly qualified personalities with a socialist consciousness who are capable of penetrating the processes of production, culture and other sectors of the socialist society with the results of the latest research and who are prepared to accept positions of responsibility in these fields" (§52). Superficially there are some similarities between the educational organisation of the D.D.R. and the Nazi régime: strict centralisation, interference by bodies such as the Socialist Unity Party and the Free German Youth, strict separation of state and church, authoritarian methods of institutional administration with little scope for autonomy, ideological indoctrination and the claim of the state to dominate and mould the total personality. Yet there are features in this system which are forward-looking, and experiments are being conducted which, when shorn of their ideological contents, are interesting. Whereas the radical realisation of the *Einheitsschule* may raise the standard of primary education, the reduction of academic training may well have detrimental results.

The Federal Republic with its pluralist society took a different course and remained more traditional than the D.D.R. On the whole it returned to Weimar. But because a democratic and republican order is now accepted by an overwhelming majority of the people, many unsatisfactory features of the Weimar system have disappeared. Educational legislation has once more been returned to the ten individual states. The difficulties caused by this fragmentation are partly overcome by a Permanent Standing Committee of the Ministers of Education and another of the Rectors of all the universities. Both committees have a unifying effect in practical matters such as administration, recognition of examinations, mobility and standardisation of curricula. In addition the Constitution ("Basic Law") of 1949 imposes certain common rules on all states and leaves room for legislation on a federal level. In spite of these unifying tendencies there is still considerable educational variation. However, the need for an all-embracing integrated school system is seen more and more as an urgent necessity. The "polytechnical" method has been under discussion, and was adopted in principle by the Standing Committee of Ministers in 1960 and again recommended by the Council for Education (*Deutscher Bildungsrat*) early in 1970 as necessary for coping with the magnitude of recent social and technological changes. It implies the creation of comprehensive schools (*Gesamtschulen*) in which the different levels, primary, technical-vocational, and secondary, are under one roof, administered by a single Directorate and providing all available facilities including

The **Bergstrasse** *community school near Darmstadt, 1954.*

a library, laboratories, excursions, musical instruction, choir, orchestra, festive occasions and contact with practical work through workshops for all grades and levels. British and American models as well as the "polytechnical" system introduced in the D.D.R. have influenced the concept, and intensive discussion is taking place at present as to the merits and demerits of the idea.

The Standing Committee of Ministers has also been instrumental in promoting education for citizenship. This is a constant concern of the authorities and the public in order to avoid the re-awakening of the kind of nationalism which frustrated the efforts of the Weimar Republic. The Committee's directives of 1950 stated that political education is a vital part of education in all types of schools, including the tertiary level. Besides being an independent subject it is to permeate all social science and humanities subjects and develop a sense of public responsibility, tolerance, sympathy and empathy for fellow human beings by being practised in various forms of activities such as student self-government, free debates, parents' participation, visits to public institutions and economic enterprises, and student and teacher exchange with foreign countries. These activities are practised on a large scale all over the Federal Republic.

The situation in the Federal Republic is in constant flux, with the realisation that a great many deficiencies prevail. Interesting experiments are conducted in many places, often on the model of British and American theory and practice; on the other hand there is also a good deal of stagnation. The situation is worst in the universities, where adjustment has been delayed for a quarter of a century. Students' revolts have also played havoc with normal teaching and examination processes, a situation which was not improved by repressive legislation on the part of several federal states such as Bavaria and Baden-Württemberg in 1969. Bodies like the Conference of Rectors and the Council for Science and Learning (Wissen-schaftsrat) have produced model reform plans, but the insistence on autonomy by

individual universities has so far prevented decisive progress. It remains to be seen whether the determination expressed by the government of Willy Brandt to legislate on a federal level for school and university reform and for greater uniformity in education will succeed. In his policy speech of October 1969 the Chancellor announced a long-term "clear cut and rational" educational plan and a national educational budget, to be submitted to the federal as well as the state parliaments, which would co-ordinate the four principal sectors of the educational system: schools, universities, vocational training and adult education. With regard to tertiary education he promised effective proposals to remove the "obsolete hierarchical structure" of the universities and of research institutions. The main principles underlying Brandt's plans were expressed as follows:

> Education policy can no longer be regarded as applying to each level of education separately. School education, vocational training and research must be seen as a whole, as a global system which takes into account both the right of every citizen to a general education and society's need for as many highly qualified specialists as possible and for the highest results in research.

In conclusion, the main positive features of the German educational tradition have been a tendency to provide a solid education in the primary field and, since Luther, to provide this for all children of the nation as a responsibility of the state (an ideal which was fulfilled in the nineteenth century), and to provide a high standard of knowledge in the secondary schools and excellence of teaching and research on the tertiary level. On the negative side have been the strict separation between primary and secondary education, the latter open to comparatively few children, and the development of two opposed teachers' professions. This situation together with the insistence of the churches, in particular the Roman Catholic Church, on state denominational elementary schools, and the tendency of the universities to isolate themselves from the main stream of the nation's development still prevails in large parts of western Germany, but is being challenged.

The history of German education over the centuries has been a succession of reforms and stagnation which, one can well say, is an inexorable law of the history of education all over the world. The fundamental factors of all education are the educator's understanding of the psychological structure and the needs of the child, the educator's love for the child and his desire to bring out the best and most creative qualities in the child and student in a spirit of mutual affection and co-operation. The most thorough and convincing school reform is bound to fail if the teacher does not possess or apply these qualities; if he does possess and apply them he will always be a source of ferment and stimulus even in times of stagnation.

Scientists: Problems and Theories

Ilse Rosenthal-Schneider

In our time of specialisation in all fields it is not easy to realise that unification of all the special sciences into science as a whole, as a unity, is nevertheless possible, if science is understood in the broadest sense like the Latin *scientia,* the French *science* or the German *Wissenschaft.* This unity is based on the method, the spirit, and the aim of science and for all the natural sciences also on their subject-matter, which is the universe we live in. This universe is given to the scientist in its uniqueness. He is restricted in his creative power by the phenomena of nature, by facts with which his findings have to be in accordance, and therefore experience (observation and experiment) plays a decisive role in his method. Experience is and remains the high court of appeal.

Each problem which may be looked at as today's cross-section of the whole development of the problem has to be studied with all its interrelations in its own sphere and also in other branches of science. In the solution of problems, findings in a completely different field have often proved of importance as complementing, verifying or falsifying a scientific theory. This interdependence is one of the reasons why it is not easy to select the great scientists of only one branch of science, one epoch or one country.

According to Aristotle, a sense of wonder aroused by observation of continual and often periodical changes in natural phenomena led in ancient times to the beginnings of philosophy and science, which were identical. Then and for many centuries afterwards a single personality could be regarded as the representative of the spirit of his age and its scientific ideas. In medieval times this was still possible, and an almost encyclopaedic knowledge and a comprehensive approach in an outstanding man were not unusual. However, this became less and less common and today all-embracing knowledge has become impossible.

Among the representatives of early German science is the Dominican Albertus Magnus of Cologne (1206-80), credited with having contributed a great deal to contemporary knowledge in various subjects, not only in astronomy, which was then extremely popular, but also in botany, zoology, geography, medicine and embryology. All his scientific writings were interspersed with and still partly dominated by Aristotelian, Neoplatonic, Jewish and Arabian philosophies and the religious dogmas of waning medieval Scholasticism. In the further development of

"theological embryology" as it was called, the question of individualisation was of supreme importance. At exactly what moment does the soul enter the embryo so that it can be regarded as an individual? Such problems are frequently discussed even today. The most famous of Albertus' pupils was Saint Thomas Aquinas.

The first great scientific writer in the German language was Conrad of Megenberg, a Bavarian, also called Conradus de Monte Puellarum (1309-74). His most important scientific works were the *Deutsche Sphaera* and *Das Buch der Natur*. The *Sphaera*, a free translation of Sacrobosco's *Sphaera Mundi*, is the first astronomical and physical textbook in the German language. It was apparently not very popular, whereas the *Buch der Natur* gained wide circulation—in one Munich library alone there are seventeen manuscripts and six Augsburg incunabula. Sarton thinks that Germans interested in astronomy preferred to read the *Sphaera* in Latin, while the non-Latin speaking Germans were not interested in astronomy, however great their astrological curiosity might have been. *Das Buch der Natur* deals with human anatomy and physiology, astronomy and meteorology including rainbows, thunderstorms and earthquakes (which Conrad thought caused the plague), plus all sorts of animals, trees, herbs and precious stones. He includes some stories full of superstition about magnetism. It is of interest that in many of the natural phenomena he describes he sees the possibility of using plants or stones for medical purposes.

In these early works we may see the beginning in Germany of botany, physics, zoology, chemistry, geology, and even biology as sciences.

In mathematics there were some prominent figures in the medieval period, for instance Albert of Saxony, who wrote a commentary on Sacrobosco's *Sphaera*. Like most mathematicians at that time he was connected with the University of Vienna, and was named as its founder and first Rector in 1366. All these mathematicians were dealing mainly with geometrical problems and with astronomy, chiefly, however, because of their interest in astrology which, after all, provided a mathematician's main source of livelihood. They often earned a good deal by casting private horoscopes in cities like Erfurt, Glogau and Frankfurt. Some of the mathematicians prepared ephemerides (astronomical almanacs) and wrote astronomical treatises; most of them studied the Greek authors in Latin after retranslation from the Arabic. For a long period this detour was the usual way that secular knowledge reached western Europe.

The Swiss doctor von Hohenheim was more independent in his work. As a teacher of medicine in Basle he was known as Bombastus Theophrastus Paracelsus (*c*. 1490-1541). He did not rely on the authority of Galen or Avicenna as physicians at that time usually did, but formed his own views according to his personal observations. This was also the advice he gave to all physicians. His followers are reported to have used chemical drugs in their medical practice. Dampier suggests: "Doubtless they killed many patients, but, in doing so, at any rate, they made experiments. They discovered a number of drugs which proved to be of value."

A completely new scientific outlook was brought about through the revolutionary work of the astronomer and mathematician Copernicus (1473-1543), who had a Polish father and a German mother and was born at Thorn in Prussia. He was a philosophically minded, mathematically gifted and deeply religious man. His aim was to explain the motions of celestial bodies by a system of greater "simplicity" than the then generally accepted ideas of Ptolemy. In his *De Revolutionibus* (the publisher added *Orbium Celestium* to the title), Copernicus introduced a heliocentric system

(as had been suggested by Aristarchos in the 3rd century B.C.) and thus got rid of the cumbrous epicycles of Ptolemy's *Almagest*. He assumed concentric circles for the planets, including the Earth, moving in cycles around the Sun in the centre. Copernicus probably felt that his theory had to be defended against the church, scientists and generally against common sense, for he had deprived the Earth of its central motionless position within the universe. This may have been the reason why he held his book back until the year of his death. His lasting achievement was that he provided a comprehensive heliocentric system of reference which has been used ever since and which solved astronomical problems in a "simpler" way than Ptolemy's theory. "Simplicity" has been an all-important concept in science from Copernicus to Einstein, who stressed its significance when he described how he arrived at the formulation of his theory. Simplicity does not mean mathematically easier equations, but rather a paucity of logically independent hypotheses.

Another great scientist to whom astronomy owes many of its basic findings is Kepler (1571-1630). He had joined the astronomer Tycho de Brahe, whose accurately recorded observations of the planetary motions were invaluable material for him. On these and on Copernicus' work he based his calculations, through which he succeeded in establishing his three famous laws for the motions of the planets. Kepler tried several mathematical formulations before arriving at the final one, which had to agree with all known facts, in this case with Tycho's records. His method of starting from general principles and trying various mathematical formulations to fit the observations may be called a typical German approach. Underlying Copernicus' and Kepler's endeavour in the "search for truth" was the desire for simplicity, harmony and beauty. A certain mysticism inherent in Kepler's attempt at finding "ultimate causes" reminds us of Pythagorean and Platonic ideas of perfect harmony; for example, he identified the Sun with the "real cause" of the planetary motions and with God the Father. Moreover, although he expressed the planetary motions in mathematical terms, he did not reject astrology as a pseudo-science and in fact worked as an astrologer.

Copernicus and Kepler were both deeply religious men, as was another great German scientist, philosopher, mathematician and jurist, Leibniz (1646-1716). His religious attitude is of paramount importance in his philosophy, determining its approach, and is also felt in all his other activities. Leibniz invented the differential calculus independently of Newton, using a symbolism which is still used today and which has proved an invaluable tool for mathematics and physics. The importance of a suitable symbolism, a clear and consistent notation for mathematics and for science, cannot be overestimated, and it is essential for scientific progress. It has been claimed that before investigating any special part of our universe a German would often try to build up a complete metaphysical system for the whole and, if possible, a theory of basic import with a special symbolism. This was certainly done by Leibniz. Whether anyone today would be willing to follow him in his metaphysics of "monads" and "pre-established harmony" is more than doubtful, but there is no doubt about the importance of his mathematics and physics. Leibniz had interesting ideas on physics, for instance the definitions and explanations of physical concepts like density, resistance, change of direction on impact and so on, which he set out in his *Nouveaux Essais* and the *Théodicée*. All his interpretations of these concepts are on the one hand quite advanced when compared with modern views, on the other hand they are interpenetrated with his metaphysical ideas.

As a personality Leibniz is highly interesting in his many-sidedness, his almost

Leibniz's design for a calculating machine.

encyclopaedic knowledge and his universality. He may have overestimated the possi-
bilities of pure logic, for instance when he claimed that the whole of mathematics
can be built up by pure logic. He himself did not do this, but when he introduced
differential calculus, he made use of the "constructive" method using visualisation
(*Anschauung*), even drawing a graph when he regarded this as helpful. Besides all
his other achievements, he was also interested in practical issues; for instance he
invented a calculating machine which may be regarded as the ancestor of all modern
computers.

 Not only in the early days of German science do we find a religious attitude to
life. In our century Planck, Einstein and von Laue show the same approach, of
course without the mystical element or the metaphysical systematisation that Leibniz
gave in his philosophy of the pre-established harmony. In spite of the widely held
idea that science and religion are incompatible, we find what Einstein called "cosmic

religion" in his works and in Planck's and von Laue's writings.

Theoretically German science had become independent of religion, particularly of theology, through the work of Kant (1724-1804), whose investigations drew a clear line between human understanding and faith. He himself had considerable scientific achievements to his credit, for instance the nebular hypothesis in astronomy (1755). His astronomical results were rejected for some time but seem to have been partly taken up again recently. His philosophy, especially his space-time theory, has often been regarded as contradicted by Einstein's relativity theory. This is not correct, however. Kant based his ideas on the mathematics and science of his age, mainly on Newton's physics. In 1786 he stated that natural sciences are "science" *(Wissenschaft)* only to the extent that they contain mathematics. What we call the philosophy of science today was initiated by Kant's fundamental work, whether scientists admit it or not. Modern epistemology, the theory of knowledge, is unthinkable without Kant's analysis of the basic conditions of experience and of thinking.

The development of mathematics and the natural sciences culminated in the nineteenth century in the work of a number of prominent scholars. The illustrious mathematicians Gauss in 1827 and Riemann in 1854 published some highly abstract work that their contemporaries might well have regarded as abstruse and of purely theoretical interest only. However, it proved to be most useful for the mathematical formulation of Einstein's theory. In contrast to ordinary Cartesian co-ordinates which may be used only in a Euclidean continuum, Gauss' co-ordinates may be used also in a non-Euclidean continuum if sufficiently small parts may be regarded as Euclidean. Gaussian co-ordinate systems may be used for the formulation of the laws of nature and are used in the general theory of relativity. Riemann's work deals with "the hypotheses on which geometry is based". The notion of curvature plays an important part in all non-Euclidean geometries, also in Riemann's.

By the middle of the nineteenth century the main principle of science, the principle of the conservation of energy, had been established. Mayer, a ship's doctor, started from his observation of the bright red colour of the venous blood of his patients in the tropics. Since he was familiar with the effects of combustion and oxidation, he formed the theory (published in 1842) that heat can be converted into work and work into heat. Through abstract thinking stimulated by observation, he had arrived at the correct conclusion—again the typical approach. He was severely criticised for "philosophising" and "speculating" until he could verify his theoretical conclusions. He then did this and was the first to calculate the mechanical equivalent of heat. Only years later was his work generally accepted as ranking with Lavoisier's principle of Conservation of Matter as the principle of Conservation of Energy (then called Force).

Helmholtz (1821-94) elaborated Mayer's findings and applied the idea of quantitative conservation of force to all phenomena in nature, a goal which Mayer had suggested but not accomplished. Helmholtz (who also started as a physician), perhaps owes his continuing influence mainly to his *Physiological Optics* and *Physiological Acoustics*. His work in physics, mathematics, philosophy and anatomy testifies to his great originality, and his inventions, for instance the ophthalmoscope, show that he did not neglect practical usefulness. But he held that "he who in the cultivation of science aims at immediate practical usefulness may be pretty sure that he will miss his aim".

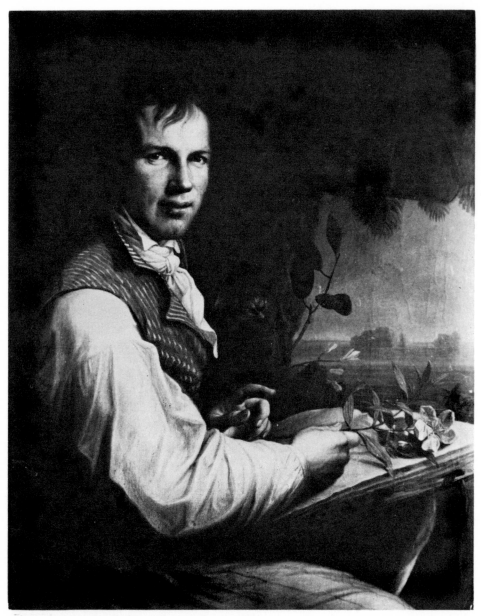

Alexander von Humboldt on The Orinoco, 1806.

Alexander von Humboldt (1769-1859) showed a similar diversity of scientific interests and activities with a very different approach to his many and various subjects of investigation. His monumental work *Kosmos*, on which he worked for fifty years, is a minutely detailed description of all the observable phenomena of nature that he was able to study on his very extensive journeys around the world. His work was a study concerning facts and relations between facts, whether they involved

currents of the oceans, the surface of the moon, earthquakes or problems of geology, astronomy, geography, meteorology, plant and animal distribution or even ethnology. He mapped the surface of the earth with respect to isobaric lines and isochimal lines, etc., compared the various climates and described magnetic storms for the first time. Humboldt attempted a comprehensive morphological world picture not only describing individual facts, but connecting them to a unity, a whole. Apart from this main goal he also worked as an experimenter. He has, for instance, been credited with having described as early as 1797 electrolytic decomposition in a cell with zinc and silver electrodes and water.

Men like Helmholtz or Humboldt represent a sort of universality that soon became impossible; although it is also true that in spite of increasing specialisation there are many fusions of branches of science in our century which did not exist previously, for example radiophysics and biochemistry.

Some of the important discoveries made in Germany in the eighteenth and nineteenth centuries that were decisive for scientific and industrial progress in our age may be mentioned. Astrology, though unscientific, had started long before with observation of nature and paved the way for astronomy just as alchemy did for chemistry. The alchemists had tried to transmute baser metals into gold and to find the philosopher's stone which would provide eternal youth and perfect health. For several centuries the Hellenistic alchemists in Alexandria did experiments, melting various metals and fusing them into a single substance in order to make gold. They may be regarded as true experimentalists just like the Arabian alchemists who worked for hundreds of years with this goal, whereas the German alchemists (and some others in Europe) are generally regarded as charlatans and often even as conscious swindlers, who hid their failures in verbose claims.

After the theory of phlogiston, the "principle of combustibility", propounded by the physician G. E. Stahl (1660-1734) had been rejected, chemistry emerged as a truly scientific discipline following the quantitative approach initiated by the French scientist Lavoisier (1743-94). The study of observed facts and of the nature of reactions enabled scientists to understand that definite quantitative laws which can be observed and measured govern events in nature. Scientific chemistry progressed considerably with the introduction of the concepts of catalysts, enzymes, ferments and—most important—of chemical valency. When the concept of valency had been understood and applied, an accepted symbolism enabled chemists to describe briefly and accurately what they watched and measured.

The principles of chemical *analysis* of organic substances were established and an increasing number of carbon compounds had been analysed by the end of the eighteenth century. The famous chemists Wöhler and Liebig exerted a decisive influence on the development of chemistry in the nineteenth century. The knowledge of chemical *synthesis* led to the artificial preparation of several organic substances. Wöhler synthesised urea in 1828 and in 1840 Liebig published his work *Chemistry in its Application to Agriculture and Physiology,* which gave impetus to the application of fertilisers. Through his exceptional methods of teaching and through his scientific work he succeeded in forging the links between the separate sciences and between laboratory work and its practical applications. He is also reported to have described chloroform and its effect long before it was used as an anaesthetic. Emil Fischer was outstanding among the chemists working on the *synthesis* of organic compounds, with his synthesis of sugars and of some substances he called polypeptides. Through such work much progress was made towards the understanding

of the nature of some of the constituents of *living organisms.*

When isomerism was discovered, structural or constitutional formulas could be used for the illustration of this phenomenon. For instance, Kekulé von Stradonitz illustrated the "benzene constitution", the benzene molecule, by the simple figure of a hexagon with six carbon atoms and a hydrogen atom attached to each of these. It has been said that the theories and illustrations of molecular constitution supplied the chemists with the map and compass by which they could penetrate the forest of organic chemistry and understand such things as structural isomers.

When through extended knowledge in organic and physical chemistry the Aristotelian authority in biology as well as the doctrines of Galen were finally completely abandoned, biology became an independent scientific subject of study.

In 1757 A. V. Haller had published his *Elementa Physiologae,* claiming that all nerves are "gathered" in the medulla cerebri in the brain. He is credited with advances in many fields: in the mechanisms of respiration, digestion, blood circulation, muscular activity and also the development of the embryo. He was called the "father of physiology", and he earned for physiology, or more comprehensively biology, the name of the "German Science". Haller's doctrine, then shared by many eminent scientists, was based on the concept of preformation, that is of growth consisting only in a process of enlargement of what is preformed (contained in miniature in the germ). This is in contrast to the theory of epigenesis that had been propounded by C. F. Wolff in his *Theoria Generationis* of 1759. By means of a microscope Wolff observed the progressive formation and differentiation of the various organs in a germ that had originally been homogeneous. He has therefore been regarded as the precursor of scientific embryology, which was founded by von Baer (1792-1876). Baer observed the mammalian egg, which he re-discovered in his experiments. Through his findings the idea of preformation was completely discredited.

The theory of the cell as the element of form and as the origin of living organisms, a morphological and embryological unit, formulated by Schleiden in 1838 for plants and shortly afterwards by Schwann for animals, elucidated the structure of these organisms. Schwann was a pupil of the famous physiologist J. Müller, to whose work we owe the knowledge that the kind of sensation we experience does not depend on the manner of stimulation of the nerve but only on the nature of the sense organ. For instance, the only sensation of which the eye is capable is light, whether the stimulation is a source of light or only a mechanical irritation.

Darwin's publication in 1859 of *The Origin of Species* exerted an extremely strong influence in Germany. Among the most enthusiastic followers was Ernst Haeckel, for instance in *General Morphology of Organisms* (1866). The term morphology was probably first used by Goethe as a way of seeing nature as a whole, breaking down the rigid partitions between the various sciences. Haeckel's "Great Law of Biogenesis," the analogy between the development of life in the individual (τὸ ὄν) and the species (τὸ φῦλον) that is between ontogenesis and phylogenesis, was to be understood as parallelism. Haeckel believed that in this way the natural sciences could sufficiently explain the origin of life.

At about the same time the monk Gregor Mendel made a series of very important experiments, cross-breeding peas in order to find out whether natural selection gave a sufficient explanation for the formation of a new species. His results, published

in a little-read paper, were forgotten until rediscovered in 1900, about forty years later; as a result the science of heredity, genetics, was established as an exact experimental science. Mendel had discovered that an organism contains certain unalterable units whose presence or absence determines definite qualities, some "dominant", others "recessive". Mendel's laws of inheritance have been generally accepted by scientists, and the role of chromosomes, genes and the number of chromosome-pairs as hereditary factors is being progressively studied. The results are of interest not only for science but are most important for agricultural industries, and have been extensively used by breeders of plants and animals to combine qualities that are desirable and to eliminate as far as possible those that seem to be harmful.

The geneticist, the biochemist and the biophysicist as well as the ecologist complement each other's work, but what is, or at least may be still missing is an explanation for a residuum left in the investigation of life. This is in many ways the most interesting and most puzzling problem of science and philosophy. Firmly interwoven with the problem of the origin and characteristics of life is the question of the relation between mind and body or more generally mind and matter—the so-called psycho-physical problem. This central query of the borderland between philosophy and science took the form of a controversy in the nineteenth and twentieth centuries between vitalism and materialism (often called mechanism). The mechanists have claimed that the body (of animals or men) works like a machine, the function of which can be fully understood, and which is controlled by the brain in all physico-chemical and also all "mental," "spiritual" or "psychical" activities without any additional force. On the other hand vitalists have claimed that even if all physico-chemical and biological causes were known there would still be an unexplained residuum which remains and which has to be explained. Can organic life be fully explained without a teleology, that is without presupposing a purpose? Many facts lend themselves readily to an assumption of purpose in all organisms—in the behaviour of plants and animals. For thousands of years the urge to live, the simple instinct of self-preservation, has been advanced in evidence. Often such evidence has been rejected as unscientific and all presuppositions in addition to a purely physico-chemical explanation have been regarded as unnecessary. Again and again however such presuppositions have appeared in biological and philosophical contexts. The name for the unknown X that has often been assumed as being beyond and above all purely physico-chemical phenomena has changed from the entelechy of Aristotle to the "sensitive soul" of Stahl, and to the "organising relations" of Hans Driesch in the twentieth century. Between antiquity and modern biology as seen from the standpoint of Whitehead's organicism there have been innumerable opinions in the systems of scientists and philosophers. The zoologist Driesch for instance was a convinced mechanist when he lectured on the developmental mechanics (*Entwicklungsmechanik*) of Roux and on the theory of Weismann, who rejected the inheritance of acquired characters. However, through the results of his extensive experiments Driesch suddenly realised that early embryonic development did not suggest a mechanistic, purely physico-chemical explanation of life. He wrote in his autobiography that it dawned on him that a machine-theory of the organic was impossible. There and then he became convinced of the necessity of assuming something in addition which makes a machine work and controls its functioning. This was the beginning of his vitalistic writings which contain his presuppositions of "organic regulations". The zoologist had become a philosopher.

In his *Critique of Judgement* of 1790, Kant had anticipated many of the biological and philosophical theories of the nineteenth century and of today. His explanation is based on the discrimination between causes that may be investigated by scientists, and on the other hand final causes concerning purpose which are typical for the teleological approach. Kant pointed out that teleology is justified as a regulative but not as a constitutive principle, in that it belongs to the *judgement* of the investigation of organisms. However, Kant held that it would be unscientific to presuppose final purposes *instead of* using the methods of science, by replacing these with teleological ideas as explanatory factors for organic structures. It is unlikely that modern neo-vitalists would fall into this error; but there are many in the opposite, mechanistic camp who deny the necessity of assuming any purposefulness in the individual organism or in the whole of nature. These "optimists" claim that biochemistry, biophysics and psychophysics have already achieved so much that the completely conclusive solution to the problem may not be far off.

Major progress in physics was initiated by Heinrich Hertz (1857-94) who, using very

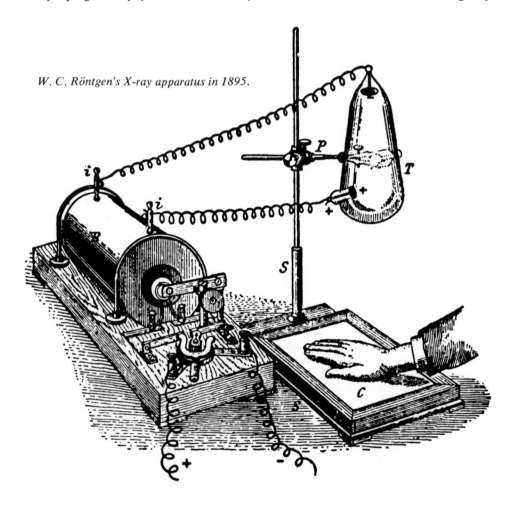

W. C. Röntgen's X-ray apparatus in 1895.

primitive means, discovered, produced and measured electrical waves travelling with the velocity of light and exhibiting properties like refraction, reflection and polarisation. It has been claimed that this discovery—of course considerably elaborated—gave birth to wireless telegraphy and, indirectly, to later applications such as the telephone and television. Another event of great consequence in which, it is true, serendipity played a considerable part, was the discovery by Röntgen of the rays which he himself called X-rays as to him they were an unknown X. This discovery and its importance for medicine and for many industrial applications are widely known and fully appreciated. In 1895 Röntgen was working late at night in his laboratory on electric discharges through vacuum tubes and a sufficiently evacuated apparatus covered with black cardboard. A screen coated with a phosphorescent substance placed near the apparatus in a completely dark room became luminous with each electric discharge. Many might have seen such a phenomenon before, but no one had interpreted it correctly, certainly no one before Röntgen had seen its significance. Often the main achievement of the discoverer is not only the discovery itself but the realisation of its importance and its possible effects and consequences.

At the beginning of this century classical physics and to some extent classical chemistry came to an end, and long cherished concepts had to be given up or fundamentally changed in scope. One of these concepts was Leibniz' idea of continuity—that there are no jumps in nature *(natura non facit saltus)*. Scientists of all ages since Leukippos and Demokritos in the fifth century B.C. had been accustomed to think of smallest indivisible particles of *matter*—atoms. However, when at a meeting in 1900 of the German Physical Association Planck announced the same idea for *energy*—that energy is emitted or absorbed only in smallest no longer divisible parts, the quanta of energy—this was regarded as complete heresy. One of the older professors is said to have left the room with the words, "This is no longer physics". Those who knew that Planck was cautious and imbued with the classical view can imagine how difficult it was for him to decide on this totally unorthodox explanation for the solution of a radiation problem he had set himself. But this was the only explanation that fitted the facts. The months preceding his decision were, in his own words, about the most difficult period in his whole working life. With this epoch-making idea of discontinuity in energy, a new "constant of nature" had to be accepted in science. It is usually called Planck's "constant h", for him "a mysterious messenger from the real world". How far-reaching the consequences of the introduction of this idea would become was not realised immediately, not even by Planck himself. Modern physics and chemistry, including all recent modifications of the quantum theory, are unthinkable without Planck's fundamental pioneering work, his "quantum of action."

Five years after Planck's revolutionary announcement, Einstein published his theory of relativity, one of five of his important papers in the same year. Whereas in Planck's theory the concept of continuity in energy exchange has to be interpreted in a new way, in Einstein's theory the concepts of space and time require an entirely new interpretation. The often-repeated statement that "they lost their independence or their absoluteness", that only their union has any meaning, can also be stated thus: all events happening and being observed are perceived in the Now-Here; everything occurs at a certain time in space. Therefore in addition to the three dimensions (co-ordinates) of space, a fourth dimension for time is needed. There is nothing mysterious about this fourth dimension. Every measurement of time includes a measurement of space and every measurement of space includes a measurement of time.

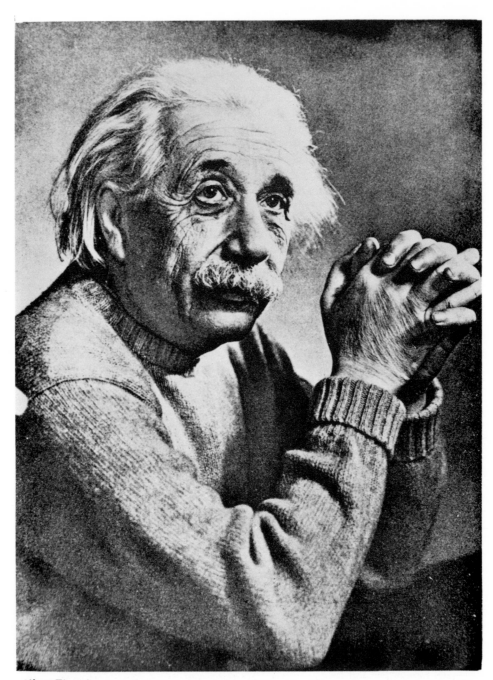

Albert Einstein.

The theory of relativity originated through Einstein's scrutiny of the definitions of the then prevailing ideas of space, time and motion. According to Newton's definitions in his *Principia,* these were absolute space, absolute time and absolute motion contrasted with the relative notions. Newton's absolute space was supposed to be immovable, in permanent rest and without relation to any external object, and always identical with itself. Absolute motion could then be defined as motion with respect to absolute space; however, all experiments designed to prove the existence of a medium which was supposed to fill absolute space had negative results. This medium, called the ether, had also been regarded as the carrier of light propagation. Einstein discarded the concept of absolute space. If someone had discovered a medium absolutely at rest, as an American scientist once claimed to have done, absolute space could not have been rejected. When Einstein was asked what he would say if the American claim were true, he replied, "the whole theory of relativity would have to be rejected as worthless." If one or more experiments are positive, a theory is not yet verified, but if even *one* of its basic assumptions is falsified, the theory has to be rejected. In relativity theory there is neither absolute space, absolute time, nor absolute motion, but all systems in uniform motion to each other are permissible. The absolute concepts have to be discarded as unobservables. There is however one assumption that cannot be discarded as an unobservable; that is the lawfulness of nature. If scientists could not believe that there are laws governing the happenings in the universe they could not apply mathematics to describe them and would have to stop work altogether. Whether the laws are strictly deterministic or statistical is another question.

One of the most important results that we learn from special relativity theory is that the difference between energy and matter (mass) is not a qualitative one, but that energy has mass and mass is energy. This is called the equivalence of mass and energy: $E = mc^2$ where E is the energy, m the mass and c the velocity of light in vacuo, 300,000 km per second. In 1905 this was probably of interest only to scientists. In fact it is the theoretical basis of the liberation of atomic energy. Einstein had himself suggested, at that time, the testing of this equivalence through the study of radioactive substances. This was done at the Institute of Chemistry in Berlin-Dahlem about thirty-four years later by Hahn and Strassmann, who split the nucleus of an atom of uranium by bombardment with neutrons. This meant splitting in two the block from which Rutherford had already chipped bits by α-ray bombardment; now there was a complete fission of the nucleus. This fateful test, fraught with destiny for the whole of mankind, was correctly interpreted for the first time by Lise Meitner and O. R. Frisch. The heavy uranium nucleus had been split by fission. The masses of the products created by the fission when added up totalled less than the mass of the original nucleus. This fission releases enormous quantities of energy according to $E = mc^2$ (because c^2 is so large). Einstein had provided the purely theoretical basis for the application of this result, but he was not responsible for the use made of it, that is, the atom bomb.

The formula teaches us that instead of two conservation laws, one of energy and one of matter, there is only one conservation law—the two are fused together. From the epistemological viewpoint it is extremely gratifying that again a step had been taken towards unification and simplicity. The same may be claimed for the transition from one co-ordinate system in the classical theory to all systems in uniform motion to each other in special relativity, and from this to still more general systems where no restriction on the movements of co-ordinate systems is

Otto Hahn's apparatus for the fission of uranium in 1938.

required. "What does nature care about our reference system?" Einstein asked.

Fortunately Einstein found that the mathematics for expressing this generalisation had been provided beforehand by the so-called "tensor-calculus". Whereas there were many possibilities of verifying the special theory, there are very few for verifying general relativity. The most impressive one was the deflection of light from a star close to the sun, which could be observed only during an eclipse. This was done in 1919 by an expedition under Eddington. Einstein's theory had predicted this deflection and he had calculated the amount expected.

The special theory became a limiting case of the general theory. Moreover, Newton's theory was not destroyed through Einstein's as one sometimes reads, but rather it has been shown to be applicable only under certain conditions. As Einstein wrote to Sommerfeld, "Now the marvellous thing which I experienced was the fact that not only did Newton's theory result as first approximation . . ." Scrutinising the definitions of concepts and theories, and finding accordance with all known facts concerning the field of investigation, has often led to great accomplishments. This procedure combined with the search for universally valid laws of nature has sometimes been called a typical German approach. It was Einstein's approach, and it also characterises von Laue's discovery of X-ray diffraction.

Laue describes in his autobiography how his idea came into being in Munich in 1912. It was prompted by a question of a then still little-known physicist, P. P. Ewald, and two other physicists at once volunteered to test the idea by experiment. He also tells us that he might not have been able to do the successful research work which was 'done in this field by Sir William and Sir Lawrence Bragg soon after his discovery. They investigated the crystal structure of many *single* substances by X-ray spectrometer, whereas Laue was always mainly interested in the great

universal principles, and felt that it was a good thing that physicists with different predilections approached problems of science. Before Laue's discovery many physicists, among them Sir William Bragg, had regarded X-rays as corpuscular radiation. Through Laue's discovery the undulatory nature of X-rays and the structure of crystals were revealed and tested by experiments using the space lattice of the crystal. Ordinary light waves cannot be used for this purpose because their wave lengths are not short enough, and an ordinary optical grating is too coarse for X-rays. Laue's discovery, represented in the famous Laue Diagrams, answers questions both about the wave nature of X-rays and about the atomic arrangement in crystals, that is, crystal structure.

Max von Laue.

Werner Heisenberg.

 With this once again a goal had been reached in simplifying and unifying. These findings are not only highly interesting for physicists, but have also been applied in various branches of science and industry.

Quite apart from applicability, there are problems of science which are of the greatest fundamental importance and are still unsolved. After many years of spectacular development in physics, the physicist in our century is now seriously confronted with problems outside the domain of his own special subject matter. It has become difficult for him even to define his subject matter without transgressing into the realm of philosophy, especially epistemology. Relativity and quantum theories as well as recent investigations on the foundations of physics are based on epistemology. As Einstein wrote about the reciprocal relationship of science and epistemology: "They are dependent upon each other. Epistemology without contact with science becomes an empty scheme. Science without epistemology is— insofar as it is thinkable at all—primitive and muddled." Such problems have come to the fore through Heisenberg's "uncertainty principle" or "indeterminacy relation." This relation expresses the fact that it is not possible to measure the velocity and position of an electron as was done in classical physics. One can measure these two quantities; however, it is not possible to measure them both accurately at the same time. The inaccuracy of a simultaneous measurement will always be not less than Planck's constant h divided by the mass of the particle. The more accurately the velocity of the particle is determined, the more inaccurately its position will be known. This may be compared with observation through a microscope. If we want to investigate two layers of an object on a slide, we cannot do this simultaneously. The more accurately one layer is focused, the more inaccurate and blurred the other one will be. The two quantities, velocity and position, are called "complementary" by Niels Bohr of Copenhagen, where the main discussion about this interpretation of quantum theory (the so-called Copenhagen interpretation) first took place in 1925.

The extremely far-reaching epistemological implications of this view become obvious: a probable result is supposed to replace a strictly determinable one. Many physicists have arrived at the conclusion that the principle of causality has broken down. This however is a rather rash inference. The Copenhagen interpretation was not accepted as a definitive solution by Planck, Einstein, Laue or Schrödinger, and arguments for and against are still going on. Often they are centred around the question: what is the role of the observer in an experiment and what is his influence, if any, on the result? What changes have occurred in the meaning of the concepts of space and time (through relativity theory), of continuity (through quantum theory) and of causality (through the indeterminacy relation)? The opponents of the Copenhagen interpretation also criticise its denial of the possibility of maintaining the "reality" of the smallest particles. Einstein felt that physicists are not compelled to relinquish the idea of physical reality, whereas the Copenhagen interpretation does claim that the particles are not real like stones or trees. However, it is generally understood that modern physics has become more and more abstract, so that visualisation is no longer to be expected in the same way as previously. Most opponents of the Copenhagen school admit that experimental results seem to be in accordance with the statistical laws. They do not, however, regard as final an explanation which describes only a so-called "ensemble" of systems and does not give any information about a single system.

In almost every branch of science there have been great achievements in our century and I have dealt only with quite an arbitrarily small selection. Those who were not fortunate enough to have known these scientists, who were always prepared to discuss scientific or philosophical questions, will get an impression of their

personalities and of their amazing unpretentiousness and modesty by reading their scientific autobiographies, where they describe their aims and methods. It is typical of these eminent German scientists that they were fully aware of their great indebtedness to their predecessors, on whose work they were able to build their own accomplishments. The idea that a new theory accepted by experts destroys all former ones, which are then relegated to the limbo of forgotten theories, is quite wrong. If it were correct, science would not be what it is—"cumulative positive systematised knowledge" (Sarton). The most desirable fate of a scientific theory will always be to live on as a special limiting case of a more general theory.

Political Theories

Walter Veit

Any brief survey of the German political tradition will be written with some obvious major questions in mind: what are the basic ideas and elements at the root of this tradition? What have been the main political objectives throughout Germany's history? What is the relationship between nationalism and particularism in Germany? Why did the liberal revolution of 1848 fail? What destroyed democracy in Germany or what made Hitler's seizure of power possible? What is the present situation?

We can try to answer these questions in two ways. First, we shall discuss the most important stages of Germany's political history: the political system of the Middle Ages in so far as it opened perspectives into the future; the rise of Prussia as a new nation-state and her political programme that led to hegemony in Germany; liberalism, socialism and the new Empire; the Weimar Republic and the rise of National Socialism; the Third Reich, and the situation today. Secondly, in conjunction with this historical survey, we shall isolate the most important recurrent political questions: the status of the citizen in German political life; the evolving roles of society, government and state; and the dialectical conflict between German particularism (with its connotations of regionalism and federalism) and German nationalism (involving the development of Germany as a nation and as a territorial unity). These questions are relevant at each of the stages of German history outlined above.

The earliest information on Germany dates from Roman times and presents the independent family-group, the military organisation and the tribe as the core of north European political life during the centuries of migration. The occasional solitary warrior and hero of the epics existed only on the margin of a society which consisted of free peasants, a warrior aristocracy and a king elected by the community of all free men. A particularly interesting feature of this polity was the full private sovereignty of its members. This found expression in the right and duty of the free man to resist any attempt to turn this system of free co-operation (*Genossenschaft*) into the "tyranny" of a group or a single member. Even at this early time there was continued opposition between the aristocracy and the king, whose family was considered noblest among nobles, but whose interest was to destroy the independence of the nobility in order to extend royal rule over all members of the tribe or *Stamm*. The Germanic tribes, referred to by the Romans as

Charlemagne's cathedral at Aachen, 9th century.

"nations", were not so much ethnic groups as communities with distinct legal and social codes. No fixed territory was as yet attributed to them.

These early forms of political organisation were the basis of later developments: the conflict between king and nobility continued as a conflict between the

supra-regional and centralising power of the king or emperor and the decentralising independence of regional tribal princes. The solution of this conflict was a federation, which is still the formula for national unity today. Furthermore, we find indications in this early society of the later system of social and political feudalism. Feudalism as it emerged in the eighth century was based on both fealty and the right to resistance. F. L. Ganshof defines it as:

> a pushing to extremes the element of personal dependence in society, with a specialised military class [the knights, or *Ritter*] occupying the higher levels in the social scale; an extreme subdivision of the right of real property; a graded system of rights over land created by this subdivision and corresponding in broad outline to the grades of personal dependence just referred to; and a dispersal of political authority amongst a hierarchy of persons who exercise in their own interest powers normally attributed to the State and which are often, in fact, derived from its break-up.

Crown of the Holy Roman Empire, 10th century.

Thus even the regal or imperial administration failed to become an integrating factor.

Out of the clash between the Roman Empire and the Germanic tribes that P. Joachimsen has described in political terms as the collision between the Roman anti-national principle of the state (*Staatsprinzip*) and the Germanic principle of the nation (*Nationalprinzip*), the state of Charlemagne arose in 768 A.D., comprising all those territories which later became France and Germany. This state was at first neither an institution nor an office but an association of persons based on mutual obligation, with the king as the feudal lord and patron. It was only later, under ecclesiastical influence and Charlemagne's deliberate attempt to revive the Roman tradition of a centralistic state and empire with an integrated legal system and administration, that this patronage was turned into an office, into the administration of an institution. Under the influence of St. Augustine's theological vision of the state, the new official political ideology split up the old commonwealth-like association into an almost theocratic polity (*Reich*) and its incumbent and administrator, the king and emperor. This polity, however, was substantiated on earth in the person of the emperor. The *Kaiser*-idea as an attempt at integration was perpetuated by a political theory provided by church doctrine and canon law. It understood the secular state as a reflection of and a preparation for the eternal state, and saw the emperor and later also the Pope as representatives of Christ fighting the Anti-Christ. Because of the preponderance of the theological element in this political theory, which had its prefiguration in the Byzantine state ideology, the whole *Kaiser-Reich* system has been described by F. Heer as "political religiousness".

The feudal system of decentralised authority, however, as indicated above, brought the germ of destruction into all moves towards establishing a centralised polity on the basis of crown land (*Reichsland*). With the help of the ecclesiastical nobility (*Reichskirche*) it sought to subjugate tribal regionalism. In fact, the final result was rather a confederation of the autonomous polities of the tribal aristocracy. The princes elected the king, who became emperor only when he was powerful enough to force his way to Rome. H. Mitteis has called this first empire a theologically grounded "federative hegemony on a feudal basis" and an idealistic construction; others saw it and its later development as a "monarchic anarchy". It nevertheless laid the foundation of a distinct national identity (*Volks- und Staatsbewusstsein*), but reduced the originally free peasant population gradually to serfdom and left as "folk" (*Volk*) only the ecclesiastical and secular nobility. It was a corporate state (*Ständestaat*) limited to two estates.

The political religiousness and imperial universalism of the Carolingian and Saxon emperors was replaced by an autonomous and more realistic understanding of political life when the emperor clashed with the Pope in the twelfth and thirteenth centuries and a dualism arose which destroyed the divine authority of the emperor. The *Kaiser*-idea was replaced by the idea of the holy empire, and Staufic imperialism was born. The empire was still a confederation of tribal territories ideologically united in the *Reich*. As Walther von der Vogelweide proclaimed in one of his political songs, "The *Reich* is higher than the king". This was another idealistic attempt to establish a centralised body politic to overcome German particularism. But it was never able to gain much more than moral authority.

In 1250, however, the German princes were granted even further independence. This was not only a victory for the nation principle, but shifted political life into

Loughlands —
near Elbow Beach Club

...an - underground

...life.

the individual territories and brought their development into independent states to a first climax. At the same time the imperial programme of peace and justice was replaced by state authority and civil discipline. Before, the political function of the emperor had been to act as the moderator of a polity of equals. The citizen was now subjected to the authority of the state, a superior entity: he became subservient, an *Untertan*.

The periods of humanism and the Reformation saw emperor and princes on an equal footing as rulers of defined territories which were the bases for their power politics. The feudal system had turned into a domination of territories and their inhabitants and it could permit no exemption from its authority. Even the independent towns, which saw a development of self-government and brought new groups of citizens to political awareness and influence, were gradually integrated. On the other hand, the Reformation had vested the secular government with authority in religious matters and thus supported the doctrine of the absolute state. Its legalistic ideology is best seen in the proposition that he who rules the country has the right to dictate the faith. The Reformation also laid the foundation of later political conservatism and the theory of a Christian State that was particularly influential during the *Restauration* period after 1815.

The emergence of Prussia as a superior independent power in Germany and Europe not only gave rise to new political situations within the empire but also led to confrontations between the traditional and the new political theories. What the French kings had achieved much earlier, the Prussian kings accomplished during the seventeenth and eighteenth centuries. They established a central authority over the nobility of the region. Their ideology aimed at a powerful absolute state; a regular army, a centralised administration, a unified common law and a protectionist

economy were the tools to forge it. This led to an all-embracing polity, to a total "nationalisation" of society, and was eased only on the surface by the enlightened despotism of Frederick II (Frederick the Great), who professed to be the "first servant of the state". T. Veblen has shown how this move depersonalised the absolutist authority which developed into an egoistic quasi-personal entity whose well-being was superior to that of the individual subject, an entity himself, reinforced by the radical and messianistic Protestantism of the earlier kings and by Frederick's philosophical rationalism. This entity was subject only to its own logic, which was interpreted by a legalistic administration. From this doctrine we see a direct link with Hegel's political theory, which raised the state to a realisation of the divine on earth, as well as with modern theories that put the state above everyday quarrels of opinions and parties.

This tendency, however, was stopped by the French Revolution in 1789, which meant so much to the German educated class because it seemed to implement their political ideas and their programme of constitutional government, individual self-determination and nationhood. It appeared to be the only answer to the absolutist régimes and a way towards national unity. Many German writers, among them Klopstock and Schiller, hailed its ideals but found themselves gradually repelled by the atrocities of the revolution and the dictatorship of Napoleon, although their own ideologies postulated the emergence of a national leader. Never again was there such a multitude of diverse political theories in Germany, ranging from ultra-conservatism to radical anarchism, as there was between the pre-revolutionary years and the failure of the German liberal revolution in 1848.

As the driving force behind all political thought, the French Revolution was at the same time the source and stain of both political liberalism and socialism in Germany. It was the origin of the fear among German politicians of exercising power and using force—until Bismarck used it, and then Hitler. From this time on the liberals and socialists stressed not revolution but reform and evolution within the frame of legality.

The revival of Prussia after its disastrous defeat by Napoleon was the work of several dedicated people, such as Karl vom Stein, Karl August von Hardenberg, and Johann Gottlieb Fichte—all non-Prussians and of different political background. In his *Reden an die deutsche Nation* (1807-8), Fichte tried to overcome the political particularism that had made Germany helpless by reverting to the cultural tradition. He hoped to establish a German nation at least as *Kulturnation* that would lead sooner or later to political unity. He conferred the task of bringing about political unity on Prussia, which was the only state in Germany with a power potential. Fichte's ideas marked the advent of nationalism in politics, a potent weapon in the ensuing "Wars of Liberation" against Napoleon but dangerous in the future when nationalism turned into chauvinism. Its most vivid expression was in a semi-mystical emotional nationalism—*Nationalgefühl*—the feeling in the individual citizen of belonging to a distinct nation. This became a strong support for the ideology of a nation state (*Nationalstaat*) and a source of uncritical acceptance of *Deutschtum* ("Germanity" or "Germandom").

This national feeling was not Fichte's idea, but was first expressed by J. G. Herder in his *Ideen zu einer Philosophie der Geschichte der Menschheit* (1783), in which historical subjectivity and ardent patriotism brought forth a new understanding of *Volk* and *Nation*. At its roots lay a new conception of a folk-nation that grows organically in history, in contrast to the static politico-legalistic state.

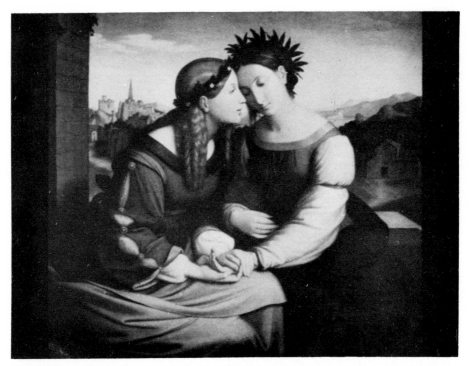

Italia and Germania. Nazarene School, early 19th Century.

Herder compared each nation as an organic personal whole to a "plant of nature" animated by the national spirit (*Nationalgeist*) or by the soul of the folk (*Volksseele*). The particular physiognomy of a nation is determined by this national spirit, which is first manifest in every individual character; each individual finds his own existence and perfection only within this national organism: the folk-community (*Volksgemeinschaft*). Patriotism thus became a basic character value. Secondly, the national spirit is manifest in the history of a nation and virtually prescribes its course and destiny. Patriotism and nationalism can be found in earlier epochs, but Herder provided a new and powerful foundation, and in the rhetoric of Fichte his ideas became potent arguments against the notorious German particularism. However, they carried the germs of totalitarianism. Hitler, who forced the theory of the organic state beyond any romantic expectation, used Fichte's biological approach to turn folk, nation, and "Germandom" into concepts of political racism.

After Herder and Fichte, this national sentiment was a strong ally in the real or imagined stress situations of the nation, sweeping away rational dissent and bringing even the sober and clear-sighted mind under the sway of a collective feeling. The dangers hidden in the organic ideology are apparent in Fichte's utopian treatise *Der geschlossene Handelsstaat* (1800), which gives a full description of the political consequences of the metaphysical concept of totality. Fichte maintained that the state alone was able to unite an "indeterminate multitude of human beings

into an enclosed totum, into a totality". To achieve this he advocated a total national autarchy, a planned economy, intensive re-arming, increased "living space", forcible occupation of territory, transfer of population, and deliberately cultivated nationalism. R. D'O. Butler has concluded from this analysis: "The words are different: *Lebensraum* and *Gleichschaltung* do not appear; it is as yet not *Einmarschierung* but *Occupationszug*. But the ideas are the same. This embryonic German socialism is national-socialism." But to assume that Hitler's National Socialism is the inevitable consequence of Fichte's utopian national socialism eliminates the element of responsibility. It is, however, safe to assume that the political culture in Germany, in so far as it rests upon this organic ideology, prepared the way for the disasters of National Socialism.

In another respect, Fichte is significant among German philosophers and writers in that he marked the beginning of direct political involvement by academics. Goethe abstained totally from politics at this turning point of political thinking. He was concerned exclusively with the tragic guilt of all human action, was intensely sceptical about Germany's political future, and at most advocated a cosmopolitan humanism that would eventually develop the German cultural potential better than under any national scheme.

After his early commitment to the ideals of the French Revolution, Schiller arrived at his theory of the "aesthetic state" (*ästhetischer Staat*) based on his contention that man is a human being only in the free play of art, which gives form to the idea of the whole. The "aesthetic state" reconciles in a dialectic synthesis the "dynamic" or primitive state in which everyone looks anarchically for his own advantage only, and the "moral" state in which the individual is subjected to an enforced authority and left without freedom. In Schiller's "aesthetic state" the individual subjects himself freely to the law of necessity. "To give freedom through freedom is the basic law of this state." The inner logic of Schiller's idealistic construction ensures its realisation in the future. Thus the logic of historical progress is charged with the advent of the ideal state, and there is little guidance for the present in Schiller's theory. Only Wilhelm von Humboldt tried to limit the power of the state as early as 1792 in his essay *Ideen zu einem Versuch die Grenzen des Staates zu bestimmen*. This was, however, not published until 1851.

Authors like E. M. Arndt, Körner, Jahn, and Görres popularised the organic ideas of Herder and Fichte in various ways, even down to the concept of physical education as obligatory for a true nationalist. They combined nationalist fervour with belief in constitutional government. Early nineteenth-century political thinking in Germany had two different though related aspects: philosophical idealism culminating in Hegel's absolute idealism, and the romantic political thought which is best represented by Adam von Müller.

Hegel recognised that individualism and particularism in German politics had weakened the empire; but at first he rejected French and Prussian centralism. The new German national state superseding the old feudal system was to have as much regional diversity and decentralisation as possible. He called for a constitution to safeguard civil rights and for parliamentary representation. The unification of German territories was to be brought about by Austria.

Hegel's later philosophical reflections, however, run counter to his earlier "revolutionary" ideas, and are the result of his dialectic philosophy of history. World history, he declared, is a continuous theodicy, a rational and necessary

Die
Elemente der Staatskunst.

Oeffentliche Vorlesungen,

vor

Sr. Durchlaucht dem Prinzen Bernhard
von Sachsen-Weimar

und

einer Versammlung von Staatsmännern und Diplomaten,
im Winter von 1808 auf 1809, zu Dresden, gehalten

von

Adam H. Müller,
Herzogl. S. Weimarischem Hofrath.

Erster Theil.

Mit einer Kupfertafel.

Berlin, bei J. D. Sander.
1809.

Title-page of Adam von Müller's
Lectures on Politics, *1809*

process of self-realisation of the spirit of the universe. It realises itself in ideas and actions that follow each other according to the law of dialectics. "World history is progressive awareness of freedom" mediated by the state. The state occupies the pivotal position, which unites universality and particularity and thus seemed to Hegel to solve the "German problem". On the other hand, Hegel rejected dogmatic apriorism in history, since he believed like Herder that everything in history grows organically, while all abstract constructions of political functions and institutions are unrealistic.

As a mode of government Hegel favoured a constitutional monarchy in the hands of a small class of administrators who were to be virtually uncontrolled by any parliamentary supervision. Independent and mutually corrective functions of government were declared dangerous since they are "apt to usurp the unity of the state, and unity is above all things to be desired". The logic of his theory carried Hegel finally to an annihilation of individual aims and ends and to a virtual deification of the state:

> The state is the realization of freedom, of the absolute final goal which it is for its own sake; all value that man has, all spiritual reality, he has solely through the state. The state is the divine idea as present on earth. In that the state, the fatherland constitutes a commonness of existence, and in that the subjective will of man subjects itself to the laws, the opposition between

freedom and necessity vanishes. Necessity is the rational in its substantiality, and we are free because we acknowledge it as the law.

These lines, and sentences of Hegel's like "What makes the state is a matter for educated cognition and not for the rabble!" and "The folk as state is the spirit in its substantial rationality and direct reality, hence the absolute power upon earth", were easily exploited later on by totalitarian political systems. Nationalism was also supported by his belief in Germany as the heir to the world-historical development.

Hegel first gained political importance through the romantic writers and philosophers, and later on through the "Young Hegelians", who developed his thought in different directions. Adam von Müller was perhaps the most active in giving a political turn to philosophical idealism. He understood the state as the culminating organism of the community of the people, as the totality of all human existence, an eternal union of the living, past and future generations. This organic theory was opposed to liberalism and Rousseau's Social Contract theory and to the free trade theory of Adam Smith. It supported the organic community's hold over the individual against individual freedom. Müller's conception of state and government shows this clearly. "It is not merely a plaything or instrument in the hand of a person but it is itself a person, a free whole, existing and growing in itself by means of endless interaction of contending and self-reconciling ideas", and "private life is nothing other than national life observed from below, and public life is ultimately nothing other than the same national life viewed from above". Thus a doubtful identity of "real nationality" and "true freedom and independence" is achieved. This emotive emphasis on the community may be linked to the anti-rational tradition in European thinking; in any case it made political matters inaccessible to rational penetration and criticism.

The conception of the state as "a great human being, human in bodily structure, disposition, mode of thinking" resulted on the other hand in a very interesting plan for a league of nations for mutual guarantee. Müller shared this idea with most of the romantic writers, and their programme was to be later realised in the League of Nations (*Völkerbund*) and the United Nations.

After 1807 the whole political structure in Prussia changed under the political leadership of Karl vom Stein and Karl August von Hardenberg. Strongly influenced by the German imperial tradition, the study of Montesquieu and Edmund Burke and the British parliamentary system, Stein set out to reorganise the Prussian state and to replace the absolutist bureaucracy and political lethargy by public spirit and civil initiative (*Gemeingeist und Bürgersinn*). He proposed the creation of a very close relationship between government and the governed by introducing decentralised self-administration of towns and abolishing all corporations and privileges. These steps led to a modern organisation of the state; a reorganisation of the government brought the institution of ministries. The introduction of a Prussian premiership directly responsible to the king was achieved later by the more resourceful Karl August von Hardenberg. Stein's plan for a national representative assembly was implemented only in 1848.

Hardenberg's political programme was rooted in the ideas of the eighteenth century Enlightenment. Its central motive was to "put into practice democratic principles in a monarchy" to achieve the greatest possible freedom and equality through social and economic reforms. But at the same time he intended these reforms to lead to a strengthening of government authority. There can be no doubt

Karl Reichsfreiherr vom Stein

Karl August Freiherr von Hardenberg.

that the political theories of Stein and Hardenberg were based on a paternalistic understanding of state and politics. This was not only obsolete at the time, but also contributed to the disillusionment of the "democrats" who had fought for national unity and constitutional government in the War of Liberation. The decentralising reforms in Prussia based on self-determination of the citizen ought to have led to public control of the almost omnipotent bureaucracy. Instead there was a constant struggle between the omniscient administration and the self-interest of the people. In fact, the bureaucracy established itself ideologically and practically as a corps of protectors of the state whose very concept of service and duty thwarted the main aims of the reformers to change the *Untertan* into a responsible citizen. The result was that under Bismarck's heavy-handed administration, German citizens settled down to economic prosperity and showed little interest in political matters, except perhaps for the spectacular successes in external affairs.

After 1815 the really effective though mutually opposing forces were the *Restauration*, which wanted to restore the pre-revolutionary order, German Liberalism, Prussia's state egoism, and a little later the rise of German Socialism. Klemens von Metternich, the Austrian chancellor, became the protagonist of a political theory that was conservative at best but was anti-revolutionary, repressive, and authoritarian. This pattern was followed by most of the German states that banded together to form the German Confederation (*Deutscher Bund*). The Holy Alliance between the Austrian, Prussian, and Russian monarchs was to watch over and guarantee the new stability. The Christian state was to stand against the "anti-Christian revolution".

Opposition against authoritarian absolutism came only partly from the radical revolutionaries or anarchists, who were in any case soon expelled from Germany. It also came from the new liberal movement, which did not deny its links with the ideas of the French Revolution although it rejected radicalism and force. In Germany liberalism meant an open rational system of liberal political ideas, centred around the freedom of the individual as set down by the law of nature and the French Declaration of Human and Civil Rights of 1789. It meant equality before the law and legal protection against the power of the state. It did not necessarily mean democracy, although the liberal political creed endorsed sovereignty of the people. The liberals realised that democracy could be just as illiberal as monarchical despotism, and thus their main concern was to restrict the compass of state activity. The radical democrats concentrated ideologically on the sovereign individual. Liberalism also meant parliamentary government, although there was no agreement as to how centralism and particularism could be balanced. Its political programme was headed by the demand for national unity, motivated partly by ideological nationalism, and partly by hope of future economic advantages. In economics, liberalism was based on free enterprise and industrialisation, and in social terms it was accompanied by the rise of a new middle class consisting mainly of entrepreneurs, merchants, academics, educated professionals and craftsmen.

The liberal theory of a capitalist economy was acceptable to Metternich and the *Restauration*, but its political ideals were suspect from the beginning. However, public opposition to the absolutist régimes had resulted in constitutional governments in the southern states of Germany. This development brought the smaller states into opposition to Prussia, whose aims of hegemony became acceptable to the liberals only on the condition of liberalisation in Prussia itself.

Revolution in Berlin, March 1848.

At a time of industrial growth in Germany it was quite natural that liberal politicians found the largest field for their activities in German economic affairs, which they thought to use as a lever in their unification policy. The most influential among the liberal economists was Friedrich List, the advocate of the Customs Union which abolished the tariff barriers between Prussia and a number of other

states in 1834, and an ardent promoter of the new railways that were to change the economic infra-structure completely.

List's greatest work, *Das nationale System der politischen Ökonomie*, shows quite clearly that nationalism was a part of his liberalism. His nationalism in economic affairs demanded protection against international competition during periods of development and industrial concentration supported by a planned economy. Hence his criticism of German "disorganising particularism and individualism" in private industry and politics. It is obvious that organic ideas were not completely alien to List and that his liberalism was somewhat restrictive.

The liberal movement came to a head in 1848 when revolution broke out in Germany. At this time liberalism was the most influential political ideology and the elected Frankfurt Parliament was dominated by liberals. The new German constitution laid down principles that were in essence to be included in the later constitutions of the Weimar Republic and the Federal Republic. Unfortunately the assembly was unable to agree on quick political action to abolish the old regimes, and it also failed to decide on the territory of the nation state. Most members wanted a greater Germany, including Austria without her non-German territories, so that "folk", state nation, and linguistic territory could coincide. This problem was inherited from the past and gained momentum through nationalism; it was revived again and again in the future and brought to an enforced solution only after World War II. When the Austrian chancellor Felix zu Schwarzenberg rejected the Frankfurt plan, the decision for a smaller Germany under Prussian leadership was made.

But although the liberals were federalists and advocated a federal state with a central authority to replace the old confederation of independent states, in 1848 they had completely misjudged the real strength of regional and particularist forces. Renouncing violence, the liberals had not only failed to overcome the egoism of the existing states, but also had not been able to direct the feeling of the people towards the nation state and establish constitutional institutions on a national basis. When the Prussian king refused "the crown of the revolution" that was to unite Germany at least partially, the enthusiasm was gone, and the liberals grew rather sceptical. They turned from politics to industry and economic progress, opposing bitterly the rise of socialism. Though liberal in economic thinking, the German liberals now supported authoritarian forms of government. They realised that a liberal economy and free trade were potent factors of integration, but that political unity could be brought about only by the defeat of regional separatism.

Nevertheless, the debates in the National Assembly in Frankfurt from 1848 are judged to be of the greatest importance in German political development. They worked out the compass and trends of rational politics, democratic institutions, and a national ideology, and also brought to light all the inherent theoretical difficulties and the practical impasses.

While the mainly middle-class liberals picked up the evolutionary and reformist tendencies in political thinking, the new socialist and communist movement, inspired by Karl Marx and Friedrich Engels and led by Ferdinand Lassalle, later by August Bebel, Wilhelm Liebknecht and Rosa Luxemburg, fought for the revolutionary cause. Hegel's dialectic method had provided Marx with the means to understand economic and social movements; he set out to correct Hegel by developing dialectical materialism in philosophy, determinism in history, and optimism with respect to political and economic progress. Progress was now held to exist as a tendency in

reality. In his book *Zur Kritik der Politischen Ökonomie* Marx says:

> The means of production of material life conditions the whole social, political and spiritual process of life. It is not the consciousness of the people that conditions their existence but on the contrary it is their social existence that conditions their consciousness. At a certain stage the development of the material means of production of society falls into contradiction with the actual conditions of production. . . . then comes an epoch of social revolution. With the change of the economic basis the whole enormous superstructure changes over, slower or quicker.

The final goal of this historical process of class struggles is the dictatorship of the proletariat. Only a minority of radicals and anarchists considered this revolution a violent one. On this point, in fact, communists and socialists differed ideologically. The majority of socialists intended to bring about political revolution and national unity by legal means within the framework of the existing political institutions.

More important perhaps for the German political scene in 1860 was Ferdinand Lassalle who, together with Marx, supported the cause of the working classes and organised the first labour union, the *Allgemeine Deutsche Arbeiterverein*, in 1863. He advocated a political system that was based on the power of the state, and he expounded organic ideas and nationalism. "The bourgeoisie conceived the object of the state as consisting solely and entirely in protecting the personal freedom of the individual and his property. This is the idea of a mere watchman . . . The state is a unity of individuals in a moral whole . . .". This system was to be headed by a social monarch (*Sozialkaiser*) unrestricted by any constitutional bonds, which Lassalle described as "organic self-destruction". "We must forge our wills together into a single hammer and must lay this hammer in the hands of a man in whose intelligence, character, and goodwill we have the necessary confidence, in order that he may be able to strike with this hammer." It is probably unjustified to say that Lassalle's power-politics, national socialism, and dictatorial tendencies form the core of German socialism as a whole. But ostracised as revolutionaries and anti-nationals, the socialists strove like any other party to create an image of a political party that would not destroy but reform the state and its institutions towards democracy. They set up the *Sozialdemokratische Arbeiterpartei* in 1875, which was able to win seats in the Imperial Diet (*Reichstag*). This national parliament became the platform of their political activities after 1877. Conservative forces reacted quickly to socialist electoral gains and Bismarck put the socialists under legal and administrative pressure, but their political growth continued strongly.

Bismarck was at first supported only by the conservatives and was alienated from the liberals and Lassalle's socialists. But he gained their support by ousting Austria from the competition for supremacy in Germany and moving to unite the rest of Germany into a nation state under a Prussian king as German emperor.

The liberals saw their aims fulfilled when an imperial parliament was voted into office by universal, free and equal franchise after the unification of Germany in 1871. Unity and representation on a national basis seemed to be achieved. Bismarck expected manhood suffrage to give the conservative rural population a handsome majority, but his plan failed because of the growing industrial population.

Beside the *Reichstag* (House of Representatives) the constitution provided for a *Bundesrat* (*Fürstenrat*, Federal Council) as representation for the federal states. This system was revived in the constitution of the Federal Republic as a

Bismarck advancing to meet Napoleon III after the battle of Sedan, 1870.

way of combining a central government with regional autonomy. To solve the old conflict apparent in this system, the *Reichskanzler* (Imperial Chancellor) was responsible both to the emperor and the Diet. The administration was given a strong place in the legislature, since the state representatives in the Federal Council were mostly administrators delegated by the state's ruling house. In short, not only was the liberal principle of separation of powers fatally watered down, but the whole mixture of parliamentary democracy and monarchic government was to the disadvantage of parliament. Parliament was, in fact, gagged by the administration.

It was not surprising that socialist, democratic or republican principles were not very popular with Bismarck, as the conservatives disliked the socialists for political and religious reasons, just as the liberals disliked them for economic reasons. Trying to shackle them politically and to neutralise their demands by state legislation, Bismarck pushed through—against the conservatives—schemes of social security, health and accident insurance. The principle of authoritarian paternalism worked well during the Bismarck era in so far as it brought an amelioration of living conditions for the working classes which was well ahead of any other state in Europe. Thus Germany avoided the formation of an impoverished industrial proletariat as a result of rapid industrialisation. But politically this principle instituted the image of the "Father State", which looks after the needs of its children according to merit. Support was to be rewarded, dissent punished. Thus the whole concept of the state and its institutions as conceived by liberals and socialists . alike was reversed, and German society became almost totally uninterested in politics and directed solely towards economic growth and stability.

Another result was a serious split in the socialist movement that was caused

by Revisionism. Even before Eduard Bernstein published his theses on the revision of Marxist theories, the party line was a much debated issue between the Marxists of the radical or the constitutional doctrine on the one hand and the socialist trade unionists on the other. The trade unionists did not want to wait till the final revolutions, but wanted better conditions for the workers immediately. The trade unions became a growing force in industry and politics, particularly after the formation of an all-German Trade Union Federation in 1890.

The rapid industrialisation after the Franco-German War of 1870, and the growing nationalism in Germany as well as in the other European states, converged on international socialism as the main enemy. The German socialist parties were forced into a frustrating opposition that was labelled "subversive, destructive, and anti-national" on the basis of the old concept of the state as an organic whole that cannot tolerate dissent or conflicting interests. Their existence was also threatened by German political and cultural regionalism. When war broke out in 1914 the Social Democrats were caught in the "German Dilemma". Politically they were centralists, but strongly opposed to any tendency towards dictatorship; ideologically they advocated internationalism but followed a national course in parliament, just as they were revolutionaries in theory but evolutionaries in practice. And when the war was over and Germany defeated, they were faced not only with the unpopular Versailles Treaty but above all with the task of gaining acceptance for a new constitution that transformed Germany into a parliamentary republic with a strong presidency and a government based for the first time on the political parties. The origin of the German parties can be traced back to the Frankfurt Parliament, but only now did they become constitutional bodies. This Weimar system was directed towards the legalised conflict of interests. But it was never able to gain support from the old bureaucracy, which saw its role as objective servants of the state, aloof from conflicts of interest. Nor was it favoured by the army, which became a "state within the state" and therefore highly dangerous. It was in the administration, in the army and in heavy industry circles that Hitler's political programme was first acclaimed.

The splendid successes of Gustav Stresemann in external affairs in the 1920s should not be allowed to conceal the internal deficiencies of democratic institutions in Germany. They had had as yet no chance to create a political culture that was able to deal with the growing radicalism on all sides. Though demonstrating their political and national integrity when no one was prepared to take on political responsibility, the Social Democrats were smeared with the blame not only for the Versailles Treaty but also for the enormous economic difficulties. Weakened as well by internal disputes, the growing strength of the radical left, and the political instability of the centre parties, they offered little resistance to the recovering nationalistic ideology.

The historian K. D. Bracher has remarked that political thought in the nineteenth century and during the Weimar Republic was occupied with two main problems: the final achievement of a nation state and, consequently, with the primacy of foreign affairs in politics. These decisively overshadowed the whole process of democratisation which was under way in England and France. Politics was taken to be the craft and actions of the great statesman; the authority of the state and its institutions were believed to be superior to the political parties, removed from the fluctuation of the socio-political life. The idea of the state was of a higher

order than society and democracy. This myth of *Überparteilichkeit* of the state found its theoretical expression in Carl Schmitt's theory, known as "decisionism": only if the administration is able to resort to a dictatorship can there be a guarantee of the government's ability to decide objectively what is best for all, unbiased by pressure-groups and special interests of individuals. This theory, which has had so much influence on the understanding of government and administration, was directed against modern democratic pluralism and thus paved the way for a totalitarian state.

Socialists and genuine conservatives alike became the victims of the Nazi movement, which combined the lingering anti-rational, anti-democratic and illiberal organic theories of the state and society and a charismatic leadership (*Führerprinzip*) with a still powerful administration and a racist ideology. Racism was a part of Nazi ideology and was used in politics with different aims. In home policies it was used to achieve national unity: there was only one German race, hence only one people, one state, one government. Citizenship itself after 1934 was no longer a right of birth but was dependent on racial qualifications.

But racism was also used in foreign affairs in order to claim more living-space (*Lebensraum*) for the new chosen people. The worst result was the declaration that Jews were "arch-enemies" of the Germanic race. The extermination programme that followed cannot be compared to medieval pogroms. It was planned genocide on a large scale, as was the deliberately started war. While the socialists rejected violence, the Nazis used it for their ends. With organised terror against the democrats and promises for the masses, supported by a very effective propaganda that dwelled on the all-embracing myth of a common spirit of the nation, Germany became a model of totalitarianism in the 1930s.

When the Nazis adopted the system of the totalitarian state (the fascist unitary state) they changed the democratic parliamentary party system into a one-party organisation. The government was in reality the dictatorship of the *Führer* of the ruling party, the *Nationalsozialistische Deutsche Arbeiterpartei*. The constitutional state was turned into a police state. All government bodies, such as the administration, the judiciary, and the army, were made to toe the party line. Moreover, party control penetrated into all sectors of social life, regulating the conduct of every individual citizen. Some pockets of underground resistance existed in the core of the socialist and communist parties, the church and the army. Open opposition was drowned in blood. After their take-over the Nazis did away with all state governments, and later combined the chancellorship and presidency in one person.

The Nazi period has sometimes been explained as the temporary insanity of a whole nation. It seems clear, however, that the German tradition of political thought and practice provided points of departure for the self-inflicted disaster.

The political ideologies of Nietzsche, Spengler, Möller van den Bruck, Schmitt, Rosenberg and Hitler show this quite clearly. On the other hand, it would dissolve all responsibility in political matters if we were to suppose an historical inescapability for the whole development. The best answer is, perhaps, that political culture in Germany was of a kind that favoured the Nazi movement.

The end of the Bauhaus. *Student collage, 1932.*

The experience of the Third Reich gave democrats the firm conviction that anti-democrats cannot be fought democratically. This view was implemented after World War II. While in the eastern parts of Germany a communist government came into office in the wake of Soviet expansion in Europe, the western parts grew into a modern parliamentary democracy that has shown considerable stability, resisting not only a communist threat from without but also new nationalistic tendencies from within. E. Stein has observed that the authors of the Basic Law (1949) instituted a "militant democracy determined on self-preservation".

The rapid economic growth was based on the Social Market Economy theory of competing interests within a legal order. This was, in fact, a revival of classical liberalism supplemented by moderate socialism. Governmental practice within the parliamentary system, however, suffered from throw-backs to organic ideas as in Ludwig Erhard's "Formed Society", an ideology that was directed towards economic stability based on the ideas of a corporate state. There are certain other problems arising from the federal constitution. While giving the *Bundestag* (Federal Parliament) the decisive weight in the legislature and strengthening the position of the Federal Chancellor, it has again introduced a *Bundesrat* (Federal Council) to represent the federal states. This Council is not directly elected (like the U.S. or Australian Senate) but represents the state government in office. This is undoubtedly a new intrusion of the executive into the legislative procedure and an acknowledgment of the still existing regional diversities, which are particularly pronounced in cultural matters.

Furthermore, there is the article that gives the new state only a provisional status. It is only in the last years that there has been a growing willingness to accept two German states on a restricted territory, since unification seems impossible for the time being.

However, the system has worked so far with a remarkable stability that has overcome threatening tendencies from within as well as external pressure. The new liberals particularly, but socialists and trade unionists too, have come out strongly against new organic and "decisionistic" tendencies in political institutions. They opposed the rather patriarchic idea of the "chancellor democracy" master-minded by Konrad Adenauer, in which the federal chancellor aimed at gaining institutional preponderance over parliament. There was also public hostility to the claim made by the recent coalition of the two major parties that an opposition-free government is desirable in the event of an alleged national crisis. The sociologist R. Dahrendorf developed his much acclaimed theory of society as an aggregation of conflicting interests, and of parliamentary democracy as an institution for managing open conflict. The foundation for this is a new understanding of the role of the citizen. It is obvious how much Dahrendorf has been influenced by Anglo-American political ideas and by K. Popper's concept of the "open society".

This theory also provides the basis for a new political liberalism which, according to Dahrendorf, is bound to succeed in the future as the rational alternative to the failing conservative and socialist systems. It would result in an intelligible administrative procedure and bring about a new understanding for political action and initiative that will bring the citizen back from his political alienation, and democratise the state.

The extra-parliamentary opposition in Germany can be understood as a sign of this growing personal engagement in politics. It consists mostly of students, who found that during the recent coalition government (1966-69) there was no longer

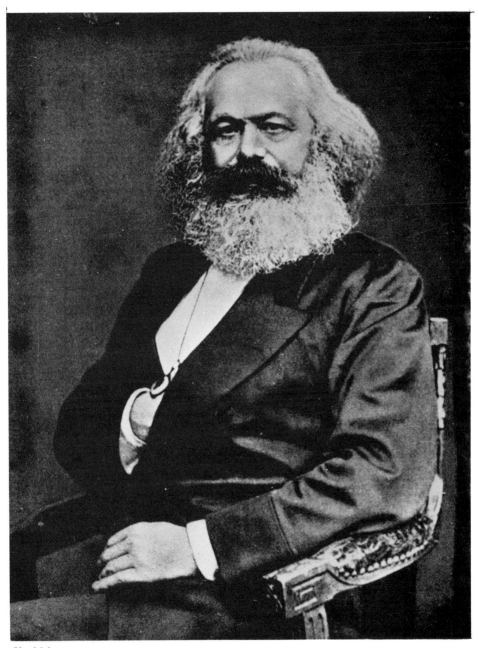

Karl Marx.

any proper opposition in parliament. Therefore they protested in the streets. Their political ideas, however, go much further. Drawing on the young Marx, the psychology of Sigmund Freud, and the political anthropology of Herbert Marcuse, their principal aim is to break through the political, economic, and philosophical ideologies which are supposed to reflect the class structure of present society.

The students' rejection of ideologies allegedly prevailing in all ways of life, and their hope of reconciling man with himself to make life in general and political life in particular more human, has had many repercussions on the political climate and has enlivened open political criticism. But it has met with severe criticism as well. Sociologists and political scientists like Dahrendorf, K. Scheuch, and H. Albert have turned their critical methods against the radicals, exposing their utopian ideals, which in fact show totalitarian tendencies in spite of their intentions. Anti-liberalism has classed the radicals among the enemies of an open democratic society.

The impact of the present vigorous discussion was clearly visible in the swing to the political left in the 1969 general elections. Since then the Socialists and Liberals have formed a coalition government replacing the Christian Democrats. Their rapprochement has taken considerable time. The Social Democrats in their Godesberg Programme came to an understanding of the modern economy and abrogated their ideals of planned economy and nationalisation of heavy industry. The Liberals have accepted society's obligation for the well-being of all. Thus the old ideological barriers have broken down, along with old party obligations. Socialists and Liberals have also now become generally acceptable to the German public.

As one looks back on the whole development, one interesting phenomenon seems to stand out: political thought in Germany has always preferred to explore an alternative to the current system in north-west Europe, sometimes ahead of the time, often falling dangerously behind. This search for alternatives is inspired on the one hand by a particularly strong regionalism that has often taken Germany as a whole out of step with international development and into political isolation. The organic ideas and their disastrous results, on the other hand, issue from a strong theoretical inclination, a search for a kind of absolute truth, that tends to overlook its own impracticability. Only today, it seems, have German political culture and institutions tuned into the tendencies of the western world.

The Economy

Raoul F. Middelmann

Most Anglo-Saxon economists are centralists at heart. They traditionally either favour or reject outright government ownership of the means of production and expect natural antipathies to exist between the long-term interests of business, government and labour. The multi-centredness of economic policy in Central Europe and its consequences must come as somewhat of a surprise to them. But the very high *per caput* wealth and living standards in Switzerland and the rapid recovery of living standards in Austria and the Federal Republic following the two World Wars suggest that this tradition of multi-centredness has not been a hindrance to successful economic development. The tradition contributed to multi-centredness of industry, to close co-operation between government, business and labour, and to a number of factors such as competent entrepreneurship, a pluralistic system of education, diverse roles for a multitude of banks, certain trends in the trade union movement and in commercial law, and a long-standing sense of social responsibility in government, employers and employees.

In Central Europe the economies first of villages and later of cities, states and nations were always interdependent with those of their neighbours across land boundaries which shifted as a result of wars, marriages, inheritance or purchases. At all times the aim of the people was to improve their lot by influencing local government policies. Competition between communities for wealth constituted a powerful stimulus for economic growth in Central Europe.

The rise of the city over the villages, the state over the cities, and the nation over the states never ended in complete victory for the superior entity. The fiscal and economic integration of various Central European states in the German Empire in 1871 was less complete, thorough and uniform than for example that of the *départements* in France in 1790 or of the Australian colonies in the Commonwealth of Australia in 1901. German unification resulted neither from a revolution nor from a union of equal partners; the two free city-states, Hamburg and Bremen, joined the Customs Union (*Zollverein*) only in 1888, under pressure from the Prussian-dominated national government. Generally, wherever powerful entities absorbed weaker ones, administrative inefficiencies and geographic proximities to neighbouring political entities caused the take-over of only a minimum of powers (for instance power to tax), and this was often done in exchange for new privileges,

financial aids, and bribes. Thus at any time in Central Europe (with the exception of the Hitler era in Germany) comparatively large territorial states have existed alongside smaller ones, and even the smaller political entities have retained powerful administrative tools to influence effectively the living standards of their residents.

The vagueness of boundaries and the competition by each entity for "a place in the sun" caused revolutions of the French type to fail in Central Europe. But governments with policies detrimental to local economic prosperity, or furthering it too little, found that men, capital and commerce fled. To avoid this, the governments developed efficient systems of transport and communication and set up partly or fully government-owned enterprises in sectors they regarded as keys to future economic growth. They also granted aid at an early period for free public education and social security, and helped craftsmen in obsolete industries to shift their production emphasis from quantity to quality. Governments also co-operated with business in export promotion (trade fairs, for example) and in rationalisation of output and marketing, thereby reducing "wasteful" competition. Initially some of these features of the Central European economy probably produced a slower form of industrialisation, but it was one that eventually became geographically very widely based.

Many of these features existed even before the French Revolution and nineteenth-century liberalism increased the number of people influencing their governments' decisions. In areas of early commercialisation and many political divisions, a comparatively wide sector of the populace could directly influence government and thereby its own standards of living. In other areas, economic policies to boost population growth and state revenue (the German form of mercantilism) had a similar effect.

The multi-centred political power at all levels of government meant that widely-scattered communities competed for industries. Although some sections of industry developed earlier and faster than others, economists seem to overrate the Ruhr's coal mines and its iron and steel industry as promoters of economic growth in Central Europe. Areas around Stuttgart, Frankfurt am Main, Mannheim, Bremen, and Hamburg in Germany, Linz in Austria, and Basle, Winterthur and Zurich in Switzerland certainly show faster economic growth at present than the Ruhr, and some of these areas have been developing faster for some time. Mainly because of improvements in inland transport, the economic heart of Central Europe had been moving west and south towards areas such as Württemberg and Switzerland long before millions of residents were pushed to the west after the Second World War and before the Common Market brought tariffs down.

The multi-centredness of economic policy-making has led Germany's largest and most famous industrial corporations to take over and retain plants scattered all over Central Europe. Analyses of cost and profit expectations have caused many factories to settle away from traditional industrial centres. This has recently been true particularly of foreign corporations or those forced to resettle from areas east of the Iron Curtain. The surprisingly large number of privately-run corporations with some local, state or federal government equity participation constitutes a further group of geographically widely-scattered businesses. In some present-day corporations, different administrative levels of governments in the same region have often held all equity in the form of public dividend capital for decades, if not for centuries. Many less well-known but export-intensive private manufacturing

Factory of Farbwerke Hoechst A. G. in 1863.

businesses are located in obscure towns remote from the well-known industrial centres.

Most currently privately-owned large industrial plants were originally handicraft businesses in small towns and villages. Some master-craftsmen developed sufficient entrepreneurship to attract skills and obtain capital and labour. Their success in conquering distant markets enabled their villages to grow into towns, sometimes even into large industrial centres. Other craftsmen were forced by the market to surrender their businesses. Their villages or towns were fortunate when new local or absentee owners continued the businesses, employing local labour and paying local taxes.

Krupp's steel factory, founded in 1811 at Essen, pushed ahead when Alfred Krupp invented—among other things—the weldless cast-iron railway tyre in the early 1850s. When Reinhard and Max Mannesmann invented seamless steel tubes in their craftshop at Remscheid in 1884, their company was soon able to expand with the assistance of the Dresdner Bank. Both steel companies remained in their geographic region and grew through able entrepreneurship. Iron and coal deposits were locally available and markets increased with the rise of the population close by and with improved transport by rail and water to districts further afield.

The main plant of the world's oldest automobile company, the Daimler Benz AG., still stands near Stuttgart. Here Gottlieb Daimler (from the nearby town of Schorndorf) established his research tooling shop in 1882, and founded the Daimler-Motoren-Gesellschaft in 1890. In 1926 his company merged with Benz & Cie., of Mannheim, to form the present company. In the small community of Rüsselsheim Adam Opel built sewing machines after 1862, bicycles after 1887 and automobiles after 1898. From 1924 Opel became the first German automobile producer to employ the assembly-line principle. In 1929 the Opel family sold out to the American General Motors Corporation, whose new German plant continued to bring wealth to Rüsselsheim. The town's population rose from only 2,922 in 1885 to some 44,000 in 1963.

Home of the Krupp firm's founder, destroyed in World War II, now rebuilt.

The name of Maschinenfabrik Augsburg-Nürnberg AG (MAN) recalls the 1898 merger of two textile machinery manufacturing companies founded in 1840 and 1841 at Augsburg and Nürenberg respectively. The MAN sign today is found on such different items as trucks, ship-motors, containers, bridges, and pipe-lines.

The head offices of Germany's three leading chemical companies are also sited at or near their companies' places of origin. In 1865 the private bankers W. H. Ladenburg & Söhne assisted in turning the anilin-dye business of Sonntag, Engelhorn & Clemm, founded in 1861 at Mannheim, into the BASF, now at Ludwigshafen. The Farbwerke Hoechst was founded in Hoechst in 1863, the same year that the Bayer Company was founded in Elberfeld (later moved to Leverkusen). Products like synthetic indigo, synthetic nitrogenous fertiliser (the Haber-Bosch process), synthetic rubber and pharmaceuticals (aspirin after 1892) carried Germany's chemical industry to world prominence.

The modern Siemens AG's main plants are also still found near where the company originated. Werner von Siemens entered into partnership with Johann G. Halske at Berlin in 1847 to manufacture telegraphic equipment. Von Siemens' long chain of inventions and innovations brought growth to Siemens-Halske. In 1903 one division of the company merged with the company of Johann S. Schuckert, founded at Nürnberg in 1877, to form the new Siemens-Schuckertwerke.

All these companies located at or near their places of humble origins shared outstanding entrepreneurship, or the ability to grasp early the significance of research, and a sense of responsibility towards their employees and their community even at times when original cost advantages had evaporated.

Particularly since 1945, governments at different levels have proved able to attract new plants of companies with head offices in other parts of Germany or in foreign countries, and of companies newly established by refugee entrepreneurs from east of the Iron Curtain. This has brought a constant migration of industry from the Ruhr region to the plains immediately adjoining in the north. It has also attracted the steel industry to Bremen, the aluminium industry to Hamburg, the chemical industry to Wesseling and Antwerp, the automobile industry to Emden, Hanover and the Ruhr region, and oil refineries to Ingolstadt. These were all either rural areas or areas which were thus rejuvenated industrially. The attractions offered by rural areas were usually the low cost of labour and land, whereas good infra-structure (transport, power and a skilled labour force) and tax incentives brought new plants to industrial centres.

Competition for the settlement of new industry between local rural and urban councils and between different provincial governments and different states has been increasing. The importance of available infra-structure and tax incentives has gained in significance in recent years as areas of relatively cheap land and labour have diminished.

The imposition of the Iron Curtain and the subsequent expropriation (without compensation) of all entrepreneurs in areas east of it led to a massive resettlement

First electric locomotive motor; Siemens and Halske, Berlin Trade Fair, 1879.

of companies in the west. Thus for example the DKW company, formed by mergers of Audi, Horch, and Zschopauer Motorenwerke at Chemnitz and Zwickau in 1932, found a new home at Ingolstadt. The old Deutsche Edison, the Allgemeine Elektricitäts Gesellschaft (AEG), which was founded at Berlin in 1883, was forced by its losses in the east to establish many new plants in the west.

A characteristic feature of the Central European economy has been government equity participation in industry. This has usually occurred through historic accidents, sometimes for reasons of military self-sufficiency and sometimes to spur economic development. Germany's main railway lines were built with greatly varying degrees of government participation, ranging from those built entirely by state governments, as in Baden and Brunswick, and those built by cities with private equity participation, to those built entirely by private interests under strict government regulations, as in Prussia before 1866. The special demands for railway services during the First World War resulted in the 1920 merger of all state government railways systems, including the previously acquired private lines. Federal Government ownership of the coal mines in the Saar region (74% of the nominal equity capital, the remainder held by the Saar State Government) also dates back to an historic accident: the area with its coal mines was returned by the French Government in 1959, when no private German capital group wished to buy the mines.

Examples of early mercantilism and of old companies still in existence in government hands are the china-ware manufacturers of Meissen, founded in 1710, and of Nymphenburg, founded at nearby Neudeck in 1746, and the Prussian *Seehandlung*, established in 1772 to conduct overseas trade on Prussian ships, which became the Prussian State Bank. Electricity supply companies, as in Berlin, tramway companies in Bremen, Stuttgart and Hamburg, shipping on the Rhine (Köln-Düsseldorfer) and Danube (Bayerischer Lloyd), "private" railway companies such as the Köln-Bonner Eisenbahnen, the Württembergische Bank and almost all savings banks are all companies in which national, state, county and local council governments, together with private interests, took up equity in greatly varying proportions and competed with each other towards the end of the nineteenth and the beginning of the twentieth centuries.

After the First World War extraordinary housing needs induced some cities like Stuttgart and Frankfurt am Main to take up equity in house building and administration companies. Housing needs also induced some state governments to establish banks (for example the Württembergische Kreditanstalt) for the purpose of guaranteeing housing mortgages, thereby enabling mortgage banks to lend for housing on other than first-ranking mortgage security. During the crisis years 1930-1934 the national government temporarily held part of the equity of all trading banks except the Berliner Handels-Gesellschaft. The national, state and local governments also took up equity in airports, electricity production and supply companies, canals and even film production companies.

National government enterprise established the Salzgitter iron works and the Volkswagen company in 1937 and 1938 respectively. Both companies brought industry and prosperity to areas which had previously been very rural. In 1960 Volkswagen's success in producing the "people's" car in Wolfsburg and marketing it the world over had outstripped the available budgetary resources of the Federal and Lower Saxon Governments, who were the new post-war owners. Consequently,

60% of the equity was "privatised". The people's car thereby boosted "people's capitalism" through control over the size of individual holdings. Lack of Federal funds also led to private equity in Lufthansa AG in 1966. Germany's international airline has been owned since then by the Federal Government (74.38%), the Rhenish-Westfalian State Government (2.25%), the Federal Post Office (1.75%), the Kreditanstalt für Wiederaufbau (3.00%), the Federal Railways (0.85%), and private shareholders (17.77%). This semi-public ownership ensures that Lufthansa's operations are kept before the eyes of the public. As with many semi-public companies, Lufthansa's shareholders directly and indirectly include the Federal Government. The Kreditanstalt für Wiederaufbau (best translated perhaps as Reconstruction Loan Corporation) is a bank owned by the Federal Government. It relends the famous counterpart funds (funds derived from payments for equipment originally supplied under Marshall Plan aid) to industries too risky for ordinary banks, and it does so profitably.

Competition between several governments for new industries, workers, and, at present, tourists resulted in technically efficient and usually economic production of goods and services even by government-owned companies. Where local provision of services was obviously inefficient, town and county administrations overcame their rivalries. Thus for example in the field of electricity as early as 1898 private entrepreneurship created the Rheinisch-Westfälisches Elektrizitätswerk AG, which at present is controlled through multiple voting rights by town and county councils, while most of the equity capital is in the hands of private shareholders.

Even more scattered than Germany's big industrial plants are the small but nevertheless export-intensive manufacturing businesses, many of which are still based on the traditions of the master craftsmen. The most famous of these are perhaps the cuckoo clocks of the Black Forest. Germany's watch industry today is centred in Schramberg, Schwenningen and Pforzheim in the south-west, and the influence of the Swiss watch industry with its headquarters in the Swiss Jura Mountains is strong. Timber, special skills, and rural under-employment in the past made Trossingen in the Black Forest well known for its harmonicas; Mittenwald, at the edge of the Alps, for its violins; and Thuringia and the Ore Mountains for their wooden toys and Christmas wares. Franconia developed with its low-grade iron deposits metal toys and also the ball-bearing industry at Schweinfurth. In the Westerwald Mountains east of Bonn, similar resources and local clay brought forth the beer-stein industry.

Originally based on local timber, Saxon coal and Czech clay, china production around Selb in north-eastern Bavaria faced difficulties when the Iron Curtain came down just to the east. However, the current fame of companies such as Rosenthal and Hutschenreuther at Selb and of nearby Arzberg suggests that able entrepreneurship—shown in particular by the special emphasis on design—in this labour-intensive industry overcame high costs when clay had to be imported from western countries and coal had to be brought in from France or the Ruhr.

The jewellery industry at Idar-Oberstein also once relied on local resources of agates. Nowadays all precious and semi-precious stones are imported from areas such as Brazil and Arizona. The diamond-cutting industry at Hanau, introduced centuries ago by Dutch and Walloon refugees, relies entirely on imports of its most important raw materials. Here the English Crown Jewels were prepared for the coronation of Elizabeth II. Ivory-carving at Erbach in the Odenwald Mountains

Balance-poising machine in Swiss watch-making.

Arzberg china, Austrian glass.

has also always relied on imports of its main raw material. In contrast to the other high-skill industries mentioned, this industry finds it difficult to export its products today.

From an early period, the cheap labour of peasants on widely scattered holdings and the supply of local wool and hides enabled the Palatinate region to become Germany's prime centre for the shoe industry. Similar labour resources and low grade iron-ore deposits resulted in the cutlery industry at Solingen. Even today, both these industries are in the hands of many relatively small establishments.

Many other industries (textiles, furniture and beer brewing, for instance) are still in the hands of a surprisingly large number of producers. While there are giant breweries like the Dortmunder Union in the Ruhr region, most of Germany's 2,000 breweries are smaller; in southern Germany, banks still regard breweries with an annual output of as little as 700,000 gallons, the average consumption of some 20,000 people, as good risks for long-term loans.

Many German industrial plants belong neither to large world-famous corporations nor to the many small businesses centred as a branch of an industry in particular regions in southern and south-western Germany. A. W. Faber Castell, probably the world's leading pencil producer, began as a small business at Stein near Nürnberg in 1761. As early as 1849 the business opened a branch in New York. Despite its world renown the company is still a comparatively small business, located at Stein, where the owner also lives.

There are few surviving old industries in areas north of the mountain ranges

crossing Central Europe from west to east and in areas east of the River Elbe, where the large-scale wealthy export-oriented rural producers were the *Junker*. As rural aristocrats they gradually destroyed the peasantry and the cities and created the larger territorial states of Hanover and Prussia. Most of the old Hanseatic towns failed to attract industry and thus to arrest the decline of their economic bases and political independence. In the southern and south-western hills of Central Europe, on the other hand, farmers produced only for local demand. The frequent subdivision of their holdings brought overpopulation and at times starvation. The local aristocrats had only slightly larger holdings. In contrast to north-eastern Germany, the south-western rulers frequently strengthened their position by ruling with the peasants and against the aristocracy. This produced government promotion of the use of local resources, even when little else was available except labour and timber. As well as tax incentives, governments in these areas offered entrepreneurs a skilled labour supply and favourable financial and legal arrangements. The results were systems of education, banking, law and social attitudes whose multi-centred origins are still evident, particularly in south-west Germany.

As in other countries, formal education benefited greatly from the Protestant drive for free and compulsory schooling. But the early state legislation to develop schools, in Württemberg in 1559 and in Weimar in 1619, was of little practical significance. However, the rapid spread of teacher-training seminars, established in Prussia at the end of the seventeenth century, brought rates of literacy in many parts of Central Europe which were remarkably high for the time. Tertiary education, for centuries the domain of the churches, came under the influence of the state with the reforms initiated by W. von Humboldt in Prussia in 1811. New technical universities, such as Karlsruhe, Berlin and Zurich, were developed under French influence during the first half of the nineteenth century.

The good but multi-centred formal primary, secondary and tertiary education, together with libraries and scientific societies, remained largely of only potential economic importance until the development of the railways. Only the railways, built in Germany from 1835, improved inland transport sufficiently for the economic shipment of bulk produce. From this time, however, local craftsmen increasingly required art-oriented training to withstand the invasion of articles produced in factories with the help of steam-engines. This resulted in special craft-schools such as those at Erbach for wood and ivory carving; Trossingen, which established a Tertiary School of Music; Mittenwald for violin construction; Solingen for cutlery and metal forming; Selb for china; Pforzheim and Hanau for jewellery and precious stones; and Pirmasens, where the German Shoemaking School was set up. In Württemberg, a state without coal or iron deposits, the government met the challenge of the 1840s by sending English machinery from community to community and allowing every interested country lad to take the equipment apart and reassemble it.

From the time of the arrival of the railways, craftsmen in Central Europe looked for cheap and ubiquitous sources of power, that is power other than that obtained directly from steam-engines or falling water. The internal combustion engines of Otto, Daimler and Benz, and Diesel and Siemens' dynamo represented solutions. In 1891, for the first time ever, high voltage electricity was transmitted over a long distance by the Swiss firm of Brown, Boveri and Co. Altogether, it was

especially through the rapid application of electricity that the challenge was met. All these inventions and subsequent innovations resulted partly from good formal education and partly from a society which was ready to accept them. Central Europeans envied the English for their industrial growth and attempted to emulate it. Graduates from technical universities were therefore given ready access to leading positions, or became entrepreneurs themselves in the new, expanding, research-intensive industries: chemical, electrical, optical and automobile manufacturing. Probably earlier than in Britain, industrial companies realised the significance of continuous research for their continuing growth.

This socio-political background of education in Central Europe explains the existence of city-owned secondary schools proud of their histories which date back centuries. Some universities of today go back to these secondary schools, and some technical universities began as trades schools. All types of tertiary institutions are found in widely dispersed centres. No "Oxbridge" exists in Central Europe. Students follow professors from one university to another, and reputations of faculties rise and fall correspondingly.

The multi-centred forces affecting political, industrial and educational decisions also affect banking and finance. There are literally thousands of banks operating in Central Europe. Several stock exchanges exist, and particularly those of Frankfurt and Düsseldorf in Germany and Zurich in Switzerland defend their relative importance fiercely.

Until the middle of the nineteenth century, widely-scattered private bankers held the keys to banking in Central Europe. With their background in trade, they used their own funds mainly for discounting short-term bills of exchange, their one safe way of granting credit to local craftsmen and merchants. They also floated issues of local and foreign governments. Their number declined, particularly in rural areas, with the shift of fiscal strength to higher political entities. Since 1945 their influence has risen with the revival of portfolio investment, especially in unit trusts and foreign securities.

Local county-owned or community-owned savings banks began to appear during the second half of the eighteenth century. As in other countries they collected deposits from the poor and made them available for local economic growth. These banks formed their central institutes, the so-called *Giro-Zentralen*, just before the First World War. Since then the savings banks have increasingly taken up other functions which the country's incorporated trading banks had pioneered. At present savings banks transfer money nationally and manage their clients' "depots" of capital market securities (in Central Europe usually bearer securities), that is, they store the securities, collect dividends or interest, and represent holdings at annual meetings. They also discount bills, grant current account and long-term credits to industrial companies and float share and debenture issues. Mergers on a regional basis constitute further devices for the savings banks to strengthen their competitive positions.

The greater capital intensity of German industries, which moved from the handicraft to the factory stage of production much later than the cotton industry with which industrialisation began in England, demanded long-term capital far in excess of savings of the entrepreneurs themselves. In Central Europe it was mainly the trading banks (as in Japan mainly the government) that provided long-term

funds. In England factory owners had accumulated funds through the retention of profits in the cotton industry, which was not only older but less capital-intensive.

Granting long-term loans has seemed safe to the trading banks on share basis ever since legislation prescribed supervisory boards for all incorporated companies, because the boards hire and fire management. Bank representatives on these boards have ensured that managers considered the long-term growth of their companies. The oldest functioning trading bank is the Bayerische Hypotheken- und Wechsel-Bank of 1835. Others date back to the 1850s or were founded in the years 1869-1872 (The Commerz, Deutsche, and Dresdner Banks). New consortia between these banks and others have been entered into continuously to lend larger amounts to industry, place its issues, and reduce the risks to bank liquidity. Government-owned trading banks have followed the example of the private trading banks on share basis and have joined with them freely.

As well as private or government-owned savings and trading banks, Central Europe also has a highly developed decentralised system of private or government-owned mortgage banks. These banks' fixed interest long-term loans are financed by long-term mortgage bonds and communal obligations. In the nineteenth century mortgage banks financed the redemption of feudal services. Since then they have provided agriculturalists, city builders and local government bodies with safe investment loans, at present usually for periods of some thirty-two years ($6\frac{1}{2}\%$ interest, 1% redemption with the interest saved through redemptions added). Today these banks even grant fixed interest amortisation loans to industry for periods of up to twenty-three and a half years ($6\frac{1}{2}\%$ interest, 2% redemption under the same conditions).

The system of mortgage banks would never have acquired the dominant position on the capital market that it now has without the safe system of public registration of titles and government supervision of borrowing by lower government bodies. Governments also guarantee that outstanding first-ranking mortgage loans, loans to communities, and especially authorised alternative securities always exceed the amounts outstanding on mortgage bonds and communal obligations. Despite the heavy write-down of monetary assets in the post-war currency reforms, for Germans and Austrians saving in mortgage bonds has once again become an alternative to saving in life assurance policies. Bearer certificates, instead of registered ones, permit easy transfers and the investment of untaxed profits and income. They thereby retain funds for investment in Germany and Austria which otherwise might flow into Swiss bank accounts, where depositors are more protected from the spying eyes of their taxation departments.

The Raiffeisenbanken and Volksbanken represent another facet of Germany's banking system. Both are local credit co-operatives. The former serve farmers, the latter small local businessmen, and both trace their origins to self-help by poor peasants and small tradesmen to whom neither the trading nor the savings banks extended working capital at the close of the nineteenth century. Both have developed central institutions which enable them to compete with the savings and trading banks for general banking business. While the level of their outstanding loans and their deposits has been rising steadily, as with the other banks, their number has contracted. However, there were still some 11,000 of them in 1961.

In short, the German banking system has become a highly competitive one in which most types of banks have moved in the direction of providing comprehensive banking services. It is a system which is rooted strongly in communities

far away from big urban centres, but nevertheless maintains direct contacts with the organised capital markets, the country's stock exchanges. Brokers in the Anglo-American sense are therefore unknown. Finally it is a system in which competition has brought on the whole satisfactory and flexible services to industry, investors and governments in all parts of the country and with a range quite unknown in English-speaking countries.

The German legal system has also profoundly affected the economy. It is a highly-developed codified system which court decisions modify continuously. It has its origins, in varying proportions depending on the geographic area, in the French *Code Civil* and *Code de Commerce* as well as in the legal traditions of the states as they existed before unification in 1871. The German Code of Commercial Laws (*Handelsgesetzbuch*) of 1861 was the outcome of discussions which had begun with the Frankfurt Parliament of 1848. Most of today's legal codes, however, have been written since unification. Probably none of the codes affecting business has been more influential than two early company laws of the national government. These were the incorporation law (*Aktiengesetz*) of 1884 with its provisions for the supervisory boards (a concept taken from France), and the GmbH-Act of 1892, which grants limited liability to small enterprises without the publicity which incorporation requires. Large corporations also choose the GmbH-form of limited liability when special risks are involved, or when publicity beyond that of the public trade registry is not wanted.

The significance of public registration of titles for long-term loans was referred to earlier. In many other ways governments at all levels as well as the courts have created a set of highly developed rules according to which society auctions land at foreclosures, protects tenants, utilises land and arbitrates labour disputes. The prices of professional services of architects, doctors and lawyers are fixed. Many rules and regulations affecting businesses are specifically local in nature, for superior political entities were never interested enough to standardise them.

Certain semi-public bodies exist in Germany which at times have held functions unknown in most other countries or which outside of Central Europe are entirely in the hands of the central government. Local *Industrie-und Handel-skammern,* which are similar to the Chamber of Commerce, represent the interests of their members in industry, transport, banking and insurance. Membership has usually been compulsory. Local *Handwerkskammern* represent the tradesmen and record all master-tradesmen, and thereby permit them to pursue a trade and train apprentices. Both *Kammern* conduct apprenticeship training programmes and examine candidates. One issues certificates for industry, transport, banking and insurance, the other for masters in the trades.

No article on traditions in the German economy would be complete without reference to the German labour movements. Karl Marx's radical socialism, which called for the abolition of the state, owed much to the rabid capitalism which he observed in Paris and Brussels and which was experienced by his friend Friedrich Engels in Manchester. They were appalled by the contrast between education, status, and wealth on the one side, and unskilled, immigrant labour without property employed in capital-intensive factories on the other. But the attempts by von Ketteler, Lassalle and the professorial (*Katheder*) socialists to improve the lot of workers through control over governments by suffrage were probably more

influential in the long run in the German labour movement than the theories of Marx. Except for the Polish migrants in the Ruhr region, German industry employed a more literate labour force in the nineteenth century than English industry. The German work force, although poor, also retained stronger connections with agriculture. Thus German entrepreneurs and their employees were forced to recognise their often life-long dependence on each other for continued success in manufacturing. The workers' settlements of Krupp at Essen in the nineteenth century and the high proportion of fringe benefits in total wage costs in German industry today reflect the social responsibility shown by German entrepreneurs, who have traditionally identified their own prosperity with that of the local community.

Germany's industrialisation accelerated after 1870. The economic crisis of 1873 brought the new iron and steel industry into alliance with eastern agriculturalists in a bid for higher tariffs. The introduction of tariffs in 1879 and the consequent protection of industry and agriculture permitted Bismarck to impose revolutionary health, invalid and old age insurance schemes for all employees, paid for with the compulsory contributions of employers, employees and the national government.

Workers' representation and profit-sharing date back to the 1830s in Germany. Robert Owen was influential here as was the German economist von Thünen. In 1849 the National Parliament at Frankfurt discussed its committee's minority report on compulsory shop councils in all factories. In 1872 L. H. Hutschenreuther provided for such a council, which arbitrated in disputes over agreed work practices. Ernst Abbe introduced a committee of this sort in his Zeiss works in 1896, after he had transferred management control to a foundation of which all employees were members. Shop councils in bigger factories became compulsory only towards the end of the First World War. At present, industrial employees must have their shop councils wherever more than five are employed. In addition, all supervisory boards of incorporated companies must have one-third labour representation, which is raised to one-half on the boards of iron, coal, and steel companies. Professors of accountancy and business administration often represent labour on these boards, ensuring greater congruence between management's policies and the interests of labour.

German labour unions have come increasingly to practice co-operation with management, which itself has grown independent of shareholders. Strikes endanger the unions' financial position, power and influence, and strikes based on a single factory or corporation have become almost unknown, since unions work with employers' federations towards new regional or national wage agreements. The re-establishment of labour unions after the Second World War along industrial rather than craft lines in industry produced sixteen large unions which in 1949 created the D.G.B. (German Federation of Labour). The German union of white-collar workers, the D.A.G., is the largest of its kind in the world and has remained outside the D.G.B. The absence of a multitude of craft unions has made lay-offs due to strike action by a few workers all but impossible.

The unions themselves today have become large owners of businesses. Among the many enterprises which they own are the largest home-building company in Western Europe, a big trading bank and a life assurance company. Together with their retraining programmes for workers in obsolete industries, German unions today are perhaps the most outward-looking and growth oriented in the world.

A Swiss town in an area of encroaching industry. Can it survive?

Before the First World War, industrial concentration (the famous German system of "cartels") reduced competition. This made industrialists more willing to accept social security legislation and workers' representation. In the 1920s "nationalisation" of heavy industry took the form of compulsory cartels with representatives of management, labour, trade and consumers meeting under government supervision and deciding on production, selling and prices.

At present cartels are generally prohibited. Competition has been widely accepted since the Second World War as a positive force in the economy. The so-called "social market economy" of the conservative Ludwig Erhard has now largely become that of the socialist Karl Schiller. Competition provides for the market content of this economy, and social security and workers' participation for the social content. In this system the government attempts to balance the interests of industry, labour and the consumers. In general the system reflects a highly developed industrial welfare capitalist society which has been stimulated by a strong sense of local identity and consequent regional competition.

Despite Europe's nationalism of the past, ideas, attitudes, men, goods, services and often capital have crossed land borders easily. However, receding nationalism after 1945 strengthened the recognition of identical group interests across national

frontiers for the first time since 1871. Otherwise, few of the economic traditions of the western areas were weakened by the defeat of Germany in 1945. In the D.D.R., a centralised type of economy on Soviet lines was gradually implemented. From its physical, social and moral shambles Germany rose not miraculously, but through hard and regular work, thriftiness, education, research in new products, and effective production and marketing techniques and their application. If there were miracles then they must be sought both in the aid from the United States which was given only to a Europe willing to liberalise its national trade, commerce, money and banking policies, and in a much greater appreciation in Germany of the advantages of competition. At the centre of Europe, and as the crossroads of the continent, Germany stood to benefit most from the new situation.

If today West Germany's *per caput* income is again among the highest in Europe, then the traditions operating in this economy have proved their worth. The traditions, however, need both continuous protection and re-examination. The late and artificial German political unification under the domination of the most powerful state, Prussia, in the nineteenth century and economic as well as political nationalism in the 1920s brought Hitler to power. An alliance of big business with his government to the exclusion of the labour unions kept him there.

Until after the Second World War the Swiss had been much more successful than either the German Empire or the Austro-Hungarian Empire and their successors in relating central government economic policies to those of the local administrative centres. For political reasons there was much less pressure in Switzerland for national economic policies. Today, the high *per caput* wealth in Switzerland (which foreigners tend to under-rate as there is little conspicuous consumption) and the high *per caput* income levels of the Swiss people hold the promise for a united, federal Europe to achieve steadier economic growth than it has experienced in the past.

Germany and
the World

Leslie Bodi

Deutschland? aber wo liegt es? Ich weiß das Land nicht zu finden.
Wo das gelehrte beginnt, hört das politische auf.
(Germany? But where is it? I cannot find the country. Where intellectual
Germany starts, political Germany ends.)

This epigram goes to the heart of the problem of Germany. It comes from the
Xenien of 1796, a collection of epigrams written in collaboration by Goethe and
Schiller which inaugurated one of the most productive periods of German intellectual
and literary life. At a time when there was no "Germany", the title—*Das deutsche
Reich*—pointed to the absurdity of a situation in which a nation was conscious of
itself as an intellectual entity, but not as a political state with boundaries a map would
show. This, I think, is a place to begin to understand the strange, highly complex,
often disturbed and disturbing relationship between Germany and the "World". Not
only "outsiders" but the Germans themselves have often found it difficult to define a
German identity. This is not at all surprising if we consider the bewildering contra-
dictions brought about in the course of the development of German civilisation by
both the lack of congruity between the nation's political life and its cultural develop-
ment, and the serious breaks in the historical tradition of those parts of Central
Europe which (to use a convenient generalisation) are called "Germany" in this
book.

The problem of nationhood as it has evolved since the end of the eighteenth
century is crucial for the understanding of the development of the German tradition.
Throughout the Middle Ages, the German element was of paramount importance
within the supra-national Holy Roman Empire. But while the modern European
nation-states were emerging, consolidating and becoming the basic factors of
European politics, Germany disintegrated into many hundreds of small principalities
and, especially after the devastations of the Thirty Years' War, it fell far behind
Western Europe in economic and social development. The Napoleonic Wars brought
a dramatic and in many respects a paradoxical change. As the "heir" of the French
Revolution, Napoleon modernised the legal, social and economic structure of Ger-
many by introducing liberal reforms in the territories under French dominance.
Thus even the rigid militarist bureaucracy of Prussia was forced into a policy of
regeneration and reform. The concept of modern nationalism as developed in revo-

lutionary France engendered and clarified the ideas of German nationalism, and finally contributed to the defeat of the Napoleonic Empire without, however, giving the German people the experience of a political revolution. The unification of Germany became the paramount task of the following decades. After the defeat of the democratic and liberal movements in the revolutions of 1848, the establishment of the new German Empire under Prussian leadership in 1871 represented the victory of nationalism won largely at the expense of the ideals of political freedom. At long last, Germany seemed to have found its national identity. As an industrial and political power it rapidly overcame the limitations impeding its economic growth and more and more aggressively claimed its "place in the sun" among the other imperialist empires. But it was a development fraught with dangers. Although the belated industrialisation of the country gave it tremendous advantages over its rivals, the price of unification was the "Prussianisation" of Germany, which entailed an overpowering growth of bureaucratic and military institutions and a strengthening of authoritarianism in all walks of life.

The unification of the country was achieved in a series of military victories, and a policy that gave questions of European power politics almost absolute priority greatly contributed to Germany's role in unleashing the cataclysms of the two World Wars. The deep resentment felt over the Versailles Treaty cannot be understood without taking into account the Germans' highly disturbed emotional relationship to their own national past. This feeling remained dominant during the brief attempt to create a modern democracy in the Weimar Republic and led to the deepest break in the German tradition, to its most catastrophic estrangement from the rest of the "World"—the twelve years of Hitler's rule. Notwithstanding the "economic miracle" of post-war West Germany and the strength of its democratic development, the question of guilt and the problem of the country's unsettled past *(unbewältigte Vergangenheit)* are far from being completely forgotten and settled inside and outside Germany. And whenever we start reflecting on questions relating to Germany, we are still immediately confronted with the dilemma posed in our introductory epigram: where to find Germany on the map? Is it West Germany or East Germany or both; are Austria and Switzerland to be included in discussions of the "German tradition" or the "German image"? In this book "German" very often means "pertaining to the German-speaking countries of Central Europe"— but this vague abstraction is certainly more difficult to define and to handle both for the "Germans" and for the "World" than concepts like "French", "Italian" or "Spanish".

Because of the dilemma brought about by the non-existence of "Germany" as a political, geographic and economic entity and the consciousness of the existence of a "Germany" defined by a common language and common historic and cultural traditions, over the last two centuries there has been a strong tendency to disregard outward realities and to establish German nationhood in the realm of the spirit, of ideas and *Kultur*. This means a withdrawal into a sphere of non-political inwardness which Thomas Mann once defined by the term *machtgeschützte Innerlichkeit*. The answer given by Goethe and Schiller themselves to the question of the introductory epigram offers the following definition of the German national character (*Deutscher Nationalcharakter*):

Zur Nation euch zu bilden, ihr hoffet es, Deutsche, vergebens;
Bildet, ihr könnt' es, dafür freier zu Menschen euch aus.

(Germans, you hope in vain to develop into a nation. By way of compensation,

however, you are able to develop the more freely into human beings.)

Goethe, whose function as an archetypal father-figure of the German tradition cannot be overrated, lived this very programme. For a decade (1776-86) he held one of the highest administrative positions in the principality of Sachsen-Weimar and proved an able statesman in all social, economic and political matters. He was to discover that the pettiness of conditions in one of the countless dukedoms that divided Germany inevitably created intense frustration. Consequently, he renounced most of his administrative duties and decided to devote his life to the pursuit of art, literature and science as the best and only possible way of realising a programme of aesthetic humanism aimed at the all-round development of the human personality.

The untranslatable word *Bildung,* with its connotations of growth, development, shaping and education, became the central theme of the classic-romantic age of Germany at the end of the eighteenth century. Ever since Heine's brilliant essays of the 1830's on the development of German thought and civilisation, it has been a cliché of German self-analysis to look at the great age of German philosophy, litera-ture and music as an artistic and intellectual revolution paralleling and to a certain extent replacing the political and social revolutions in France. It is this Germany of introspective feeling, sentiment, music and *Geist* which the writings of Mme de Staël and Thomas Carlyle presented as a positive example to France and England at the time of the deep social and moral crises arising in the wake of the Industrial Revolution. The image of the German people as "a race of thinkers and of critics" (Bulwer, 1837) *"das Volk der Dichter und Denker",* has been accepted by genera-tions of German conservative intellectuals as a highly flattering description. But it has also been violently attacked by Germans ranging from nationalists of the extreme right to radical revolutionaries and democrats. Heine's *Germany: a Winter Tale* (1844) presents this division between the "political" and "spiritual" aspects of German nationalism with trenchant irony:

> In German feather-beds you sleep
> And dream exceeding well.
> Here at last the German soul
> Escapes its earthly cell . . .

> The French and the Russians rule the land;
> The British rule the sea;
> But in the realms of dream we own
> Unchallenged mastery.

> Here we become one mighty state,
> Here, in dreams, we are crowned—
> While other peoples build their realms
> Upon the level ground . . .

(Translated by Aaron Kramer.)

As shown in previous chapters, the "World" owes a great deal to the process by which the best talents and energies of Germany were channelled into cultural activities. But the imminent dangers and contradictions arising from this develop-ment have always been clear to the best minds of the country, especially after 1871 when the disproportion between the unpolitical "inwardness" of the German intelli-gentsia and the aggressive politics of the ruling classes, the rift between *Geist und Tat* (Mind and Action) became more and more apparent. Here lie the roots of Nietzsche's relentless criticism of the German bourgeoisie, and of Thomas Mann's fascinating political development from his early attacks on Western democracy and

Zivilisation in the name of German introspection and *Kultur* to his realisation during the rise of German Fascism of the potential inhumanity and barbarism involved in his country's tradition of a-political romantic aestheticism.

Over and above the general trend of withdrawal into the sphere of internalised human values, the belated establishment of Germany as a modern nation-state created additional problems for Germans in search of a national identity. There is, for example, the strong regionalism of a country which for centuries did not have a political, administrative and cultural centre such as Paris or London provided for France and England. Then there are the strong religious divisions between the Protestant and the Catholic territories, and the regional language differences which were not counter-balanced by the powerful centralising tendencies at work in most other European states. It is significant that Martin Luther, who inaugurated a standardised German literary language with his translation of the *Bible*, put the Reformation at the service of territorial absolutism and thus greatly contributed to the division of Germany. All these factors had their positive sides, such as the growth of regional centres with an active and sophisticated cultural life, or a heightened awareness of the problems of language in all its aspects. This is especially so if Austria and the German-speaking parts of Switzerland are included in our investigations. On the whole, it has been extremely difficult for the Germans themselves to define their national identity, and this is probably one of the causes of the prevailing extremes in the image of Germany with its traits of intense emotionalism, abstract speculation and high efficiency.

The studies contained in this book have shown how despite all breaches of continuity in national development, the Germans had ample reason for taking pride in their efficiency in all organisational matters, ranging from Prussian military discipline to the workings of highly expedient bureaucratic structures. They were also proud of the diligence, devotion and competence which brought about the post-1871 and post-1945 economic "miracles". This efficiency has grown out of a series of components inherent in earlier traditions. The survival in many areas of small mastercraftsmen well into the industrial age helped to preserve much of the ethos of the medieval craft guilds. This was reinforced by the Protestant emphasis on material gain and achievement and was also helped by strict centralisation within the mercantilist framework of absolutism in the smaller German states. Here many forms of local initiative were encouraged as long as they did not enter the political sphere. Economic progress has also been promoted over a long period by a highly sophisticated educational system and by the development of research in universities and academies. Here again, the general trend towards abstraction and speculation proved fruitful. While withdrawing from political and public life in the course of the eighteenth century, German universities became the centres not only of philosophical speculation and metaphysical theorising. They were also the basis of intensely concentrated intellectual efforts at systematising and generalising both the empirical knowledge that became available with the breakdown of the closed medieval system of thought, and the wealth of facts and data provided by the age of discoveries. High social status was attached to a life devoted to *Wissenschaft*, an untranslatable word meaning both science and scholarship. In the last two centuries, Germany has made decisive contributions to the humanities in the fields of rational theology and *Bible* criticism as well as aesthetics, linguistics and history. In the social sciences, geography and ethnography were first brought into coherent modern systems by German

scholars, while the age of the Industrial Revolution led to a momentous development of medicine, biology, physics and the German science *par excellence*, chemistry. This development in turn had a tremendous impact on technological and economic progress.

When talking about the image of a nation, we have to take into account not only what it objectively *is* but also what others subjectively think of it as being: for instance a very different picture of the "Germans" has developed within the traditions of Eastern and Western Europe. But in both pictures Germany appears more clearly as a nation of contradictions and extremes than most other nations. For many observers, the events of the last century would have confirmed Coleridge's words recorded in his *Table-talk* of 2 June, 1834: "There is a nimiety—a too-muchness —in all Germans. It is the national fault." And this feeling, even if objectively unjustified, has contributed a great deal to making the image of Germany a highly contradictory one, more strongly coloured by emotional exaggerations and omissions than that of many other European nations. This aspect of the "German image" is very well summarised by Golo Mann in his *History of Germany since 1789:*

> The student of the history of the German nation easily gets an impression of restless oscillation between extremes . . . At times Germans reach the highest spiritual heights ever scaled by men, even though public life is dominated by a dreary mediocrity. Disinterest in politics gives way to hectic political activity, variety to complete uniformity; from prostration Germany rises to aggression, collapses again into chaos and then with incredible speed recovers a new and hectic prosperity. It can be receptive, cosmopolitan, admiring of things foreign; at other times it despises and rejects everything foreign and seeks salvation in the exaggerated cultivation of its national characteristics. At times the Germans seem a philosophical people, at others the most practical and most materialist; at times the most patient and peaceful, at others the most domineering and brutal. (p. 4)

The essays in this volume have demonstrated some of the fields in which Germany has made important contributions to the development of civilisation, and many of these achievements have, though sometimes with considerable delay, been recognised and assimilated by the "World". Over the past century, Germany has earned great respect for its achievements in science and technology, learning, scholarship and music. The typically "German" atmosphere of artistic and intellectual introspection conveyed by untranslatable words like *Bildung, Geist* or *Gemüt* has found many admirers all over the globe. The story of how "specifically German" attitudes and ideologies were suddenly discovered and assimilated by other peoples has yet to be written. However one can point to the suddenness and amazement with which the existence of a great German literary culture incorporated in Schiller, Goethe and the Romantics or later in Thomas Mann, Kafka and the Expressionists was noted by the other Western nations. And in talking about the contributions Germany made to the modern "World", we must not forget that the insights which led to the development of the two most important secular world-religions of our age, Marxism and Freudianism, came from within the framework of the German tradition.

We have described some of the traits which have made Germany the heart-land of Romanticism. This is also true on the most popular level of looking at "national characteristics" both from inside and outside Germany. I am thinking here of the

semi-rural romanticised idyll of German, Swiss and Austrian landscapes and people, an imagery recreated and reinforced daily all over the world by tourist posters and traditional school textbooks but also by some of the most important export articles of the German cultural heritage: the *Lied* and Grimm's fairy tales. These present a Rousseauistic myth the real basis of which virtually disappeared at the latest a century ago with the emergence of the united German Empire as a strong industrial and political power. But the image persisted, and we certainly cannot be surprised by the strength of the shock created for both Germans and non-Germans by the contrast between Nazi extermination camps and Eichendorff's and Schubert's moonlit streams, forests and sentimental journeymen. The prisoners' orchestra playing pieces of German classical music on the ramp of Auschwitz was a more horrifying confrontation of "extremes" in a national character than anything modern Europe had experienced before.

As mentioned earlier, the lack of continuity within the German tradition and the elements that have been felt as utter and irreconcilable extremes in the German character have led in many fields to marked delays in the reception of German achievements by the "World". While the fame of German music, science and technology was never hampered by national barriers, German philosophy has with some very few exceptions never been really accepted in the Anglo-Saxon world, and the eminently historical method which for the last two centuries has dominated the German approach in the humanities often appears extremely strange and foreign to students brought up in the English tradition. While the interactions have always been close between English, French and Russian literature, based on an efficient translating activity, the volume of German literature translated into foreign languages has never been very large and the German canon of "great books" has often proved to be markedly different from that shown by the world index of translations. To a certain extent this can be explained by the specific function of literature within the German tradition: in a basically authoritarian society which debarred its citizens from the political sphere, the writers and poets tended to assume the role of prophets and social reformers proclaiming their *Weltanschauung* (view of the world) in their works. This led to the development of the characteristic form of the German novel, which not only presents the reader with an interesting narrative but also tries to incorporate a philosophical and often highly speculative or even mystical interpretation of the human condition. The German tradition of inwardness is also mirrored in the predominance in German literature of an important body of lyrical poetry, which has posed many difficulties for translators. We must remember of course that much of this poetry was set to music by generations of great German composers and was received by the world as music rather than literature.

Germany's quest for a national identity, however, has also given birth to attitudes which were extremely favourable to the development of open-minded cosmopolitanism at its very best. In the growth of German philosophy from Leibniz to Herder, Kant and Hegel, ideas of nationalism were always counterbalanced by visions of the totality of mankind proceeding to a universal goal of peace and happiness. These thinkers developed a comprehensive idea of humanity in which the individual nations could fulfil and transcend their national identity only by acting in harmony like the masterfully played individual instruments in a universal symphony. In this spirit, Alexander von Humboldt devised a geographic system in the framework of which he was able to show the organic unity of the cosmos and, at

the same time, the highest development of individuality within the various regions of the globe. This thought was at the base of Leopold von Ranke's historicism as expressed in the phrase *"Jede Epoche ist unmittelbar zu Gott"* (Each epoch is immediate to God); this was also meant by the Swiss historian Jacob Burckhardt when he said: *"Ein wahrhaft großes Volk ist dann reich, wenn es vieles von anderen übernimmt und weiterbildet."* (A truly great people is really wealthy if it takes over and develops many things from other peoples.) It is interesting in this context to note that the term "world literature" *(Weltliteratur)* was coined by Goethe in 1827. He used it extensively in the last years of his life to stress the importance of a fruitful interaction between the writings of all peoples and periods. He based his views largely on the extensive translating activity which from the age of Herder and the early Romantics had made a concentrated effort at bringing the literary masterpieces of all nations into easy reach of the German reading public. Goethe himself, with his use and adaptation of oriental poetic forms in the *West-Östlicher Divan,* opened up a new world for Germany. One of the first epigrams from this collection, an adaptation of a verse of the Koran, gives an indication of the mood of openness and tolerance that is so very characteristic of this poetry:

> *Gottes ist der Orient!*
> *Gottes ist der Occident!*
> *Nord- und südliches Gelände*
> *Ruht im Frieden seiner Hände.*

(The East is God's. The West is God's. The lands of North and South rest peacefully in His Hands).

The older Goethe was delighted by all signs of fruitful literary and cultural cross-fertilisation. In 1828 he wrote an enthusiastic article on some Scottish reviews which had devoted considerable space to the development of German and French literature:

> These journals . . . will contribute in a most efficient way to a hoped-for general world-literature. We only want to emphasise again that this should on no account imply a compulsion for all nations to think in the same way; they should only take note of each other's existence, understand each other and—if they cannot bring themselves to like each other—at least tolerate the other nation's existence.

When talking about the emergence of a "world literature", Goethe showed considerable foresight in emphasising the impact of an age of rapid change and improved communications on the eve of Germany's entry into the era of the Industrial Revolution. It is interesting to note that two decades later the words of the German authors of *The Communist Manifesto* read almost like a quotation from Goethe: "National one-sidedness and narrow-mindedness become more and more impossible, and from the numerous national and local literatures there arises a world literature."

The Prussian-led unification of Germany resulted in a drastic change of many attitudes. Although official German politics still paid lip service to the ideals of classical philosophic and literary humanism, the "World" tended to regard with growing suspicion the official *Kulturpolitik* of imperial Germany, which developed in the atmosphere of the increasing world-wide chauvinist propaganda of the main imperialist powers. In the eyes of the "World", the Germans have never fully recovered from the hateful image of the barbarous Huns imposed upon them by their enemies in the First World War. Between the two World Wars this image was

reinforced even for many of Germany's friends by disappointment over the failure of the policy of appeasement, and rejection of the crimes of the Third Reich. It was also strengthened by the world-wide fears of a policy that tended to misuse respect for the scientific and cultural achievements of Germany for the boosting of "fifth columns" in countries it wanted to conquer. The image of the "ugly German" built up by the mass media over more than half a century cannot easily be effaced. As late as December 1969, a well-reasoned article by John Mander in *Encounter* on English-German relations bore the title: "Must We Love the Germans?"

The highly involved and contradictory relationship of Germany to the world can probably best be illustrated by mentioning one paradoxical and fascinating feature of our age. I am referring to the fact that the deepest rift between Germany and the civilised world simultaneously meant the most far-reaching penetration of this world with the best elements of the German tradition. In 1933 Hitler seized power and cut Germany off from its most valuable traditions and from the rest of the world by embarking on a policy of crude chauvinism and mass-hysteria, by relentlessly destroying the excitingly modern artistic and literary life of the Weimar Republic and replacing it with woolly mysticism, book-burnings, concentration camps, and a highly efficient militarisation of the country. Tens of thousands of German intellectuals, including some of the best scientists, scholars, artists and writers, had to leave Germany and later Austria and were joined by emigrés from Eastern Europe fleeing Hitler's advancing armies. They represented a great variety of beliefs and attitudes. Many of them were Jews or of Jewish extraction; others had to leave Germany because of their political or religious views, their artistic creeds or their humanist convictions. They all had in common, however, involvement with the German tradition or with that specific brand of German-Jewish intellectualism which had developed into one of the most exciting and productive attitudes within Germany and which was regarded as especially pernicious by Hitler. Moreover, their expulsion from Germany forced them to become aware of the problems involved in their "Germanness". Many of them were overtaken by Hitler's advancing armies and perished in German or sometimes Russian concentration camps; many committed suicide or could never find their place in life again. The survivors found new homes predominantly in the Anglo-Saxon world, and are now spread all over the globe.

We cannot yet assess the full impact of this exodus, which has been compared to the flight of Greek scholars after the fall of Byzantium in 1453 which was so crucial for the inauguration of the Renaissance and the Reformation. We know for certain that in philosophy, sociology, aesthetics, architecture, art, music and literature the creative impulse given to the world by this intensive merging of the German spirit with foreign media has been immense, even if not always producing such dangerously spectacular results as in the field of nuclear physics. This whole process had almost immediate consequences for Germany proper when in the complete moral and cultural vacuum created by the catastrophic defeat of 1945 it was crucial to repair the breach in the cultural tradition of Germany created by Hitler's rule, and to bring the "lost generation" of the war years to a renewed contact with their own traditions and with the world. The post-war reception and impact of writers like Thomas Mann, Kafka and Brecht clearly exemplifies the way in which important elements of the German tradition were retransmitted to Germany, having first been absorbed into the framework of western civilisation.

At the end of a book of this kind we will want to ask: has "Germany" now found its place in Europe and in the world? Germany, at least within the Federal Republic, has succeeded in creating a state of great economic prosperity and political stability, with a young generation apparently unwilling to repeat the mistakes of their fathers. But the walls and the barbed wire that divide the country demonstrate that the question of its national identity is still unsolved, at least in the traditional meaning of nationalism. It can, however, be assumed that in our modern world this question has lost much of its relevance, and that the problems of individual nations will be solved only as the world solves its universal problems and dilemmas. In a very beautiful though slightly utopian way, this hope is expressed in the concluding sentences of an address given on *Germany and the Germans* by Thomas Mann, delivered at one of the most crucial turning points for German and world history in 1945:

> Despite all drastic warnings against the excessive expectations that we have had from the past performance of power politics, may we not cherish the hope that after this catastrophe the first experimental steps may be taken in the direction of a world condition in which the national individualism of the nineteenth century will dissolve and finally vanish, and which will afford happier opportunities for the development of the "good" in the German character than the untenable old conditions? Is it not possible after all that the liquidation of Nazism may pave the way for a social world reform which would offer the greatest prospect of happiness to Germany's very inclinations and needs?

References and Further Reading

Artists

HEINRICH WÖLFFLIN. *The Sense of Form in Art.* Chelsea Publishing, New York, 1958. (transl. of *Italien und das deutsche Formgefühl*, 1931).

HANNS SWARZENSKI. *Monuments of Romanesque Art; the art of church treasures in north-western Europe.* Faber & Faber, London, 1954.

ERWIN PANOFSKY. *Albrecht Dürer.* 2nd ed. Humphrey Milford, London, 1945.

THEODOR MÜLLER. *Sculpture in the Netherlands, Germany, France and Spain, 1400-1500.* Pelican history of art, 1966.

GERT VON DER OSTEN and HORST VEY. *Painting and Sculpture in Germany and the Netherlands, 1500-1600.* Pelican history of art, 1969.

OTTO BENESCH. *The Art of the Renaissance in Northern Europe.* Phaidon, London, 1951.

FRITZ NOVOTNY. *Painting and Sculpture in Europe, 1780-1880.* Pelican history of art, 1960.

HENRY RUSSELL HITCHCOCK. *Rococo Architecture in Southern Germany.* Phaidon, London, 1968.

WERNER HAFTMANN. *Painting in the Twentieth Century.* Lund Humphries, London, 1960.

Catalogues of the *Documenta.* Kassel.

Composers

ARNOLD SCHERING. *Geschichte der Musik in Beispielen.* Breitkopf and Härtel, Leipzig. 1931.

SIDNEY FINKELSTEIN. *How Music Expresses Ideas.* International Publishers, New York, 1952.

FRIEDRICH BLUME. *Renaissance and Baroque Music.* Norton, New York, 1967.

ROBERT W. L. SIMPSON. *The Symphony,* Penguin Books, 1966/67.

WALLACE BROCKWAY and HERBERT WEINSTOCK. *The World of Opera.* Methuen, London. 1963 (first published Pantheon Books, New York, 1941).

BENCE SZABOLSCI. *A History of Melody.* Barrie and Rockliff, London, 1965.

OTTO DERI. *Exploring Twentieth-Century Music.* Holt, New York, 1968.

GEORGE PERLE. *Serial Composition and Atonality.* Faber & Faber, London, 1962.

Medieval Literature

JOHAN HUIZINGA. *The Waning of the Middle Ages.* Pelican Books, 1955 (first published 1924).

WILLIAM JAMES. *The Varieties of Religious Experience.* Fontana Library, 1960 (first published 1902).

W. P. KER. *Epic and Romance.* Dover Books, 1957 (first published 1897).

W. P. KER. *The Dark Ages.* Mentor Books, New York, 1958 (first published 1904).

C. S. LEWIS. *The Allegory of Love.* Oxford University Press, London, 1958 (first published 1936).

D. G. MOWATT. *The Nibelungenlied.* Everyman's Library, 1962.

D. G. MOWATT and HUGH SACKER. *The Nibelungenlied. An interpretative commentary.* Toronto, 1967.

HELEN WADDELL. *The Wandering Scholars.* Pelican Books, 1954 (first published 1927).

Modern Authors

FRITZ MARTINI. *Deutsche Literaturgeschichte von den Anfängen bis zur Gegenwart.* 1st ed. Kröner, Stuttgart, 1955.

JAMES RITCHIE, (ed.). *Periods in German Literature.* Wolff, London, 1966.

MARIAN SZYROCKI. *Die deutsche Literatur des Barock. Eine Einführung.* Rowohlt, Reinbek bei Hamburg, 1968.

E. A. BLACKALL. *The Emergence of German as a Literary Language 1700-1775.* Cambridge University Press, 1959.

W. H. BRUFORD. *Germany in the Eighteenth Century; the social background of the literary revival.* Cambridge University Press, 1935.

ROY PASCAL. *The German Sturm und Drang.* Manchester University Press, 1953.

ROY PASCAL. *The German Novel.* Manchester University Press, 1956.

RONALD GRAY. *The German Tradition in Literature 1871-1945.* Cambridge University Press, 1965.

VICTOR LANGE. *Modern German Literature 1870-1940.* Kenniket Press, Port Washington, 1967 (first published by Cornell University Press, 1945).

HANS STEFFEN, (ed). *Der deutsche Expressionismus.* Vandenhorch and Ruprecht, Göttingen, 1965.

WALTER MUSCHG. *Die Zerstörung der deutschen Literatur.* 3rd ed. Francke, Bern, 1958.

WALTER MUSCHG. *Von Trakl zu Brecht.* Piper, München, 1961.

Philosophers

FREDERICK COPLESTON. *A History of Philosophy.* vol. V, From Wolff to Kant and vol. VI, From Fichte to Nietzsche. Burns and Oates, London, 1950.

"German philosophy", by L. W. Beck and "German philosophy and National Socialism", by H. Kuhn, in vol. 3 of *The Encyclopaedia of Philosophy.* Macmillan, New York, 1967.

WERNER BROCK. *Introduction to Contemporary German Philosophy.* Cambridge University Press, 1935.

HANS KOHN. *The Mind of Germany.* Scribner, New York, 1960.

Psychology and Psychiatry

F. G. ALEXANDER and S. T. SELESNIK. *The History of Psychiatry.* George Allen and Unwin, London, 1967.

ROBERT THOMPSON. *The Pelican History of Psychology.* Penguin books, 1968.

G. and H. ZILBOORG. *History of Medical Psychology.* Norton, New York, 1941.

H. KRAMER and J. SPRENGER. *Malleus Maleficarum.* (1487) Reprinted by Pushkin Press, 1948.

ERNEST JONES. *Sigmund Freud: Life and Work.* Hogarth, London, 1954-1958.

KONRAD LORENZ. *On Aggression.* Methuen, London, 1966. (transl. of *Das sogenannte Böse*).

HERBERT READ. *Art and Society.* Macmillan, London, 1937.

Educators

HENRY BARNARD. *German Pedagogy; education, the school and the teacher in German literature.* Hartford, 2nd ed. 1876.

HENRY BARNARD. *German Education Reformers; Memoirs of eminent teachers and educators with contributions to the history of education in Germany , ibid.* 1878.

ANDREAS FLITNER. *Die Politische Erziehung in Deutschland. Geschichte und Probleme, 1750-1880.* Niemeyer, Tübingen, 1957.

ANDREAS FLITNER. "Wissenschaft und Volksbildung", in: *Deutsches Geistesleben und Nationalsozialismus,* edited by A. Flitner. Wunderlich, Tübingen 1965, pp. 217-235.

FRANZ KADE. "Zur inneren Schulreform", in: *Die Neue Volksschule in Stadt und Land,* vol. 6, Dümmler, Bonn, 1955 pp. 395-406. (The whole February-March issue of the journal discusses Kade's system.)

WOLFGANG KLAFKI. "Integrierte Gesamtschule—ein notwendiger Schulversuch" in: *Zeitschrift für Pädagogik,* 1968, pp. 521-581 (for the controversy regarding the comprehensive school see *Die höhere Schule. Zeitschrift des Deutschen Philologenverbandes,* vol. 23, February issue 1970, pp. 27-32; 36-42; 49f.)

G. F. KNELLER. *The Educational Philosophy of National Socialism.* Yale University Press, Newhaven, 1941.

JOACHIM H. KNOLL. *The German Educational System.* Inter Nationes, Bonn, 1967 (Describes the present situation in the Federal Republic of Germany.)

FRIEDHELM NICOLIN (ed.). *Pädagogik als Wissenschaft.* Wissenschaftliche Buchgesellschaft (Wege der Forschung, vol. XXXII), Darmstadt 1969. (Contains extracts from writings on education from 1806-1966.)

R. H. SAMUEL and R. H. THOMAS. *Education and Society in Modern Germany.* London 1949; reprint Greenwood Press, New York 1970 (cf. Bibliography pp. 182-187).

D. F. S. SCOTT. *Wilhelm von Humboldt and the Idea of a University.* University of Durham, 1960.

FRIEDRICH SEILER. *Geschichte des Deutschen Unterrichtswesens* (2 vols.), Leipzig 1906.

Scientists

W. C. DAMPIER. *A History of Science.* Cambridge University Press, 1942.

ALBERT EINSTEIN. *Relativity, the Special and the General Theory; a Popular Exposition.* Methuen, London, 1954.

ALBERT EINSTEIN. *Autobiographical notes,* in P. A. Schilpp (ed.). *Albert Einstein. Philosopher-Scientist.*

P. P. EWALD and numerous crystallographers. *Fifty years of X-Ray Diffraction.* Oosthoek's nitgeversmaatschappij for the International Union of Crystallography. Utrecht, 1962.

WERNER HEISENBERG. *Philosophy and Physics; the revolution in modern science.* George Allen & Unwin, London, 1958.

MAX VON LAUE. Autobiography in P. P. Ewald, *Fifty Years of X-Ray Diffraction.*

C. E. K. MEES. *The Path of Science.* John Wiley & Sons, New York, 1946.

J. T. MERZ. *A History of European Thought in the Nineteenth Century. Scientific Thought,* vols. 1 and 2. Dover, New York, 1965.

MAX PLANCK. *A Scientific Autobiography and other Papers.* Philosophical Library, New York, 1949.

GEORGE SARTON. *Introduction to the History of Science; Science and Learning in the 14th Century* (2 vols.) Williams & Wilkins for the Carnegie Institute, Washington, 1947.

P. A. SCHILPP (ed.). *Albert Einstein: Philosopher-Scientist.* The Library of Living Philosophers, Evanston, Ill. 1949. (essays by Niels Bohr, Louis de Broglie, Max von Laue, Ilse Rosenthal-Schneider, Arnold Sommerfeld *et al.*)

ERWIN SCHRÖDINGER. *What is life? The Physical Aspect of the Living Cell.* Cambridge University Press, 1944.

Political Theories

KARL DIETRICH BRACHER. *Die Deutsche Diktatur.* Kiepenhauer & Witsch, Köln, 1969.

ROHAN D'O. BUTLER. *The Roots of National Socialism 1783-1933.* Faber & Faber, London, 1941.

RALF DAHRENDORF. *Society and Democracy in Germany.* Weidenfeld and Nicolson, London, 1968 (transl. of *Gesellschaft und Demokratie in Deutschland,* 1965).

THEODOR ESCHENBURG. *Staat und Gesellschaft in Deutschland.* Schwab, Stuttgart, 1956.

F. L. GANSHOF. *Feudalism.* Longmans, London, 1952 (transl. from the French).

PAUL JOACHIMSEN. *Vom Deutschen Volk zum Deutschen Staat.* Vandenhoek & Ruprecht, Göttingen, 1956.

E. J. Passant. *Short History of Germany 1815-1945.* Cambridge University Press, 1966.

K. S. Pinson. *Modern Germany, its History and Civilisation.* 2nd. ed. New York, Collier-Macmillan, 1966.

Thorstein Veblen. *Imperial Germany and the Industrial Revolution.* (1915) Reprinted by University of Michigan Press, 1966.

Economy

J. H. Clapham. *The Economic Development of France and Germany,* 1815-1914, Cambridge University Press, 4th edition, 1936.

A. Gerschenkron. "Economic backwardness in historical perspective", and "Reflections on the concept of 'prerequisites' of modern industrialization" in: *Economic Backwardness in Historical Perspective,* edited by A. Gerschenkron, Cambridge, Mass., 1962, pp. 5-51.

W. G. Hoffmann. "The take-off in Germany" in: *The economics of take-off into sustained growth.* W. W. Rostow (ed.), Macmillan, London, 1965, pp. 95-118.

G. V. Klass. *Krupp—the Story of an Industrial Empire,* Sidwick & Faber, London, 1954.

D. S. Landes. *The Unbound Prometheus,* Cambridge University Press, 1969.

N. J. G. Pounds. *The Ruhr.* Faber & Faber, London, 1952.

A. Sampson. *The New Europeans.* Hodder & Stoughton, London, 1968.

G. Stolper et al. *The German Economy 1870 to the Present.* Harcourt, Brace & World, New York, 1967.

R. Tilly. *Financial Institutions and the Industrial Development in the Rhineland, 1815-1870.* University of Wisconsin Press, Madison, 1966.

D. F. Vagts. "Reforming the 'modern corporation': Perspective from the German" in Harvard Law Review 80 (1966-67), pp. 23-89.

H. C. Wallich. *Mainsprings of the German Revival.* Yale University Press, 1955.

Was gehört zu wem? Commerzbank, 8th and revised edition, 1968.

Contributors

Margaret Plant (M.A., Melb.) is lecturer in art history at the Royal Melbourne Institute of Technology and an art critic for *The Australian*. She was introduced to the German tradition in art by the late Mr. Franz Philipp, of the Department of Fine Arts, University of Melbourne.

Felix Werder is a composer and music critic for *The Age,* Melbourne.

Constantin Kooznetzoff (Dr. phil., Heidelberg) is professor of German at the Victoria University of Wellington, New Zealand.

Marion Adams (A.M. Harv., Ph.D., Melb.) is principal tutor in German at the University of Melbourne.

Gershon Weiler (B. phil., Oxon.) is reader in philosophy at La Trobe University, Victoria.

Herbert M. Bower (M.D., Basle, D.P.M. Melb.) is Director of Post-Graduate Studies for the Mental Health Authority in Victoria.

R. H. Samuel (Dr. phil., Berlin, Ph.D. Cantab.) is Professor Emeritus at the University of Melbourne.

Ilse Rosenthal-Schneider (Dr. phil., Berlin) is lecturer for the Extension Board of the University of Sydney.

Walter Veit (Dr. phil., Cologne) is senior lecturer in German at Monash University, Victoria.

Raoul Middelmann (Diplom-Volkswirt, Frankfurt) is assistant lecturer in Economic History at the University of Melbourne.

Leslie Bodi (Dr. phil., Budapest) is professor of German at Monash University, Victoria.

Chronological Table

	Art	Music
2nd c. B.C.-5th c. A.D. Confrontation between German nations and Rome, especially along Rhine and in Switzerland and Austria. Roman occupation and settlement.		
5th-8th c. Under pressure from Huns, German nations overrun Roman territories and establish independent Christian kingdoms.	Jewellery and metal utensils	
Charlemagne (742-814) consolidates France, Switzerland and most of western Germany and Austria into a Frankish kingdom. Crowned emperor by the pope in 800; inauguration of thousand-year Holy Roman Empire.	Carolingian art	
9th-11th c. Division of Charlemagne's empire and reconsolidation of German territories under Henry I and Otto I of Saxony. Otto crowned emperor 962. Austria an eastern Carolingian outpost; Switzerland part of duchy of Swabia, later an imperial territory. From 1096 European crusades against the Moslems, which continue intermittently until 1270.	Ottonian art Romanesque art	
12th-15th c. Feud between emperors and popes over their relative powers (Investiture Controversy). Rise of Hohenstaufen and Habsburg dynasties. Order of Teutonic Knights founded 1190 to campaign in pagan Prussia. Rivalry between Hohenstaufen and Welf families becomes in Italy struggle between Ghibellines (supporting the emperor) and Guelphs (supporting the pope). No emperor 1254-1273 (the Great Interregnum); afterwards decline in emperor's political importance. Austria taken over 1278 and developed by Habsburgs, who from 15th c. are always emperors. From 1291 the Swiss cantons begin to unite against the Habsburg emperors; in 1499 emperor recognises Swiss independence.	Gothic art	Minnesang
	Conrad Witz Schongauer Dürer Adam Kraft Veit Stoss	Polyphonic style

Literature	Philosophy	Psychology & Psychiatry	Education	Science
Merseburger Zaubersprüche *Hildebrandslied* *Abrogans*				
Wessobrunner Gebet *Muspilli*				
Hrotswitha von Gandersheim Notkar Labeo				
Kaiserchronik Der von Kürenberc *Salman und Morolf* Hartmann von Aue Walther von der Vogelweide Gottfried von Strassburg Wolfram von Eschenbach *Nibelungenlied* *Carmina Burana* Rudolf von Ems Der Stricker Meister Eckhart Tauler			First universities	Albertus Magnus Conrad of Megenberg
Gutenberg's printing press		*Malleus Maleficarum* H. C. Agrippa		

	Art	Music
Reformation and religious wars. Martin Luther attacks in 1517 sale of papal indulgences and initiates the Reformation. Peasants' Revolt 1522-1525. War between Emperor Charles V and German Protestant princes. Peace of Augsburg 1555 recognises Lutheranism. Calvin dominates Geneva 1541-1564; Swiss expansion into former French and Italian areas. Through marriages and annexations Austria acquires the Netherlands, Bohemia, Hungary and Spain. Thirty Years' War 1618-1648 between Catholic and Protestant European coalitions devastates Germany. Vienna besieged 1683 by the Turks, who are driven back by a central European alliance.	Riemenschneider Cranach Altdorfer Grünewald Holbein Baroque art	Hymns and chorales Meistersang Schütz
Rise of Prussia from around 1700 under the Hohenzollern dynasty, which until its final victory in 1870 repeatedly challenges the Austrian Habsburgs for control of Germany. Frederick II of Prussia takes Silesia from Maria Theresa of Austria in 1748. At the instigation of Prussia, Poland partitioned from 1770 between Prussia, Austria and Russia.	Rococo art Balthasar Neumann Ignaz Günter Winckelmann	J. S. Bach Handel Telemann K. P. E. Bach & W. F. Bach Haydn Mozart
French Revolution 1789. Intervention in France by the west European monarchies, followed by revolutionary and Napoleonic wars until 1815. Prussian armies defeated by France in 1795 and 1805-1807. Switzerland occupied by French troops; Helvetic Republic proclaimed 1798. Austria loses territories and in 1806 dissolves the Holy Roman Empire.	C. D. Friedrich Runge	Beethoven
Wars of Liberation against France 1813-1815. At Congress of Vienna in 1815, Austrian Chancellor Metternich recognises Swiss neutrality but establishes a Germanic Confederation under Austrian presidency.	Nazarenes	Schubert Weber
Restoration 1819-1848. Conservative policies and censorship throughout Confederation. Customs Union organised by Prussia.	Biedermeier art	Mendelssohn Schumann
Year of Revolutions 1848. An elected national parliament meets in Frankfurt am Main 1848-1849. Civil war in Switzerland 1847 over attempts at religious separatism; a federal constitution achieved 1874.	Menzel	Wagner

Literature	Philosophy	Psychology & Psychiatry	Education	Science
Luther's Bible translation Hans Sachs		Paracelsus J. Weyer	Luther Melanchthon Leading schools founded in Germany	Copernicus Kepler
			Jesuit colleges and didactic drama	
Gryphius Grimmelshausen	Leibniz			Leibniz
	C. Wolff		Pietism A. H. Francke and Thomasius at Leipzig University	
Klopstock Lessing Wieland Herder Goethe Lenz. Klinger Schiller	Kant		Prussia leads educational reforms Philanthropic schools Neo-humanism F. A. Wolf at Halle University	von Haller Kant
Novalis, Tieck Brentano F. Schlegel, A. W. Schlegel Jean Paul Hölderlin Kleist	Fichte	Platner Langermann Reil Mesmer Gall	Pestalozzi W. v. Humboldt vom Stein	A. v. Humboldt
E. T. A. Hoffmann		Heinroth Haindorf Carus	F. Jahn	
Eichendorff Heine Grillparzer Raimund, Nestroy, Hebbel, Droste-Hülshoff	Hegel Schelling Schopenhauer		Herbart Fröbel and the kindergarten	Gauss. Riemann Wöhler. Liebig
				Helmholtz
Keller Meyer Gotthelf				

	Art	Music
Bismarck as Prussian Chancellor from 1862 moves to consolidate the German states and exclude Austria. Successful Prussian campaigns against Denmark (1864), Austria (1866) and France (1870-1871) result first in a North German Confederation, then in proclamation of William I of Prussia emperor in 1871, with a national elected parliament but a personally appointed cabinet. Bismarck Chancellor of Germany 1871-1889. Industrial Revolution and major social welfare legislation; conflict with Catholic church and with the Socialists, who become the majority party. Austria reconciled with Germany. Triple Alliance founded between Germany, Austria and Italy. Germany annexes vast colonial territories in Africa and the Pacific.	Böcklin Busch	Brahms
	Liebermann Slevogt Corinth Käthe Kollwitz Paula Modersohn-Becker Behrens	Mahler Richard Strauss Schoenberg
Triple Entente between Britain, France and Russia aligned from 1904 against Austro-Germany. Crises between Germany and Britain over colonial disputes and naval rivalry, and between Austria and Russia over the Slavonic Balkan states.	Gropius *Brücke* (Kirchner, Heckel, Pechstein, Schmidt-Rottluff) *Blaue Reiter* (Klee, Kandinsky, Marc, Macke) Barlach	
First World War 1914-1918 involves most European nations (Switzerland remaining neutral) and battles from Belgium to Turkey. Public support for war in Germany in 1914 turns in 1917 to calls by parliament for negotiated peace. Munitions workers strike and naval units mutiny 1918. William II abdicates; Germany proclaimed a republic in November 1918 and an armistice declared. Austro-Hungarian empire dissolved into independent states, and an Austrian Republic established 1919.		
Weimar Constitution adopted in Germany and Treaty of Versailles signed in 1919. Political and economic chaos in Germany and Austria 1919-1924: separatism, inflation, private armies, political assassinations, revolts from the left and the right. N.S.D.A.P. (Nazi Party) emerges under Hitler 1919.	*Bauhaus* Beckmann Ernst	Berg von Webern
Stresemann's policies lead to Locarno Pact with Russia 1925, Germany's admission to League of Nations 1926. Currency stabilised and Germany prospers briefly.		Hindemith
International economic crisis and mass unemployment 1929-1932. Electoral gains in Germany by N.S.D.A.P. and Communists. Parliamentary deadlock and disunity in the left and centre parties brings in Hitler as chancellor January 1933.		

Literature	Philosophy	Psychology & Psychiatry	Education	Science
Stifter	Nietzsche			Haeckel
Raabe		Lotze	Nietzsche's	Mendel
Fontane	Dilthey	E. H. Weber	criticisms	
		J. Müller		Hertz
	F. Brentano	G. Fechner		
	E. Mach	Wundt		
Holz. Schlaf		Ebbinghaus		
Hauptmann		Kräpelin		
George				
Mombert			Lagarde	
Rilke			Langbehn	Röntgen
				Planck
Hofmannsthal	Husserl	Bleuler		Einstein
Else Lasker-Schüler		A. Meyer		
		Freud		
		Jung		
			Youth movement	
			Kerschensteiner	
Heym. Trakl			Gaudig, Lietz	
Benn			Wyneken	
Barlach			Geheeb	
Sternheim				
Kafka		Gestalt		
Döblin		psychology		
			Waldorf	
			schools	von Laue
			(Steiner)	
Brecht				
Kaiser	Wittgenstein			
Toller				
			C. H. Becker	
Jahnn	Heidegger	Existential		
		psychology		
		Jaspers		
			Nazi programme	
			and	
			centralisation	

Hitler suspends the constitution during elections in March 1933
and orders censorship and mass arrests. Coalition of N.S.D.A.P.
and Nationalists wins majority in parliament. Hitler legislates
dictatorial powers and eliminates Nationalists as well as the
opposition. In 1934 he assumes title of *Führer* and rapidly
centralises all aspects of German life. In June purge many
leading Nazis executed. During attempt at a Nazi coup in
Austria, Chancellor Dollfuss assassinated; but Mussolini
prevents German intervention. Nürnberg race laws
promulgated.

Repudiation of Weimar Republic's treaties. Rome-Berlin Axis
and anti-Comintern pact with Japan 1936. Hitler assumes
supreme command of the army 1938.

Nazi Chancellor appointed in Austria under German pressure;
Austria occupied by German troops and becomes part of the
new German empire. Dispute over German-speaking minority
in the Sudetenland leads to partition and annexation of
Czechoslovakia 1938-1939. Dispute with Poland over access to
separated city of Danzig. After failure to secure an alliance with
Britain and France, Russia signs non-aggression pact with Orff
Germany. Germany and Russia invade and divide Poland.
Britain and France declare war on Germany. Egk

Second World War 1939-1945. German armies, aided in the
south by Italy, overrun and occupy most of continental western
Europe in 1940 from Norway to Greece. Battle for Britain.
Breakdown of pact with Russia over Russian annexations in the
Balkans and on the Baltic; Germany invades Russia June 1941.
Japan enters war on Germany's side; the U.S.A. declares war on
Japan and Germany in 1941. Switzerland maintains neutrality.
Defeat of German armies at Stalingrad and defection of Italy
1943. Allied landing in Normandy June 1944. Abortive attempt
by German officers to assassinate Hitler July 1944. Allied armies
cross Rhine March 1945; Russians besiege and take Berlin
April-May 1945. Germany surrenders May 1945.

Germany occupied by Allies 1945-1948 in four zones; Berlin
(in the Russian zone) also divided into four zonal districts.
Potsdam agreement among the Allies cedes Germany's eastern
territories to Poland and Russia; Germans expelled from new
Polish area. Differences develop between Allies over reparations
and zone mergers as well as over conflicting ideologies.
Establishment of Federal Republic in the west and Democratic
Republic in the east 1948-1949.

Chancellor Adenauer (centre parties) in the Federal Republic Stockhausen
and Chairman Ulbricht (Communist) in the Democratic
Republic lead the two Germanies into opposed political and
economic alliances. Anti-government strikes and riots in East
Germany 1953. Berlin Wall erected 1961.

Grand Coalition 1966-1969 in the Federal Republic of centre
parties (C.D.U.-C.S.U.) and Socialist party (S.P.D.).
Reappearance of right-wing and left-wing extremism and
student unrest.

Socialist-Liberal coalition elected 1969 in Federal Republic
under Chancellor Brandt.

Literature	Philosophy	Psychology & Psychiatry	Education	Science
				Hahn
				Strassmann
			Diverging systems in the Federal Republic and the D.D.R.	
Borchert				
Böll				
Grass Enzensberger		Lorenz		

Index of Names

Numbers in *italics* indicate references to plates.